Seeing the Unspeakable

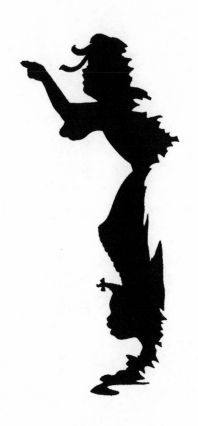

DUKE UNIVERSITY PRESS DURHAM AND LONDON 2004

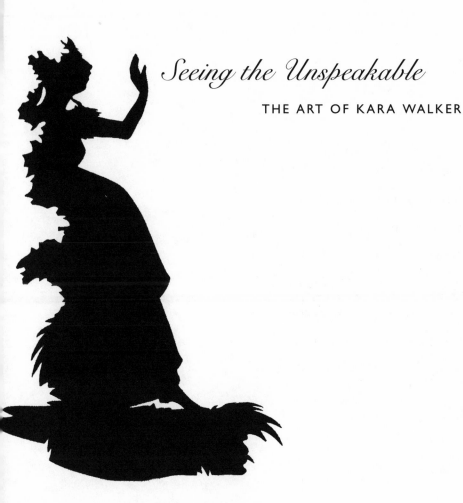

Seeing the Unspeakable

THE ART OF KARA WALKER

GWENDOLYN DUBOIS SHAW

2nd printing, 2005

© 2004 Duke University Press

All rights reserved

Printed in the United States of America

on acid-free paper ∞ Designed by Amy Ruth Buchanan

Typeset in Baskerville by Tseng Information Systems, Inc.

Library of Congress Cataloging-in-Publication Data

appear on the last printed page of this book.

Contents

Illustrations

Acknowledgments

From my time as a graduate student in the Department of Art and Art History at Stanford University I would like to thank my dissertation advisor, Alexander M. Nemerov. The dissertation, and the book that it has now evolved into, owe much to his pedagogy, his high standards, and his belief in my abilities. Similarly, I owe my second chair and de facto advisor, Wanda M. Corn, unending gratitude for the challenges she set before me and for all that she has taught me. I am also indebted to the other members of my committee, Pamela M. Lee of Stanford and Judith Wilson of the University of California, Irvine, for their attentive criticism and continued support.

At Harvard I have benefited from the generous attention of my many distinguished colleagues, foremost among them Suzanne Blier, Werner Sollors, Karen C. C. Dalton, Kimberley McClain DaCosta, Jeffrey Hamburger, Robin Kelsey, David Roxburgh, Evelyn Brooks Higginbotham, and Tommie Shelby. Special thanks go to my department chairs, Ioli Kalavrezou and Yve-Alain Bois in History of Art and Architecture and Henry Louis Gates Jr. in African and African American Studies for helping me to secure fellowship support for my research. I am particularly grateful for the attention of the late Richard Newman, director of research at the W. E. B. Du Bois Institute. Richard was both a gracious reader and a nonstop cheerleader who helped me to thrive in my first year of professional teaching and writing. I also wish to thank my research assistants Rebecca Keegan and Monique Bell.

Many members of the Americanist community in the Boston area have also offered help and support, including Eric Rosenberg at Tufts University and especially Patricia Hills of Boston University, who has selflessly mentored me over the past three years. And thanks to Estelle Freedman in Stanford's History Department and Janet C. Berlo of the University of Rochester for being unofficial advisors of supreme impact and importance.

I wish to acknowledge the support of the Radcliffe Institute for Advanced Study at Harvard University and the Art History Department at Boston University for hosting my Ford Foundation Minority Postdoctoral Fellowship during my sabbatical in 2002–2003. Without the time, space, and support that these institutions provided I would not have been able to finish my revisions on this book. I would also like to thank my fellow fellows at Radcliffe, who provided me with great insight and many good references.

I was pleased to have been able to present pieces of this work in several public venues, including the W. E. B. Du Bois Institute for African American Studies at Harvard University, the College Art Association annual meetings in 1999 and in 2001, the University of Rochester Art Gallery, Tufts University, Rhode Island College, Wesleyan University, the University of Western Ontario, London, and the Ringling School of Art and Design in Sarasota. A portion of chapter 5 can be found in the essay "Final Cut," in *Parkett*, no. 59 (2000). An early version of chapter 2 is included in the forthcoming volume *Trauma and Visual Representation in Modernity* edited by Lisa Saltzman and Eric Rosenberg (University Press of New England, 2004).

I would also like to acknowledge the support of my family and friends, without whom there would be no reason to work so hard or to even get up in the morning.

Final thanks go out to Kara Walker, who gave me access to her artistic practice as well as a new understanding of my own academic interests. I hope that she will find my thoughts on her work as interesting as I have found her work to think about.

In the spring of 1997 I visited Kara Walker's exhibition "Upon My Many Masters" at the San Francisco Museum of Modern Art (SFMOMA). One of the works I saw that day was a physically imposing installation titled *The End of Uncle Tom and the Grand Allegorical Tableau of Eva in Heaven* (figure 1). It was a huge piece that spread across the gallery walls, like a shadow drama being played out by actors hidden behind a scrim of white fabric. Each of the work's many characters was presented in formally elegant profiles that froze the motions of their wildly gesticulating bodies in erotic, satiric, and violent poses that were both attractive and repulsive. Many of my fellow gallery visitors stood before the piece, jaws slack and eyes wide, staring in puzzled disbelief at what they were seeing, or at least at what they thought they were seeing. I, too, was stunned by the graphic nature of the piece, its violence and its hard-core sexual content, the way that it seemed to attack the clichés and stereotypes about plantation life that have become a part of the popular understanding of the past. It was a moment of communal visuality in which the act of viewing within the space of the gallery became a spectacular spectacle, a cyclical scopic activity in which museum patrons watched other museum patrons watching them back. The phenomenological effect of the installation, its very "thingness," following Martin Heidegger's 1936 essay "The Origin of the Work of Art," was like a physical blow to the observer; it rendered many viewers temporarily disoriented and speechless.

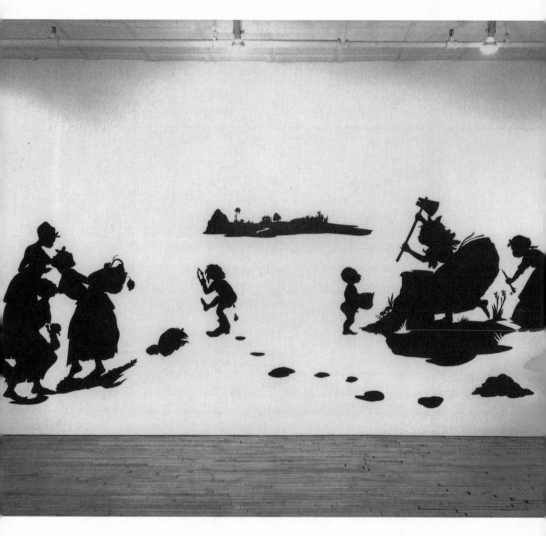

FIGURE 1. Kara Walker, *The End of Uncle Tom and the Grand Allegorical Tableau of Eva in Heaven*, 1995. Private Collection. Cut paper and adhesive on wall, 15 × 35 ft. (dimensions variable). Photo courtesy of Brent Sikkema Gallery, New York City.

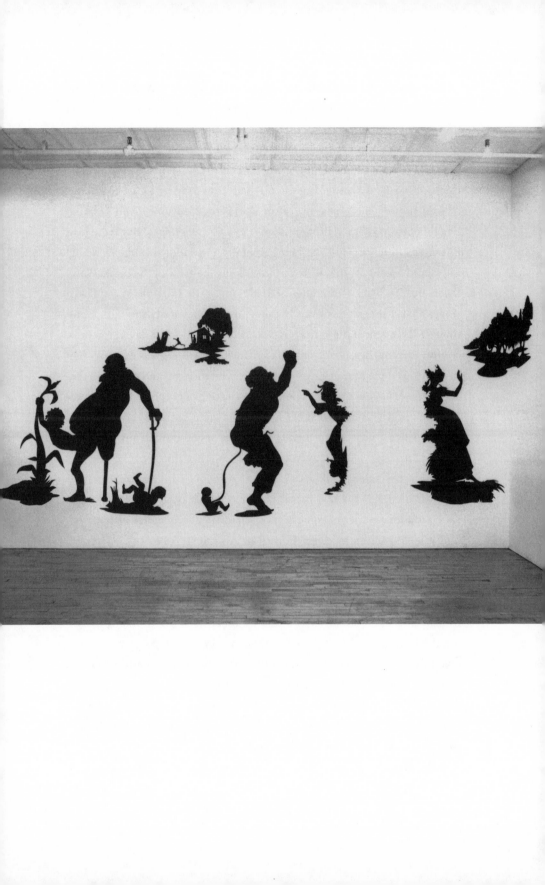

The experience of the power of the spectacle that Walker's silhouettes had created was profoundly exciting to me, but I was even more intrigued by the sophisticated references that the work made to antebellum history and to nineteenth-century American visual culture. This "Grand Allegorical Tableau," with its axe-wielding Little Eva, spike-brandishing Topsy, and eviscerated Uncle Tom praying for deliverance, evoked for me the restaging of an apocryphal episode from Harriet Beecher Stowe's 1852 sentimental novel, *Uncle Tom's Cabin*.[1] But I also saw piles of excrement, children being sexually assaulted, and babies being murdered, elements that didn't fit in with my memory of the book. Were these elegant black silhouettes actually doing the horrible and ghastly things that I imagined, or was I projecting my own nasty thoughts onto them? Like many of the other spectators around me that day, I, too, was confounded by the uncanny drama in which these life-size, cut-paper figures required me to participate. I was both bewildered and elated by the exciting, yet largely incomprehensible narrative of graphic violence and sexual depravity that spread before me in a great gothic panorama.

When I first viewed *The End of Uncle Tom* and the other artworks assembled in "Upon My Many Masters" I knew only a little of the controversy that preceded Walker's work to San Francisco. I had read about how her ideologically provocative art had drawn both vociferous critical condemnation from some senior African American artists and six-figure bids from many eager European American collectors. After my visit to the show, I read everything I could find on her work, which at the time was limited to a few newspaper and art magazine articles. I made repeated trips to the museum and had many heated, critical discussions with friends and colleagues. I attended receptions for Walker, the lectures and the gallery walkthroughs that she gave at SFMOMA, and I even managed to talk John Weber, the museum's curator of education, into inviting me to lunch with her. Through this preliminary research, I started to see that there was something phenomenal going on in her images, something that was being overlooked by the various reactions of the so-called African American community and the mainstream art world.

Soon, *The End of Uncle Tom and the Grand Allegorical Tableau of Eva in*

Heaven began to reveal itself as more than just a provocative artwork that used antebellum imagery. In it I saw that Walker was engaged in an artistic process of racialized signification. In her visual revision of Stowe's written text the artist was signifying on the predictable horrors of historicized, fictionalized, and mythologized slavery in a uniquely African American way.[2] As the literary historian Henry Louis Gates Jr. has theorized about the slave narrative in his germinal book *The Signifying Monkey: A Theory of Afro-American Literary Criticism*, Walker was making "the white written text speak with a black voice, [which] is the initial mode of inscription of the metaphor of the double-voiced."[3] I became convinced that Walker was signifying on the predictable myths of antebellum plantation life using a combination of nostalgic silhouette imagery and a bold display of wildly corrupted social mores. She was skewering the mythologies of iconic texts like Margaret Mitchell's *Gone With the Wind* and historically remote documents like *Uncle Tom's Cabin*, so familiar to contemporary audiences.[4]

These revelations about the signifying power of Walker's art raised important questions about her historical influences and about her conceptual intentions. What was the nature of the antique silhouette format that gave it such an uncanny ability to express current American cultural and racial ideologies? What motivated a young African American woman artist to create a fantastically horrific narrative out of racial stereotypes, nostalgic themes, and historical mythology? Over the course of the next few years, the magnetic power of this artist's nostalgic postmodernism, her trenchant visual wit and fondness for allegorical obfuscation, and her ability to show what so many of her critics were unable to say fascinated me. I wanted to understand better how she could tap both the latent and the virulent racist icons of the visual and textual past in order to make her audience "see the unspeakable."

At first, my project was one of excavation. It was a search for sources and signs, for signifiers and silhouette history. I wanted to better understand Walker's place within the current artistic discourses on race, as well as her relationship to the nineteenth- and twentieth-century ideologies that her project so often critiqued. I came to understand the con-

stant self-referentiality of Walker's work, her various personae, which included the "nigger wench" and the recurrent self-inclusion in titles and textual material ("Upon My Many Masters," for example), as symptomatic of her raced and gendered artistic conciousness (a sort of triple consciousness).[5] They were a part of the post-Warholian relationship that she had come to have with her own celebrity. I came to see her work as being about both artistic subjectivity and the subjection of history, and its varying modes of representation, to an artistic vision.

In the study that follows, I argue that the disturbing and often melancholic tone of Walker's art reflects, and offers up for critique, the problem of the broader culture's inability to come to terms with the past. Through a series of engagements that begins with an overview of the artist's career and the history of African American visuality with which her work engages, I examine Walker's brief mature artistic production and the process of signifying in which she is actively involved. To provide close examination of her artistic practice as a whole, subsequent chapters concentrate on interpreting the content of only four of Walker's paper cutout "pageant" installations, prints, and gouache drawings: *The End of Uncle Tom and the Grand Allegorical Tableau of Eva in Heaven, John Brown, A Means to an End*, and *Cut*, respectively. Each work proves itself an intricate web of historical, theoretical, and cultural contexts. They are potential sites of meaning within which the collective terror of our shared legacies and our desires to transcend them through the use of cultural mythologies may be graphically foregrounded.

The first chapter provides an overview of Walker's career and a general history of race and representation as it pertains to her artistic production. Here I discuss major sources for her work, the broad themes in which she is interested, and historical precedence for the use of silhouettes and profiles to image race and "otherness." I outline the way that her work confronts and addresses the ongoing battle to counteract negative images of the African American body in Western visual culture and in the United States in particular. She follows an avant garde tradition of African American artists who have chosen to sacrifice communal

approval for their work in favor of the freedom to pursue independent and sometimes transgressive visions.

Chapter 2, "The 'Rememory' of Slavery," focuses on the uncanny ability of Walker's 1997 installation of *The End of Uncle Tom and the Grand Allegorical Tableau of Eva in Heaven* to haunt the spectator through its visualization of the "discourse of the unspeakable." It is a discourse made up of the horrific accounts of physical, mental, and sexual abuse that were left unspoken by former slaves as they related their narratives, the nasty and unfathomable bits of detritus that have been left out of familiar histories of American race relations. The "unspeakable" may be understood as a traumatic site, what literary historian Cathy Caruth has called "unclaimed experience," and it is the temporal nature of the slave narrative and its painful history that art historian and literary critic W. J. T. Mitchell has argued must be "rememoried" in order to be reconciled.[6] This unclaimed discourse of the unspeakable continues to impact the ability of many European Americans and many African Americans to confront the terrible impression that the legacy of slavery continues to have on our individual and collective psyches. In this chapter, the work's psychological relationship to both the artist and her audience is examined, revealing a deeply embedded gothic culture of denial and repression at the core of contemporary society.

The 1996 gouache drawing *John Brown* is at the center of the third chapter, "The Lactation of John Brown," in which I investigate Walker's critique of a specific mythic construction of history that has sought to circumvent the visualization of the unspeakable by presenting an idealized aesthetic of martyrdom. Through an in-depth visual examination of the formative images for representing the executed radical abolitionist revolutionary John Brown made by nineteenth-century European American artists and the alternative twentieth-century traditions developed by their African American counterparts, I argue that Walker's *John Brown* deconstructs this doubly racialized and wholly patriarchal martyrdom aesthetic—an aesthetic that canonized and celebrated an executed white man as a secular saint for popular African American veneration. In the

end, her image of Brown is one that is constantly degrading and decomposing in a process that follows Walter Benjamin's description of allegorical ruination in *der Trauerspiel*.[7]

The fourth chapter in this study, "Censorship and Reception," discusses the difficulties that Walker's artistic production and various personae have presented to the African American and the general arts communities. It examines how her work within the "discourse of the unspeakable" has literally been "unseeable" for some spectators, due to its being protested against or having been pulled from exhibitions. By comparing the censorship of Walker's 1995 print suite *A Means to an End: A Shadow Drama in Five Acts* by the Detroit Institute of Arts with an uproar at the University of Missouri, St. Louis, over the work of Robert Colescott, I demonstrate the way that her art transgresses certain ideas about the established decorum and suitable subject matter for an African American woman artist to engage. At issue here is not only the graphic nature of her work, but also the manner in which her artistic persona flouts an African American code of visual conduct that has traditionally been closely, and quite reasonably, guarded. This argument relies on elements of literary critical theory surrounding ideas of gendered and raced "otherness": in particular, cultural critic Michele Wallace's conception of the black woman artist as the "'other' of the 'other,'" and the way it reveals the complex structural relationship of the artist to society and to her own identity.

The subject of the fifth and final chapter is the 1998 silhouette *Cut*, a self-portrait of Walker that I read as revealing the artist's self-realization of her status as the "'other' of the 'other'" and one who dares to speak the unspeakable. Building on ideas developed in chapter 4, I use the idea of post-Negritude visual practice, recently set forth by film historian and cultural critic Mark Reid, as a way to frame Walker's work within a contemporary African American creative milieu. I show that despite its contemporary currency, the image in *Cut* of a mutilated woman propelled by veiled forces also has deep roots in the artistic roles that women of color inhabited during the nineteenth century. In this way, as a self-portrait, *Cut* visualizes Walker's personal experience as being in line with

the treatment that African American artists have historically received in the mainstream art world.

Over the course of these five chapters, the images that Kara Walker has created prove themselves to be detailed excavations of the visual history of multiple genres of American raced and gendered representation. They form a body of work that ultimately reveals the generational schism inherent in the work of a postmodern, post-Negritude, African American woman artist who was born after the major battles of the civil rights movement had been fought. By mapping the process of rewriting and revision, of active signification in which Walker was engaged between 1995 and 1998, I hope to show that her challenges are to both the middle-class African American culture in which she was raised and the liberal, white-dominated art world that currently supports her work.[8] I believe these are challenges that cannot be easily dismissed or even fully understood due to their constantly unfolding relationship to what might be called a "postblack" artistic practice.[9] She is shown to be a powerful young artist who is questioning, rather than accepting, the strategies and tactics of social responsibility that her parents' generation fought hard to establish. Kara Walker is an artist with the uncanny ability to make her audiences see the unspeakable.

Chapter 1

TRACING RACE AND REPRESENTATION

The Negro is sort of a seventh son born with a veil, and gifted with a second sight in this American world—a world which yields him no true self-consciousness, but only lets him see himself through the revelation of the other world. It is a peculiar sensation, this double consciousness, this sense of always looking at one's self through the eyes of others, of measuring one's soul by the tape of a world that looks on in amused contempt and pity.

—W. E. B. Du Bois, *The Souls of Black Folk*, 1904

Joy is unity. Laughter is the expression of a double or contradictory feeling, and it is for this reason that a convulsion occurs. From the artistic point of view: the comic is an imitation; the grotesque a creation.

—Charles Baudelaire, "The Essence of Laughter, and generally of the Comic in the Plastic Arts," in *Baudelaire: Selected Writings on Art and Artists*, 1972

Kara Walker's career as an internationally recognized artist has only just begun, but so far her life has been full of change and varied experiences. She was born in 1969 in Stockton, California, where her father, the artist Larry Walker, taught painting at the University of the Pacific. When she was thirteen he moved the family to the small town of Stone Mountain, Georgia, just outside Atlanta, to take a position at Georgia State University. Stone Mountain is notable for being the birthplace of the modern Ku Klux Klan in 1915 and the site of annual Klan rallies through the early 1980s. The transition was difficult for her and she rapidly became a loner.[1] She believes that the other African American children in her new community ostracized her because her California accent was too "white." At the same time, she was deemed to be too dark-skinned to be friends with the European American children. In this strange and new world of the suburban Deep South there seemed to be no racially neutral ground on which she could stand, so she withdrew into the realm of observation.

Surrounded by the legacy of the Jim Crow laws and the *Gone With the Wind* mystique that Atlanta self-cultivates, the teenage Walker viewed her life as though it were being led in a minstrel show, one that she had accidentally fallen into. She began seeing her racial identity as something that was lived and performed on a daily basis in a sort of "pageant" in which she was an unwilling participant. Her experience of this pageant, which she has likened to a continual reenactment of the Civil War era in the present day, became a metaphor for her contact with the unknown. In reflection of these teenage experiences, much of her art has been a search to discover exactly what *her* role might be within this unbidden drama.[2] "When I began graduate study at RISD [Rhode Island School of Design] I was coming out of a period where I was experimenting socially and theoretically with the 'psychosexual Legacy' of southern racism [if you will] but this experimentation did not take on any clear visual form." Walker has explained, "I was thinking along the lines of some of Adrian Piper's early performances, where she invented an identity for herself and spoke through her 'Mythic Being' in public arenas.

These actions of mine were only missing the necessary elements of structure and documentation. So it was not until I escaped the South (where I still find it impossible to speak) that I began to seek out any references to Interracial Romance, American Chattel Slavery, Black Womanhood and the Fictions of the South."[3] It was only after having effected this "escape" following graduation from Atlanta College of Art to the MFA program at the Rhode Island School of Design in Providence that Walker was able freely to explore her own complex consciousness. She began this process by abandoning the abstract painting she had been doing in favor of pieces that combined text and image.

However, as a student in Atlanta in the late 1980s, Walker was initially resistant to exploring racism or history in her art. This reluctance stemmed from the simple reason that her instructors expected it of her, and she is not the type of woman that bows to the expectations of others. So it was not until she began graduate work at RISD that she decided to abandon her previous methods and begin to work with racial and sexual themes. At first, her work was varied in style and uneven in quality. "RISD presented me with an all too common problem," says the artist, "that of having to rely on myself to discover source material regarding Race and racism. So methodologically my research was and continues to be pretty chaotic. I was reading bell hooks, Michele Wallace, Pornographic novels, looking at reference books on early American painting and portraiture . . . and twentieth century works by Black artists." By the mid-1990s she had found an exciting medium in the form of the silhouette. "In a way making Silhouettes kind of saved me. Simplified the frenzy I was working myself into. Created the outward appearance of calm."[4] It was a medium that meshed with her concepts, and it offered a stylistic niche that would transform her artistic practice and rapidly bring her to the attention of the art world.

From this point forward, the works Walker created and exhibited often had the epic scale of history painting, the caustic bite of political satire, and the scopophilic draw of pornography. They displayed the influence of large swaths of "high" and "low" European art that Walker encountered in her art history classes, trips to the library, and her work

in a used book store. It began to lean toward the grotesque, the carnivalesque, the transgressive, and the abject.

As Thomas Mann has noted, "The striking feature of modern art is that it has ceased to recognize the categories of the tragic and the comic. . . . It sees life as tragi-comedy, with the result that the grotesque is the most genuine style."[5] It is this very modern sort of tragicomic grotesquerie that we see in Walker's work. With their abnormal features, comical stereotypes, and bizarre interactions, the works recall the satirically moralizing work of William Hogarth and Francisco Goya, in particular, Hogarth's *Marriage-a-la-mode*, a lascivious representation of upper-class conjugal dissolution, and Goya's *Los Caprichos*, which examined the follies of Spanish court life through carnivalesque images.[6] The carnivalesque link between Hogarth, Goya, and Walker can be seen in their mutual desire to overturn the ruling ideologies of propriety and authority. In their work, as in carnival, where men dress as women and walk on their hands, the world is turned upside down and the codes and modes of society are flouted.

The political drawings of the German dadaist George Grosz, which mock the pretensions and failures of the Weimar bourgeosie, also echo in the grotesque characterizations and political overtones of Walker's images. For the philosopher Mikhail Bakhtin, the carnivalesque is "that peculiar folk humour that has always existed and has never merged with the official culture or the ruling classes."[7] In this sense, the carnivalesque attitude that we see in Walker's work, like that of Grosz, may be viewed as just that: an idea, a way of looking at the world that subverts the dominant oppressive vision into one that can be laughed at and ridiculed. These silhouette caricatures insert laughter where it is most forbidden, and therefore most meaningful.[8]

Immediately after graduation from RISD, Walker participated in a number of group shows that introduced her work to the international art world. Her breakthrough came when she exhibited the ambitious, 50-foot-long silhouette wall installation *Gone: An Historical Romance of a Civil War as It Occurred Between the Dusky Thighs of One Young Negress and Her Heart* at the Drawing Center in New York City in "Selections 1994."

Following her success in the Drawing Center show, Walker quickly found gallery representation with Wooster Gardens, now Brent Sikkema Gallery, in New York City. She was given solo shows there in 1995, "The High Sweet Laughter of the Nigger Wenches at Night," in 1996, "From the Bowels to the Bosom," and in 1998, "*Missus K. Walker* returns her thanks to the Ladies and Gentlemen of New York for the great *Encouragement* she has received from them, in the *profesβion* in which she has practiced in New England," such wry titles recalling the frontispieces of antebellum books and broadsides.

In 1996 she exhibited a commissioned work in the show "La Belle et La Bete" at the Musée d'Art Moderne de la Ville de Paris in France. That same year she participated in "New Histories" at the Institute of Contemporary Art, Boston; "Look Away! Look Away! Look Away!" at the Center for Curatorial Studies at Bard College in upstate New York; and in "Conceal/Reveal" at SITE Santa Fe, New Mexico.

In 1997 her work was featured in the high-profile Biennial at the Whitney Museum of American Art in New York City. She also contributed work to a group show, "Real," at the Bass Museum, Miami, and created three solo exhibitions: "no place [like home]" at the Walker Art Center, Minneapolis, where she exhibited the large wall installation *Slavery! Slavery!*; "Upon My Many Masters—An Outline," at the San Francisco Museum of Modern Art; and an exhibition at the Renaissance Society in Chicago that produced the self-titled catalogue "Kara Walker," which until 2002 remained the only major volume of her work and writing to have been published.

In 1997 Walker also designed a limited-edition pop-up book, *Freedom: A Fable,* for the collectors Peter and Eileen Norton and funded by the Norton Family Foundation. Printed in an edition of four thousand, the laser-cut book was presented as the couple's annual Christmas gift to their friends and associates. The work was subtitled *A Curious Interpretation of the Wit of a Negress in Troubled Times* and featured the broken narrative of a young black woman who dreams of transcending race by immigrating to Liberia. The text was accompanied by nonliteral illustrations that included four pop-up silhouettes of a southern plantation,

the Negress stranded on a desert island, piles of feces, and a birth scene. While the pop-ups were laser cut, each book was assembled by hand, giving the mechanically reproduced object an aura of originality and individuality.[9]

These highly successful shows and commissions were followed by a joint exhibition with Arturo Herrera at the Stephen Friedman Gallery in London and a piece in the "Strange Days" exhibition at the Art Gallery of New South Wales, Sydney, in 1998. While most of the exhibitions that Walker participated in during this period featured large-scale silhouette wall installations by the artist, she continued to experiment with form and size issues, occasionally submitting smaller drawings or individual silhouettes rather than multifigure groupings. For example, Walker contributed two small works, *Lil' White Drop* (1995) and *B'rer Fox* (1995), to the group show "Pagan Stories: Situations of Narrative in Recent Art" at Apex Art C.P. in New York. These works recalled Victorian children's book illustrations in their scale and textual relationships, and they continued to assert the artist's interest in themes of mythology and history.[10]

Walker's work was included in three other major group exhibitions during 1998: "Global Vision: New Art from the '90s" at the Deste Foundation, Athens, Greece; "Other Narratives" at the Contemporary Arts Museum, Houston; and "Secret Victorians: Contemporary Artists and a Nineteenth-Century Vision," organized by the Hayward Gallery in London for the Arts Council of England. At the conclusion of its London run, "Secret Victorians," which featured a rather brief yet interesting catalogue, traveled to the Armand Hammer Museum of Art in Los Angeles.

That same year Walker was given several solo exhibitions: "Presenting Negro Scenes Drawn Upon My Passage Through the South and Reconfigured for the Benefit of Enlightened Audiences Wherever Such May be Found. By Myself, Missus K. E. B. Walker, Colored," at the Carpenter Center for the Visual Arts at Harvard University, which accompanied a conference on art and race that is discussed later in this study; "Kara Walker" at the Forum for Contemporary Art, St. Louis; and she

produced the "Opera Safety Curtain for 1998–99 Season" at the Vienna State Opera House, Vienna, Austria.

For the winter and spring of 1999 Walker accepted an artist-in-residency position at the California College of Arts and Crafts (CCAC) in Oakland under the auspices of Lawrence Rinder, director of the College's Institute and the Capp Street Project. Out of this came the exhibition "No mere words can Adequately reflect the Remorse that this Negress feels at having been Cast into such a lowly state by the former Masters and so it is with Humble heart that she brings about their physical Ruin and Earthly demise."[11] The works in this show, which traveled to the Armand Hammer Museum at the University of California, Los Angeles, proved unique in their departure from the black-on-white silhouettes for which she had become so well-known. Here she introduced characters inspired by the myth of Leda and the Swan, executed in a scheme of black and white paper cutouts glued onto a curving gray wall.

In the autumn of 1999 Walker's work was featured in the Sixth International Istanbul Biennial alongside the work of the South African artist William Kentridge, an artist to whom, among others, she has been frequently compared for formal reasons. In Istanbul, Kentridge's 35-millimeter animated film *Shadow Processions*, a misty evocation of the pain of apartheid in South Africa, contrasted dramatically with Walker's hard-edged fantasy of the antebellum South.[12] That same year she exhibited in a joint show with Glenn Ligon at Brent Sikkema, and was featured in the 1999/2000 Carnegie International in Pittsburgh. Walker subsequently issued *The Emancipation Approximation*, which reproduced in boxed form her monumental, cycloramic wall piece of the same name that was shown at the Carnegie, as a portfolio of twenty-six screenprints, each measuring an impressive 34 × 44 inches. These works continued the black-and-white-on-gray palette of the CCAC show, but on a more monumental scale.

As the new millennium dawned, Walker's wall installations had begun to sell for well over six figures, the boxed set of screenprints for a price in the mid-five figures. She had made it to the A-list. This status was

reinforced when she was chosen to represent the United States at the São Paulo Biennial in 2001. In spring 2002 an exhibition and catalogue, again titled "Kara Walker," was produced at the Kunstverein Hannover, in Germany, and the University of Michigan Art Museum presented "Kara Walker: An Abbreviated Emancipation (from The Emancipation Approximation)," with an accompanying best-selling catalogue, *Kara Walker: Pictures from Another Time.* Another, larger catalogue, *Kara Walker: Narratives of a Negress,* edited by Darby English, accompanied an important exhibition of her work in the spring of 2003 at the Tang Museum at Skidmore College before traveling to Williams College.

Today, Walker remains most well-known for her life-size silhouettes of racially coded mayhem, characterized by the scenes of nightmarish antebellum plantation life found in *The End of Uncle Tom and the Grand Allegorical Tableau of Eva in Heaven,* the wall installation that was at the center of her 1997 SFMOMA solo show and is discussed at length in the following chapter. Between 1994 and 2002, the artist created over twenty of these large-scale wall installations. In their deceptive simplicity, silhouettes had established themselves as a way that Walker could signify on the racialized imagery that had been a challenge to her artistic practice since Atlanta. Through the evacuated interior and expressive exterior line of the form, she could reshape and manipulate racist icons of white supremacy such as the nigger wench, the mammy, and the pickaninny. In this way, she was able to exert a certain amount of control over the stereotypical images that had shaped the way others so often viewed her. "For me they become characters the moment I start working with them. Because they become mine in a way. So that when I encounter the much-contested African American tchotchkes and derogatory images, they don't have the power over me that they used to. . . . Being an artist in control of characters that represent the social manipulations that blacks have undergone in this country at least, puts me in the position of being the controller or the puppet master of imaginary black people."[13] The ironic impact of the black paper image is particularly compelling to her. "It is not a silhouette of Goethe," she asserts, "it is Goethe in blackface," recognizing the peculiar "othering" effect this type of "profiling"

can have on a body.[14] In this way, the titling and potential textual references of each piece become increasingly important as the responsibility of assessing the identity of a character that Walker has created is shifted away from form as the site of representation.

In constructing her silhouette "pageants," Walker is drawn time and again to the symbols, themes, and tropes that have served to reinforce racist, sexist, and class-based American hegemony over the past three centuries. "I do love *The Image of the Black in Western Art,* I refer to its volumes often," she says when discussing her library, "and other art historical reference books like *Mine Eyes Have Seen the Glory,* about paintings from and about the Civil War, are dog-eared."[15] Walker then melds this material into a visualization of what she has termed her personal "slave narrative." It is a narrative that began in childhood, when she was taken from the relative racial freedom of northern California to the segregated world of suburban Atlanta, before gaining her artistic freedom by "escaping North" to graduate school in Providence. The characters that fill the narrative are a way of overcoming the power that stereotypes and negative representations of African Americans have had in the artist's life. Through the journeys of the nigger wench, a constantly recurring character in Walker's work, we are witness to the animation of a character culled from an anonymously authored pornographic novel, *The Master's Revenge* (Star Distributors, 1984) that was published as part of the "Slave Horrors" series. The nigger wench is a "young and pretty black girl whose function is as receptacle—she's a black hole, a space defined by things sucked into her, a 'nigger cunt,' a scent, an ass, a complication," states Walker. "She is simultaneously sub-human and super-human." Beginning with the literary reference, the artist has created a multidimensional character that speaks through writing and appears in silhouettes and drawings. The nigger wench is re-visioned through themes culled from contemporary culture and post–sexual revolution mores. In creating and propelling such characters, the artist makes us see things that historically have remained unspoken. She creates new characters, new clusters of fixations, with which to tap the guilt reservoirs that lie within her spectators.

Walker has stated on numerous occasions that silhouette cutting has historically been a weaker, more feminine form, one that might have been accessible to nineteenth-century African American women artists. As such, her silhouettes create a space in which she can combine her personal interest in exploring her own role as a raced and gendered artist through a vast array of nineteenth- and twentieth-century literature and imagery. However, Walker's use of the silhouette as a form to explore racism and representation can be traced beyond her own stereotype of the silhouette as a feminine art, back to the beginnings of racial anthropology and the eighteenth-century pseudo-science of Johann Casper Lavater's physiognomic theory. In his work with the silhouette profile form, the Swiss German Lavater treated physiognomy, the theory that facial features reveal a person's natural and "national" character, as a science whose "primary concern was to identify the moral code inscribed in the human form."[16] This use of the silhouette, or the "shade," as Lavater referred to it, which was made by tracing the cast shadow of a person's head onto a piece of paper, evacuated a subject's bothersome interiority while at the same time inscribing "character" (figure 2). The form line, the outer edge of the shade, was then interpreted within a physiognomic discourse via the specialist's trained reading of the forehead, nose, and chin. "Shades are the weakest, most vapid, but, at the same time, when the light is at a proper distance, and falls properly on the countenance to take the profile accurately, the truest representation that can be given of man," wrote Lavater. "The weakest, for it is not positive, it is only something negative, only the boundary line of half the countenance. The truest, because it is the immediate expression of nature, such as not the ablest painter is capable of drawing, by hand, after nature."[17] Lavater supported his theories of the shade's ability to convey truth about its sitter's character and racial attributes with a battery of quotes by contemporary philosophers, scientists, and art historians. He invoked George Louis LeClerc Buffon, Immanuel Kant, and even the father of modern art history, Johann Jacob Winkelmann, to buttress his arguments on the shade's usefulness for scientific endeavors.[18]

To Lavater and subsequent followers of physiognomy (and its heir

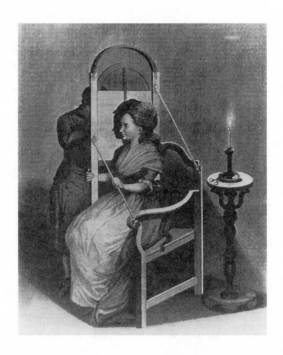

phrenology), a shade contained the key to a subject's character, one that might be gleaned more accurately from its essentially reportorial form than from the potentially obfuscating subjectivity of a painting. Because of its supposed lack of human mediation, its direct mimetic relationship to the sitter having been established through its media dependency on the indexically cast shadow, the shade contained an essence that was potentially immutable. Shades were a space whose margins contained all pertinent information and whose centers were spaces of blank, yet readable, negative interiority.

In considering the work of Lavater with shades, one can imagine that the outer form line of a silhouette might indeed work well as a place that could create and contain an interactive identity, a form that can both confound and conflate complex racial and narrative representation. This space of connotation and denotation that Lavater found in the

FIGURE 2. Illustration from Johann Caspar Lavater, *Physiognomische Fragmente zur Beförderung der Menschenkenntniss und Menschenliebe* (Leipzig, 1775), 8.

silhouette was linked inextricably to whatever text he chose to accompany the image and to whatever ideological baggage (such as physiognomic pseudo-science) that the spectator/reader brought with him or her to the experience. It is this same situation that attends the presentation and viewing of Walker's silhouettes today.

But what evidence is there for the physiognomic "racial profiling" of African Americans by silhouettes during the antebellum period that pervades Walker's work? Following Lavater's racist overtures and his interest in the expressive possibilities of the pseudo-scientific shade, one can look to early profile images of African Americans. Of the dozen or so silhouettes of this type that survive from the late eighteenth and the early nineteenth centuries, the haunting pencil drawing known as *Flora* is perhaps the most enigmatic and suggestive of the brutality of slavery and the blank darkness that the black body inhabited within such an oppressive system (figure 3). This cut paper and brown ink silhouette of a young enslaved woman is distinguished by soft facial features that are abruptly juxtaposed with spiky, abstractly rendered hair. In its organic regularity the choppy locks become like the petals of a flower, marking the visual and verbal amalgamation of "Flora" and "flower," the merging of woman and object. Her image transforms into one of a pressed blossom, sandwiched into the two dimensions of the paper. At the time of its creation, like flowers, one could also purchase people. According to the bill of sale, which is dated 1796 and is displayed under a homogenizing mat with the anonymously made silhouette, "Margaret Dwight of Milford in the County of New Haven and State of Connecticut sold Flora, a nineteen-year-old slave, to Asa Benjamin of Stratford in Fairfield County, Connecticut, for the sum of twenty-five pounds Sterling."[19] Like a photographic mug shot used by contemporary police, or like an FBI Most Wanted poster, Flora's silhouette seems to have been part of the documentation that her owner kept on his purchase for identification purposes in case she ever ran away.[20]

Walker's pairing of a historically remote textual reference with the immediate visual reality of a life-size silhouette, for example, the adept use of Harriet Beecher Stowe's text in the titling of her installation of *The End*

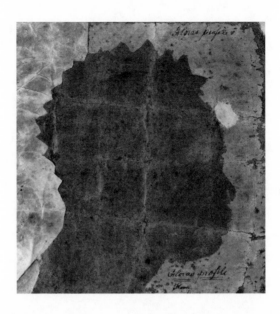

of Uncle Tom and the Grand Allegorical Tableau of Eva in Heaven, unknowingly comments on *Flora* and the bill of sale that accompanies her by highlighting the relationship between black bodies and white text. The potentially oppressive nature of the *Flora* image is further augmented and explained by the repeated naming in three different places on the paper: "Floras profile," "*Floras profile,*" "Flora Benjamin." It is a repetition of denotative information that serves to control the subject/object's identity in both the figural and the discursive fields. Likewise, the spectator/reader of Walker's work is similarly dependent on and manipulated by the dyad of text and image in an effort to surmount the black void found in the ripe blankness of the silhouette. In her words, the silhouette is a "blank space that you [can] project your desires into. It can be positive or negative. It's just a hole in a piece of paper, and it's the inside of that hole."[21]

As helpful as the phrenology of Lavater and the mysterious silhouette of *Flora* are in understanding the racialized precedence for Walker's postmodern work, so too is the early-nineteenth-century portrait pro-

FIGURE 3. Unknown artist, *Flora,* 1796. Silhouette. Cut paper and brown ink with bill of sale, 14 × 13 in. Stratford Historical Society, Stratford, Connecticut.

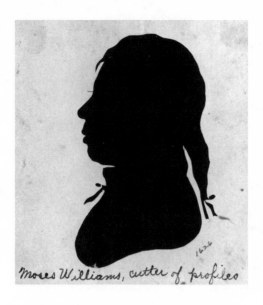

Moses Williams, cutter of profiles *1820*

file practice of the mixed-race artist Moses Williams. The example of Williams's own silhouette provides another window onto the raced antebellum prehistory of Walker's silhouettes (figure 4). Beginning in 1802, Williams, the manumitted slave of the painter/naturalist Charles Willson Peale, was responsible for the operation of a silhouette-making machine called the Physiognotrace device.[22] Like Flora, who was dependent on the Dwight and then the Benjamin family for her corporeal maintenance, Williams worked in the literal shadow of his former owner at Peale's museum in Philadelphia. Using a machine whose tracing capabilities were more technologically advanced than the one illustrated in Lavater, he produced thousands of silhouettes of white sitters between 1802 and the mid-1820s. When the time came for Williams to make his own portrait he took technical liberties with his scissors and fashioned an image that expressed his own racial ambivalence as a person of mixed race in antebellum society. In his self-portrait, embossed pentimenti from the machine's trace line appear prominently in the areas of the

FIGURE 4. Moses Williams, *Moses Williams, Cutter of Profiles*, 1803. Silhouette. Cut paper and ink, approx. 3 × 5 in. The Library Company of Philadelphia.

queue and the necktie. Here, the discrepancy reveals both what was ignored and what was embellished: the trace lines reveal that the cutter altered the length of the hair by extending it nearly one centimeter from the original trace line, causing it to lie closer to the head. In concert with the stylized lock that curls over the forehead, the altered hair follows a smoother, more flowing line. And although the rounded nose and full lips of Williams's African blood remain to dominate his facial features, it is his European heritage that crowns him in the form of long, straight hair. This is decidedly anglicized hair when compared to the staccato nappy peaks of *Flora*.

Williams's portrait illustrates that by deviating from the original form line, an artist may create an image in which the sitter's features connote stereotypical tropes of whiteness rather than blackness. By doing so, Williams was signifying on a white method of image making (the silhouette machine that he operated was designed and constructed by his former owner and current employer, Peale) and he was demonstrating his own agency in the visualization of his selfhood. It was his way of subverting the negation of voice that blackness connoted during the antebellum period, and as such, his self-portrait records the anxiety and confusion that Williams may have had about his position as a person of mixed race in a white society that despised that heritage.[23] As a newly freed man he needed to create an identity for himself, and he had to do it with the tools he had been given. As literary historian Henry Louis Gates Jr. has argued for the African American literary tradition, "To rename is to revise, and to revise is to signify," and in an act very much related to writing, Williams inscribed a visual record of his identity using the Physiognotrace.[24]

In this act of redrawing, which is kin to the renaming or revising that Gates argues occurred when African Americans engaged the dominant culture's literary forms, we can see Williams signifying on his own profile. Rather than letting the traced image remain as the machine had recorded it, he went back into it and revised it with his scissors. As he cut into the paper, Williams wrote his own story on the one produced by the mechanical conception of his enslavers. Through this act he achieved agency over a small part of his representation in the public sphere.[25]

Just as the racist work of Lavater and the anonymous drawing of Flora illuminated the oppressive uses to which the silhouette form had been put during the antebellum period, the self-portrait of Williams suggested that there was indeed a profound legacy of signification in this area. His work, like Walker's, intimated that, given an opportunity to trope the silhouette's conventions, African American artists would rise to the occasion. Walker's late-twentieth-century self-portrait silhouettes, including *Cut* (1998), which is the subject of the last chapter in this study, provide evidence of a similar torturous process of self-scrutiny as a raced artist that Moses Williams experienced at the turn of the eighteenth century.

Through this research into the history of silhouettes and race in American visual culture, we can begin to see that the artistic practice of Kara Walker is important not only for the ruckus that it stirred up, but also for the profound way that it redraws issues of race through the nostalgic and deceptively innocent form of the silhouette. These silhouettes are then combined with a textual and literary element. The presence of the semi-self-reflexive character of the nigger wench, who recurs frequently throughout Walker's visual and textual work, as seen in the 1998 pop-book *Freedom,* is used in an authorial function by the artist to rewrite the white voice of the nineteenth-century sentimental novel, the mediated voice of the slave narrative, and the twentieth-century historical romance novel, as well as assorted libertine pornography of the previous two centuries. However, these subversions, when viewed within the African American tradition of the signifying slave narrative, function as a site for Walker's creative voice to be heard. By rendering all of her characters black ciphers she is able to incarnate the "master, mistress, overseer, pickaninny, and buck,"[26] and elucidate the way power relations and the sexual exchange of raced and gendered bodies occurs within our varied cultural fantasies of race and representation.

By signifying on the visual form of the silhouette and American literature in this way, Walker engages the long history of the representation of the African American body in the United States and strains against African American attempts to control negative images of blacks. In Walker's

oeuvre, the silhouette is a formal choice that, as Richard J. Powell has observed, is indebted to the collage techniques pioneered by Romare Bearden and the graphic style of Aaron Douglas.[27] It speaks to the legacy of subject matter and style within the African American artistic tradition, and as such, it signifies on the blackness of her artistic predecessors, as well as the whiteness of the stereotypes and literary references that her images reshape. In a discussion of race and representation in the nineteenth and early twentieth centuries, Gates explains, "The large number and variety of inherently racist images in American culture attest to a particularly American preoccupation with marginalizing black Americans by flooding the culture with an-Other Negro, a Negro who conformed to the deepest social fears and fantasies of the larger society." Gates asserts that because "the complexity of African-Americans or their status as fully endowed human beings could be openly denied in the popular arts, and bracketed within the margins of formal art, then the African-American could be easily relegated and confined to the margins of society."[28] Because the reality of the black body in popular culture has continued to be that of an-Other, a negative stereotype, African Americans have continually had to prove their humanity and their right to exist in a positive way in the center of American culture. "One of the virtues of [Walker's] work is to demonstrate the extent to which the very concept of race is a powerful fiction based on the construction of a mythical Other upon whom we project our irrational fears and compulsive desires," wrote Miles Unger, managing editor of *Art New England*, in 1998.[29] This move to unmask the power of the white supremacist construction of a mythical otherness that negates black subjectivity and humanity that operates in Walker's work is best understood through the lens of historical precedence.

Since the first freed and free-born Africans in the New World gathered together and sought to assert a collective identity that elevated them above their enslaved countrymen, continuing through to the end of slavery and the postbellum struggle for social and political enfranchisement, one of the strategies employed by the African American intelligentsia to counteract negative stereotypes has been to support the

production of positive visual and textual representations. By the early twentieth century the sociologist W. E. B. Du Bois advocated the use of art as a tool for racial uplift, a way for the communal type who was then called the "New Negro" to define himself and herself as legitimately American. (The enduring legacy of Du Bois's ideology of respectability is examined in the subsequent discussion of the censorship and reception of Walker's work.) This position was also supported by the theories of the philosopher Alain Locke, who felt that both African and African American culture was a well to be tapped by New Negro artists to bring attention to the social interests of their people. During the first half of the century, the magazine *The Crisis*, published by the National Association for the Advancement of Colored People (NAACP), supported artists who presented a positive and progressive face of black America. A cover for *The Crisis* by Aaron Douglas illustrates this effort (figure 5). The profile of a woman's face is framed by the dates "1909" and "1929" and by details of urban architecture. Her hair is styled in a fashionable "marcel," a lye-process coiffure. Beneath her chin, at the lower left margin, a sun rises from the cityscape beaming the acronym NAACP. She is figured as the product of twenty years of progress in the urban environment, looking to the future, represented by the ladder-like structure that rises in front of her.

 The New Negro, a volume of writing, photography, and drawings edited by Locke, contained a wide array of artistic productions by African Americans that drew on race-related themes.[30] A sample from its pages reveals a wistful portrait, *Young Negro*, by the German American artist W. V. Ruckterschell, set beside a stylized border (figure 6). The portrait is an arresting image of a clean-cut young man who addresses the spectator with direct eye contact. His penetrating gaze is solemn, thoughtful, and self-confident, while being entirely unthreatening or aggressive. The facing page features a small border at the top by Winold Reiss, another German artist working in the United States during the period. The horizontal strip contains modernized organic forms reminiscent of jungle motifs and is placed directly above Locke's essay "Negro Youth Speaks."

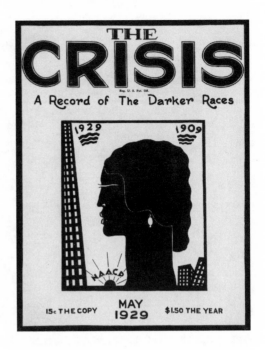

This juxtaposition implies that if the portrait could speak, this is what the *Young Negro* would say.

While these two publications focused their energy primarily on literature, with the presence of visual art for illustrative and propaganda purposes, the fine arts of painting and sculpture received similar support, attention, and direction from other organizations interested in using artistic production as a means of racial advancement. One such organization, the Harmon Foundation, sponsored annual exhibitions of painting and sculpture by African American artists from 1928 to 1933. These shows featured socially progressive artists such as Sargent Johnson, whose work had a populist mission of racial redemption, and Richmond Barthé, whose art was more bourgeois in orientation while still being celebratory of the African American experience. In their work they shunned the classic negative tropes of blackness, the stereotypes

FIGURE 5. Aaron Douglas, *The Crisis*, 1929.

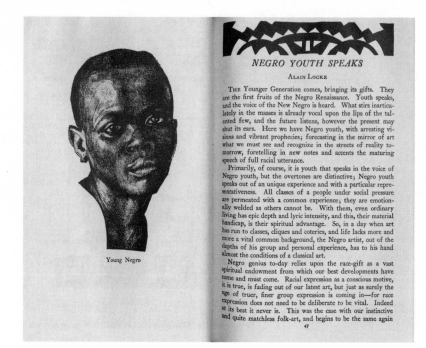

NEGRO YOUTH SPEAKS

ALAIN LOCKE

THE Younger Generation comes, bringing its gifts. They are the first fruits of the Negro Renaissance. Youth speaks, and the voice of the New Negro is heard. What stirs inarticulately in the masses is already vocal upon the lips of the talented few, and the future listens, however the present may shut its ears. Here we have Negro youth, with arresting visions and vibrant prophecies; forecasting in the mirror of art what we must see and recognize in the streets of reality tomorrow, foretelling in new notes and accents the maturing speech of full racial utterance.

Primarily, of course, it is youth that speaks in the voice of Negro youth, but the overtones are distinctive; Negro youth speaks out of an unique experience and with a particular representativeness. All classes of a people under social pressure are permeated with a common experience; they are emotionally welded as others cannot be. With them, even ordinary living has epic depth and lyric intensity, and this, their material handicap, is their spiritual advantage. So, in a day when art has run to classes, cliques and coteries, and life lacks more and more a vital common background, the Negro artist, out of the depths of his group and personal experience, has to his hand almost the conditions of a classical art.

Negro genius to-day relies upon the race-gift as a vast spiritual endowment from which our best developments have come and must come. Racial expression as a conscious motive, it is true, is fading out of our latest art, but just as surely the age of truer, finer group expression is coming in—for race expression does not need to be deliberate to be vital. Indeed at its best it never is. This was the case with our instinctive and quite matchless folk-art, and begins to be the same again

47

Young Negro

and the exaggerated parodies, in favor of compositions that depicted the humanity of African American people. They opted to produce images of blacks that projected normalcy and that showed a hardworking, well-mannered people who were essentially American.

As these examples suggest, during the 1920s and 1930s, many African American artists and cultural critics proposed that an assimilationist approach was the best way to overcome the high saturation level of negative imagery. However, there was never unanimous agreement among New Negro artists and cultural critics that the assimilationist approach was indeed the best way. When challenged about the antiestablishment nature of his poetry in 1926, Langston Hughes replied to his critics, "If white people are pleased we are glad. If they are not, it doesn't matter. . . . If

FIGURE 6. W. V. Ruckterschell, *Young Negro*, and Winold Reiss, *Book Decoration*, ca. 1925. Reproduced in Alain Locke, ed., *The New Negro: Voices of the Harlem Renaissance* (New York: Albert and Charles Boni, 1925).

colored people are pleased we are glad. If they are not, their displeasure doesn't matter either. We build our temples for tomorrow, strong as we know how, and we stand on top of the mountain, free within ourselves."[31] As this familiar quote attests, there have always been African American artists who have chosen to sacrifice communal approval for their work in favor of the freedom to pursue an independent vision.

Because of the historic efforts of the African American cultural establishment to counteract negative visual imagery in popular culture by championing a positive message in black art, since the 1970s rebellious young African American artists, the parents of the generation to which Walker and her colleagues belong, have sought to differentiate themselves from their elders. They did so by embracing ideas of blackness, political themes and expressions of the personal over the general.[32] Filmmaker Melvin Van Peebles and painter Faith Ringgold accomplished this through a choice of provocative content and contemporary themes. Actor/director Van Peebles started his career working in the Netherlands and France because he felt the United States was too racist and conservative. His first feature, which was shot abroad, *Story of a Three Day Pass* (1967), was a low-budget film about a romantic affair between a black GI and a white Frenchwoman. This was followed several years later by the groundbreaking (and completely over the top) saga, *Sweet Sweetback's Baadasssss Song* (1971). Arguably the first film in a genre that would come to be called "blaxploitation," *Sweet Sweetback's Baadasssss Song* chronicled the X-rated exploits of a pimp on the run from the law after having "had enough of the Man."[33] In it the protagonist, played by Van Peebles himself, becomes a cultural icon and folk hero for a disenfranchised community by screwing white women and killing white men.

The type of racially charged violence and rage that runs throughout Van Peebles's film is also found in the early work of Faith Ringgold. Ringgold, who is known today for her painted quilts and children's books, began her career in the late 1960s with provocative political work, such as *Flag for the Moon: Die Nigger* (1969; plate 1). This reworking of cultural icons and current events raised the issue of universal imperialism and white cultural hegemony by reconfiguring the American flag as a sym-

bol of oppression and hatred from which black Americans are alienated as well as absent.[34]

The themes of race, rebellion, and rage that are explored in the early work of Ringgold and Van Peebles can still be seen today in the satirically charged work of Walker and other African American artists of her generation who employ what art historian David Joselit has recognized as the "repetition and re-framing of normative images drawn from the media and elsewhere" in an effort to expose and eviscerate stereotypes.[35] Renée Cox's large cibachrome *The Liberation of Lady J and U.B.*, for example, works to transform the classic racist imagery of American advertising by making the familiar faces behind such magical products as converted rice and instant pancake mix come to life as svelte, virile, and newly empowered characters (plate 2). Led by Cox in the role of her own alter ego, "Rajé," the imaginary superheroes and superstereotypes of Lady J and U.B. are both arresting and emphatic as they materialize from the confines of their smiling vignettes, which have literally cornered them for the better part of the past century.

Much of the other stereotype-exploding work found in Walker's art and Cox's photographs is clearly informed by the early work of the artist and folklorist Carrie Mae Weems. One of Weems's best known series, *Ain't Jokin'* (1987–88), explores the cultural internalization of colloquial language and the qualification of subjectivity by pairing photographic portraits of individual African Americans with racist jokes, while another series, *American Icons* (1988–89), uses elaborately simple still lifes of racist memorabilia, such as blackface salt and pepper shakers, to examine the way that stereotypes insidiously inhabit contemporary domestic spaces (figure 7).

As in Walker's work, Weems's and Cox's photographs convey a sense of the knowing artist in control of ironic processes. Conversely, the painter Michael Ray Charles's work is more about the artist revealing the way that the stereotype controls the masses. In *The NBA is Tantastic* Charles uses classic advertising techniques to signify on the way the lure of big paychecks and a high-profile lifestyle has captivated a large segment of young black male America (plate 3). His begloved and grinning basket-

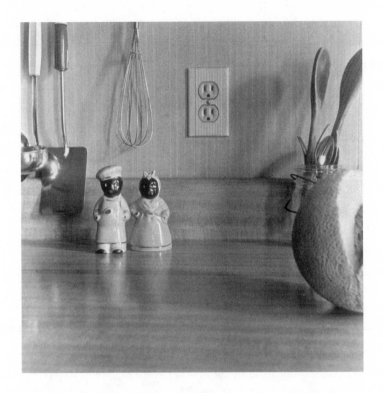

FIGURE 7. Carrie Mae Weems, Untitled (Salt and Pepper Shakers), *American Icons* series, 1988–89. Silver print, 15 × 15 in.

ball player is a blackface version of the National Basketball Association's logo made over with the spastic braids of the Little Rascal's Farina (visual kin to those of the rapper Coolio). The work comments on the nature of the contemporary ball player, whose freakish size and abilities have made him both a spectacle and a curiosity.[36] Charles's painting critiques the NBA's grotesquely entertaining blend of freakishness, fortune, and fame as well as the sad ends toward which the physical virtuosity of so many young African American males is being trained by the media. In this way it echoes David Hammons's installation piece *Higher Goals* (1986), in which basketball hoops have been extended to unreachable heights to emphasize the dysfunctional relationship between sports, education, and achievement in African American culture.

The blackface makeup that Charles uses to create this character is important to consider in relation to Walker's self-professed interest in blackface minstrelsy and racialized pageants and the current critique of it in American visual culture. From director Spike Lee's film *Bamboozled* (2000), which featured Charles's paintings in many scenes, to the work of the Arizona-based painter Beverly McIver, blackface has become a way for African American artists to examine the complexity of their commodification in the market and the public sphere.[37] However, unlike Charles, both McIver and Walker seem to insert themselves into the pageant of blackface. In a series of portraits from 2002–2003, McIver painted herself wearing blackface makeup and a wig (plate 4). These images were created while she was working on a larger project called "The Liberation of Mammy," in which she transformed recently gleaned oral histories of her mother's life as a domestic into a visual narrative starring a made-up version of herself. The type of signifying in which McIver's work engages, a sort of liberation through transgressive co-optation and the development of oppositional personae who inhabit traumatic experiences that cannot be claimed by the self, is similar to Walker's use of the nigger wench in her writing and silhouettes.

The "Recoloration Proclamation" project of conceptual artist John Sims participates in the legacy of African American symbol subversion witnessed in McIver's blackface portraits and Charles's advertising icons.

But perhaps it most deeply resonates with Ringgold's *Flag for the Moon* in its attack on systems of political symbology. In an ongoing series of full-size, recolored Confederate battle flags begun in 1999, Sims, a Detroit native who, upon finishing graduate school at Wesleyan University in Middletown, Connecticut, moved to Sarasota, Florida, to take a teaching job at the Ringling School of Art and Design, explored the power of the preeminent sign of Southern white racism (plate 5). He began by signifying on the flag's red, white, and blue color scheme by first changing it to the red, black, and green of the Universal African colors first conceived by Black Nationlist Marcus Garvey in the 1920s, and then to all-black, all-white, and black and white.

Sims's project, derived from an artistic dilemma spawned by a northerner's transplantation in southern culture that echoes Walker's youthful experience of moving from California to Georgia, raises trenchant questions about the way we experience and display prejudice, history, and regional identity. And like Walker's work, it follows an avant garde tradition in the African American artistic community that has often taken the form of signifying on derisive images. When asked to comment on Walker's work, Gates asserted that the subversion of negative stereotypes by African Americans has been, and remains, key to the dynamic development of African American artistic expression:

We are enjoying a period of tremendous artistic energy, which has manifested itself especially in post-modern forms of pastiche, parody, rifling and signifying. Several of these postmodernists have chosen to draw upon seminal stereotypical images of African Americans that were created as a fundamental part of the white racist onslaught against our people. These artists have done so not to glorify and perpetuate those images; rather, they have done so to critique the racist impulses that manifested themselves in bizarrely heinous representations such as Sambos, Coons, Mammies and Jigaboos. In doing so—that is, in drawing upon this peculiarly American repertoire of debased, racist images—these artists are seeking to liberate both the tradition of the representation of the black in popular and high art

forms and to *liberate* our people from residual, debilitating effects that the proliferation of those images undoubtedly has had upon the collective unconscious of the African American people, and indeed upon our artists themselves and their modes of representation.[38]

Gates is careful to emphasize that the process of reinterpretation, which we see active in Walker's work, is essential to a postmodern African American artistic practice.

However, a general resistance to postmodernism, as to modernism before it, can be found throughout contemporary African American artistic culture, wherein its complex theoretical tenets are viewed as having been engineered to continue the "othering" process of people of color.[39] This situation has served to create a climate of suspicion in these art audiences, who see work by artists who utilize postmodern critical theory as elitist and alienated from their values. It is a complex circumstance that many avant garde African American artists have had to deal with, and one that is discussed at length in the chapter devoted to the censorship and reception of Walker's work.

Through her words, drawings, and silhouettes Kara Walker plumbs the unspeakable regions of our American collective memory as a way to confront spectators with their own psychological repression of negative historical imagery. As spaces of blank darkness rendered intelligible by their margins, as reductions of form that still maintain certain key characteristics, her silhouettes encourage involvement and interpretation, making for an interactive art form in which the racial and cultural specificity of the spectator takes primacy. As she recovers for us the nasty science of Johann Caspar Lavater, she makes us look closer at the silhouettes of Flora and Moses Williams and prods us to (re)read Harriet Beecher Stowe's sentimental fictions. In so doing she participates in an African American tradition of questioning and signifying on the dominant visual culture, of bucking convention and conservatism, and of challenging hegemonic codes of repression and representation.

THE "REMEMORY" OF SLAVERY

If this is what is inside of me, then nobody is safe.

—Kara Walker, "Fireside Chat," 1999

What if the materials of memory are overwhelming, so traumatic that the remembering of them threatens identity rather than reconstituting it? What if identity had to be reconstituted out of a strategic amnesia, a selective re-membering, and thus a selective *dis*(re)membering of experience? What if the technology of memory, the composite visual-verbal architecture of the memory palace becomes a haunted house?

—W. J. T. Mitchell, "Narrative, Memory, and Slavery," in *Picture Theory: Essays on Verbal and Visual Representation*, 1994

The End of Uncle Tom and the Grand Allegorical Tableau of Eva in Heaven is one of Kara Walker's most impressive large-scale works (see figure 1). When fully installed, it covers the gallery walls with haunting, life-size silhouettes that seem to evoke specific vignettes from Harriet Beecher Stowe's 1852 sentimental novel about

slavery, *Uncle Tom's Cabin*. And yet, when the work is read against the text, there are no easy connections that can be made between what Stowe writes and what Walker has created. It is much like comparing Alice Randall's recent satire, *The Wind Done Gone*, with the book on which it signifies, Margaret Mitchell's *Gone With the Wind*.[1]

When read from left to right, *The End of Uncle Tom* comprises four groupings of silhouette characters involved in nightmarish acts.[2] The first scene contains a group of three slave women and a child involved in a moment of mutual nursing. This is followed by a larger arrangement of three small slave children, one holding a basket, another a spike, and the third a tambourine. Their young mistress, who raises an axe high above her head, stands in the center of the grouping. The third scene is dominated by the character of a corpulent and crippled master who rests his belly on the back of a pubescent slave whom he is sodomizing. He counterbalances his girth with the aid of a saber that is thrust into the body of an infant beneath him. The final scene centers on a balding male slave who, knees bent and hands clasped in prayer, is connected by a cord dangling from his anus to a baby lying on the ground. The tableau concludes with two partially obscured women.

Standing before the piece, the viewer is brought eye to eye with the silhouettes, making the viewing experience more complex than if solely witnessing a drama.[3] These characters have the power to call forth nostalgic emotions from the Durkheimian collective consciousness as they reference the archaic visual culture of the eighteenth and nineteenth centuries, as well as silhouette portraits made in one's own childhood.[4] Originally mounted in 1997 at the Whitney Biennial, and then again the following year at the San Francisco Museum of Modern Art, the work translates the nostalgic form of the silhouette into a contemporary, museum-ready format by increasing its scale from preciously small to shockingly monstrous. The ambitious scale not only asserts the work's authority within the space of the museum, but the scale of the individual character silhouettes, their human size, helps them to force their way into the space of the viewer. They become the shadows of those standing before them. They are the visualization of private sexual fantasies or

violent nightmares, thoughts too terrible to utter or enact in the form of black paper glued to white walls. "I think that my work has tended to make people a little flustered at times, which is nice," Walker confessed in a 1995 interview. "I mean very often because of the nature of the cut-outs, the content doesn't reveal itself right away. So audiences have sort of giggled or said things like, 'oh, these remind me of my childhood' and then notice that the happy little 'pickanninies' are running away with a soldier's leg and hand from a previous scene. Suddenly that leg and hand belonged to that viewer."[5]

With their elegant, albeit negative, form, Walker's silhouettes express a void: an unknowable black hole, a kind of blank darkness, which is signified by an outer contour line. When combined with what is argu-ably the most pervasively traumatic, guilt-ridden episode in U.S. history, the experience of African slavery in America, this delineation produces an extraordinary space of psychological projection. It is a gothic space, belonging to the dark ages of American history, one that is barbarous, rude, uncouth, unpolished, in bad taste, and completely savage, a space made real on the walls of the gallery, in which the present-day viewer comes in contact with magnetic and disturbing specters from a mythi-cal past engaged in an apocryphal and pornographic, unsentimental master-slave dialectic.[6] In it all of the figures are black; they operate on a plane where bits and pieces of memory and experience and myth are sutured together into a crazy quilt of neohistorical romance.

The physical connection between the work of art and the viewer that the installation effects is further emphasized by the format of the piece, the way it wraps around the gallery, adapting the shape of a nineteenth-century cyclorama. Walker stated in a 1996 interview, "Well, from the moment that I got started on these things I imagined that someday they would be put together in a kind of cyclorama. I mean, just like the Cyclo-rama in Atlanta that goes around in an endless cycle of history locked up in a room, I thought that it would be possible to arrange the silhou-ettes in such a way that they would make a kind of history painting en-compassing the whole room."[7] In addition to referencing this type of theatrical artwork, the silhouette characters are reminiscent of shadows

cast by Javanese puppets or by actors behind a scrim. And like Peter Pan's shadow cavorting around the room of Wendy Darling, these errant phantoms have disturbingly separate minds of their own. They exist in a fantasy world that is just beyond the apron of an imaginary stage, an effect that is furthered by the artwork's curtain-like, scalloped lower border that floats a few feet above the gallery floor.

Like a play, it is a work meant for public consumption. The life-size scale of the silhouettes produces an uncanny effect that is almost like seeing one's own outline being projected onto the gallery wall. This is an effect on which Walker has capitalized recently by adding projectors to her installations so that the viewer's body is actually cast into the shadow play in works like *Insurrection* (figure 8).[8]

The uncanny confrontation with the ghostly shadow that the viewer experiences when standing in front of *The End of Uncle Tom* may be read in terms of Carl Jung's concept of the shadow as the primary archetype of the collective unconscious.[9] For Jung, the shadow, the anima, or the spirit within represents our hidden nature, and as such it is generally opposite in temperament to what is revealed on the outside. The Jungian shadow is the antagonist within the repressive exterior personality; it may be linked to Sigmund Freud's idea of the sadistic superego, which is "the expression of the most powerful impulses and most important libidinal vicissitudes of the id."[10] The "super-ego manifests itself essentially as a sense of guilt (or rather as criticism—for the sense of guilt is the perception in the ego answering to this criticism) and moreover develops such extraordinary harshness and severity towards the ego. The excessively strong super-ego which has obtained a hold upon consciousness rages against the ego with merciless violence, as if it had taken possession of the whole of the sadism available in the person concerned."[11] Freud states that in mastering the Oedipus complex, the ego has "placed itself in subjection to the id. Whereas the ego is essentially the representative of the external world, of reality, the super-ego stands in contrast to it as the representative of the internal world, of the id. Conflicts between the ego and the ideal will . . . ultimately reflect the contrast between what is real and what is psychical, between the external world and the internal

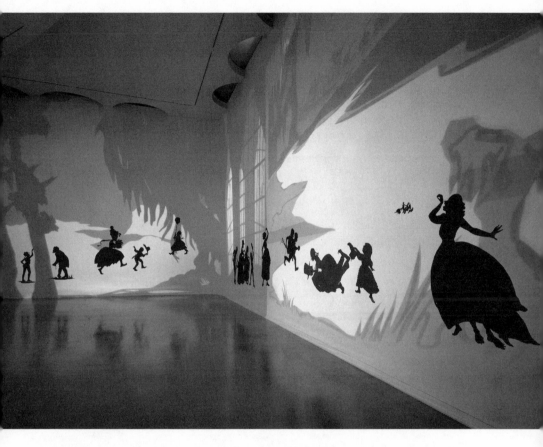

FIGURE 8. Kara Walker, *Insurrection! (Our Tools Were Rudimentary, Yet We Pressed On)*, 2000 (installation view). Cut paper silhouettes and light projections, site-specific dimensions. Guggenheim Museum. Purchased with funds contributed by the International Director's Council and Executive Committee Members. 2000.68. Photo: Ellen Labenski, © The Solomon R. Guggenheim Foundation, New York.

world."[12] In Freudian terms, then, the physical confrontation between the spectator and the shadow scenes on the gallery walls is one of witnessing a personally repressed anima, the cruel superego within the psyche, let loose to roam at will, thoroughly unchecked.

In the world of *Uncle Tom* the Jungian shadow and the warring superego of Freud are the stars of the show; they are black paper doppelgängers created to bring forth the dark side of the viewer's imagination and are responsible for dealing with the guilt that the rest of the psyche must repress.[13] Here we see Walker's dynamic use of the silhouette form combined with her revision of the uncannily familiar yet naggingly obscure subject matter of Stowe's sentimental novel boldly visualizing the discourse of the unspeakable, the unknowable trauma of slavery. The piece illustrates myths and histories that, as Toni Morrison so eloquently put it in her gothic novel *Beloved*, have been "disremembered" in the public discourse of American slavery and race relations.

In many ways, *The End of Uncle Tom* is the visualization of the haunted house to which W. J. T. Mitchell refers in the opening epigraph, taken from his essay, "Narrative, Memory, and Slavery."[14] Here Mitchell argues that the writing about slavery by ex-slaves in the nineteenth-century slave narrative genre, and by the descendant of enslaved African Americans in Morrison's twentieth-century gothic novel, reveals a psychical process of disremembering the trauma of slavery, of repressing a horrific experience that can never be truly known, in order to remember what can never be fully understood. *The End of Uncle Tom* offers a haunting visualization of the disturbing "rememories" of the personal and collective trauma of slavery that Mitchell has identified in literature. Further, Walker is signifying in a Gatesian way on a particularly racialized history, not simply by showing generic stereotypes of slaves and masters doing nasty things, but by radically transfiguring and subverting specific sources culled from nineteenth-century American visual, political, and literary culture: from slave narratives and sentimental novels, from abolitionist propaganda and scientific documents. She is re-membering an antinarrative that exists in a place before memory and beyond it, always familiar, yet resoundingly alien. The phenomenological impact of her

silhouettes can be understood in terms of both Freudian and Jungian psychoanalytic theory, as well as through manifestations of the gothic in American culture and literature. In *The End of Uncle Tom and the Grand Allegorical Tableau of Eva in Heaven,* Kara Walker takes a deficient history that is both visual and textual and re-members it in a way that calls forth the ghosts from our collective psyche.

When Walker's life-size silhouettes are read in this way, as the independent-minded shadows of those who gaze upon them, they may be viewed as icons of death that have been resurrected to haunt the living. In nineteenth-century gothic literature and imagery the term "shadow" has often appeared as a reference to the personification of Death and to the spirits of the dead returned to haunt the living. In the work of Edgar Allan Poe, for example, the term is used as a double for the figure of Death in the short story "Ligeia," in which the narrator describes the fatal illness of his first wife: "Words are impotent to convey any just idea of the fierceness of resistance with which she wrestled with the Shadow." Later in the story, the shadow is present in the form of the spirit of the dead woman returned to the world of the living in a furious attempt to regain life through the possession of the husband's second wife: "And I saw that there lay upon the gold carpet, in the very middle of the rich lustre thrown from the censer, a shadow—a faint, indefinite shadow of angelic aspect—such as might be fancied for the shadow of a shade."[15] This deathly relationship reappears in Walker's shadow characters, as they resurrect and trope Poe's nineteenth-century tradition of shadows as related to death and to the dead. In this way, these life-size, almost alive "shadows of shades" are able to remind spectators/readers of their own corporeality and mortality.

Female sexual self-reflexivity is at the core of the first section of *The End of Uncle Tom.* In this scene, the viewer is presented with an unsettling arrangement of four silhouetted characters, three bare-breasted slave women and an infant child, who are engaged in a chain of mutual nursing. All three women essentially look alike: they are young, they have kerchiefs on their heads, their dresses are pulled down about their waists, their backs arch forward, and their rear ends press outward. This

arrangement presents their breasts in a psychologically subversive context. Feminist historian Marilyn Yalom claims, "On the one hand, breasts are associated with the transformation from girlhood to womanhood, sexual pleasure, and nursing. On the other, they are increasingly associated with cancer and death. . . . Breasts literally incarnate the existential tension between Eros and Thanatos—life and death—in a visible and palpable form."[16] This scene of adult women acting as wet nurses to each other transgresses a number of boundaries. In one sense, this image, in which the nourishing and the sexual nature of the breast becomes confused, alludes to the horrific impact that slavery wrought upon the bodies of African American women. It prompts the viewer to remember that a slave woman's breasts, along with the rest of her body, did not actually belong to her; rather, her owner controlled them. In a well-known 1850 daguerreotype of a slave woman made by J. T. Zealy, as spurious evidence for Harvard scientist Louis Agassiz's campaign to assert his theories of polygenesis and the inferiority of African people to Europeans, "Delia" has been stripped to the waist and presented to the invasive eye of the camera (figure 9). The exposure of her body reminds the viewer of Delia's physical subjugation, and the trauma of this visual violation and its attendant humiliation can be read in the sorrowful affect that consumes her face. The manner in which her bodice drapes around her hips is echoed in the way Walker's slave women's clothes straddle their waists, emphasizing the fact that for many slave women in Delia's situation, functional worth was tied not only to their ability to work in the fields or elsewhere on the plantation at domestic chores, but also directly to their ability to produce milk when a wet nurse was required by their owners. A former slave from North Carolina recalled in the 1930s, "My Aunt Mary b'longed to Marse John Craddock and when his wife died and left a little baby—dat was little Miss Lucy—Aunt Mary was nussin' a new baby of her own, so Marse John made her let his baby suck too. . . . If Aunt Mary was feedin' her own baby and Miss Lucy started cryin' Marse John would snatch her baby up by the legs and spank him, and tell Aunt Mary to go on and nuss his baby first."[17]

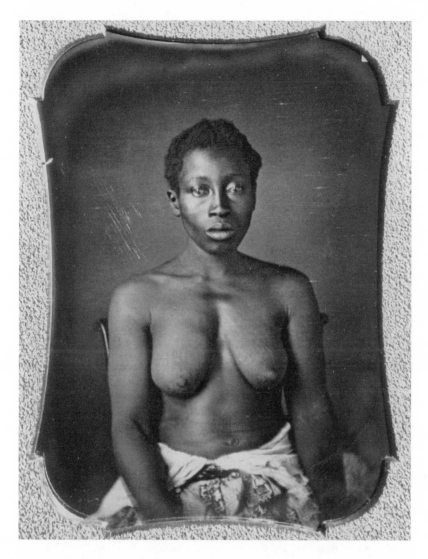

FIGURE 9. J. T. Zealy, *Delia*, 1850. Frontal, 11.9 × 9.7 × 2.1 cm. Peabody Museum, Harvard University, © President and Fellows of Harvard College.

The legacy of the abuse of the slave woman's breasts that Walker's image addresses is also found at the center of Sethe's story in Morrison's *Beloved,* a "rememory" of the tale of Margaret Garner. A runaway slave threatened with imminent capture, Garner had attempted to murder her three children, one of them successfully, rather than see them returned to the state of bondage from which they had just escaped. In Morrison's retelling of the story, the ghost of the dead child, Beloved, returns to haunt her surviving family members and, most intensely, to plague her mother, Sethe. In the following passage, Sethe attempts to reconcile her horrible deeds as having been at least partially the result of the systematic abuse of her breasts by her owners:

> I'll explain to her, even though I don't have to. Why I did it. How if I hadn't killed her she would have died and that is something I could not bear to happen to her. When I explain it she'll understand, because she understands everything already. I'll tend her as no mother ever tended a child, a daughter. Nobody will ever get my milk no more except my own children. I never had to give it to nobody else—and the one time I did it was took from me—they held me down and took it. Milk that belonged to my baby. Nan had to nurse white babies and me too because Ma'am was in the rice. The little white babies got it first and I got what was left. Or none. There was no nursing milk to call my own. I know what it is to be without the milk that belongs to you; to have to fight and holler for it, and to have so little left. I'll tell Beloved about that; she'll understand. She my daughter. The one I managed to have milk for and to get it to her even after they stole it; after they handled me like I was the cow, no, the goat, back behind the stable because it was too nasty to stay in with the horses.[18]

Beloved, the ghostly rememory of Sethe's Medean action, is the classic gothic trope of the past haunting the present. She is the literal return of the repressed; the uncanny incarnation of trauma's trace, Sethe's Freudian superego, in the physical form of her dead child, called up to punish her ego for the guilt that she feels; she is a demonic rememory who enables the "disremembering" of a traumatic past and allows the un-

speakable to be spoken.[19] And for Sethe, the act of confession is the first step toward reconciling her unspoken personal dialectic between good and evil, transgression and transcendence.

The "stories" of these three women—the fictional account of Sethe's ordeal, the image of Delia, and the narrative of Aunt Mary—are "rememoried" in the half-naked, fervently nursing female slaves of Walker's installation. Their fictionalized, imagined, and rememoried emotions of pain, anger, and humiliation over the abuse of their enslaved black female bodies are present as ghostly specters in the silhouette characters, as shadowy icons of death that have been resurrected to haunt the living.

In the image that Walker has created, the women have neglected their duties as slaves and are now nursing each other. The child, instinctively knowing that it must obtain the breast in order to be satiated, in order to survive, strains hopelessly to get a teat within its grasp. However, the women have lost all desire to placate it. With the attention they give to their erotic activity, they all but forget the infant. To emphasize the sexual nature of the women, rather than their nurturing side, Walker has not cut their forms to resemble the grossly corpulent body of the mammy. Unlike the stereotype of the mammy, Walker's women do not focus their attention outward, seeking the satisfaction of white others, but toward each other instead. Having rejected maternal action, they are orally fixated on nursing, the activity that Freud believed was a man's first sexual experience, the one for which other objects and body parts are later substituted during the post-Oedipal period.[20] And yet, for these women, as they turn inward toward the replicas of their own bodies, there is no need for a substitutional object on which to shift their attention. Male presence is also inconsequential to their actions and independent of their desires.

This orgiastic carnality speaks of a racialized transgression of sexual and gender roles. No longer are their bodies to be used by others, by men or by babies; now they are to be enjoyed by the self and one's own kind, now they are in themselves the objects of desire as they consume the bodies of their analogues. Given these associations, Walker's image

at first seeks to engage in this discourse of lesbianism as an alternative to heterosexual relationships among African American men and women. However, with her injection of a third woman into the scene, along with the presence of the neglected child on her lap, Walker takes a step further into the realm of the gothic as the three women engage in complete cultural and sexual transgression.[21]

It is important to note that in certain African American communities, lesbianism, even more than male homosexuality, has been slow to gain public recognition and social acceptance. More often, it has been viewed as the rejection of the already downtrodden and abused African American male, rather than an embracing of female sexual desire. In the 1980s, Alice Walker's novel *The Color Purple* encountered much antagonism from a variety of African Americans because of the lesbian relationship between Celie, who had been abused by her husband, and the free-spirited blues singer Sug, who helps her to recognize her own humanity and inner strength.[22]

The depiction of sexual self-reflexivity in Walker's scene may be read, then, as an institutionally imposed mother hunger (and here I am referring to what has been called the "peculiar institution" of slavery). As they suck on and suckle each other, the history of slavery is passed between them. It visualizes a desire for the lost maternal nurturing that was systematically withheld under the system of slavery, rather than the breast that is withheld by a "bad" mother. Walker's slave women live in the immediate moment in which their needs are being fulfilled. The beginning of their sexual experience is in fact the end, as what had so often been withheld from their grasp is finally released into it. The child, however, will simply have to wait.

If repressed sexual transgression and mother hunger can be said to dominate the scene of mutual nursing that begins *The End of Uncle Tom*, then sadomasochism and defecation dominate the one that follows. In this scene, the largest shadow character is that of a young mistress who leans precariously over a tree stump. She holds an axe above her head with its blade turned backward. Her unbalanced position and the inverted axe hint that a masochistic act of self-inflicted mutilation is about

to occur. Behind her crouches the character of a slave girl, whose out-stretched arm ends with a fist that is clenched tightly around a sharp-ened stick, which she holds at a sadistically threatening angle toward the larger girl's bottom. Opposite her stands a naked boy holding a small basket. And to the far left, another child stands midstride, having left in its wake a trail of globular piles of fecal matter. The piles grow and then diminish in size until they are reduced to a final teardrop attached to the child's buttocks. The child stands in midstride with one leg in an adult-size boot, as if playing dress-up, and with its hand upraised, holding a tambourine. Together, the slave children exude an aura of malicious mis-chief that implies mutual participation; they are both ready to serve and to skewer their axe-wielding mistress.

This scene visualizes the difficulty of seeing the unspeakable, of ade-quately articulating trauma, by expressing a hidden discourse of the dis-remembered through the action of the shadow characters, in particular through the character of the defecating slave child. The imagined noise of his evacuating bowels and the tambourine that he holds provides the sound track for the scene. The implied noise the child makes is impor-tant: "I could sort of hear this character with the tambourine stomping with one foot."[23] Sound is represented here as form. The unspeakable trauma of slavery spurts out of the tambourine player, as reversed and uncontrolled "diarrhea of the mouth," a metonymic process in which words become excrement, a gothic night soil born of the legacy of slav-ery.

This struggle to articulate the traumatic impact of slavery is witnessed at its most potent during the antebellum period in the rise of the slave narrative as a literary and reportorial genre. In his own slave narrative, Frederick Douglass, while not omitting the graphic details of the physi-cal torture that he endured during his early life, was unable to verbalize adequately his feelings about what had been done in front of him and what had been done to him:

> He would whip her to make her scream, and whip her to make her
> hush; and not until overcome by fatigue, would he cease to swing the

blood-clotted cowskin. I remember the first time I witnessed this horrible exhibition. I was quite a child, but well I remember it. I never shall forget it whilst I remember any thing. It was the first in a long series of such outrages, of which I was doomed to be a witness and a participant. It struck me with awful force. It was the blood-stained gate, the entrance to the hell of slavery, through which I was about to pass. It was a most terrible spectacle. I wish I could commit to paper the feelings with which I beheld it.[24]

Some narratives were written by former slaves, as in the case of the *Narrative of the Life of Frederick Douglass, an American Slave, Written by Himself*; others were told to an intermediary amanuesis, who then recorded it as mediated words. These ghost writers were usually abolitionists who were more committed to their cause than to the accuracy with which the personal details of the former slave's life was recorded. As a result, many elements, ones that deviated from the conventionalized form of the genre, were simply dropped from the account. These disturbing specifics, often sexual in nature, constitute an important aspect of the unspeakable in nineteenth-century slave history. A recent analysis of this genre by historian Nell Irvin Painter provides a context for the repressed discourse of the unspeakable that is present in the mediated *Narrative* of Sojourner Truth.[25]

In the vein of Douglass's autobiography, Truth's *Narrative* (originally written by a European American amanuensis, Olive Gilbert, in 1850 and expanded in 1875 by Frances Titus), speaks of the New World relationships that were forged between masters and slaves in the late eighteenth and early nineteenth centuries in the United States. Until recently, the unspeakable subtext remained obfuscated by Truth's amanuensis's inability to give voice to the full extent of her subject's suffering.[26] Thanks to her efforts to provide a context for Truth's story, Painter is able to furnish the contemporary reader with a better understanding of the conditions under which Truth lived. For example, Painter points out that because most slaveholders in New York State, where Truth lived the first part of her life under the slave name Isabella, had only one or two slaves,

the relationships between owners and their property were analogous to those in an extended family. She contrasts this with the southern situation, in which the owners of massive plantations lived separately from their chattel, who remained down in the slave quarters. For Isabella this meant that her owner, John Dumont, had a particularly potent and patriarchal influence over her life as his slave. "Dumont only beat her when she deserved it, she said later, but her narrative attests to her hypervigilance, the wariness of a person who lives with the specter of violence. Isabella would sometimes stay up all night, afraid to sleep, trying to do her work well enough to gain approval." Painter explains that this relationship was characterized by an abusive and complex attachment with both her master and her mistress: "Her anxiety to please Dumont earned her the scorn of his other slaves, who may have isolated her even before the sexual abuse began. . . . The sexual abuse came from her mistress Sally Dumont, and Truth could tell about it only obliquely, in the scattered pages of her Narrative."[27] There were certain things in the nineteenth century that, despite the sentimentalist and abolitionist belief in their own enlightened understanding of the horrific nature of slavery, could still not be said publicly. Truth's inability to give voice to the pain and humiliation of having been sexually violated by Sally Dumont is as much Olive Gilbert's as it is hers.

In addition to interrogating notions of humanity, Walker's rememory of the trauma of slavery re-visions and de-familiarizes the sentimental fictions of slavery written by European Americans, most obviously represented in this instance by Stowe's *Uncle Tom's Cabin*. It visualizes questions of authenticity in order to interrogate notions of artistic identity and authorship: Are we reading the words of the freedwoman Sojourner Truth, the slave Isabella, or the European American amanuensis Olive Gilbert? Is the creator of *The End of Uncle Tom* the young African American woman artist Kara Walker, or is it "Missus K. E. B. Walker," the persona responsible for the *Negress Notes* drawing series and one of the various signifying pseudonyms that Walker has assumed in her work?[28] It is a name reminiscent of obscure, middle-class nineteenth-century African American women writers like Mrs. A. E. Johnson and Mrs. N. F. Mossell,

and references the role that these women played in the world of polite middle-class letters by departing from the propriety and piety that their work represents.[29] Walker uses the archaizing persona of Missus K. E. B. Walker as a mechanism to free the Freudian superego that she is required to repress in her contemporary social identity. "I imagine that most of us have some kind of fictive world that we can retire to during our day. An imaginary self or an imaginary location," Walker responds when asked about her role as narrator. "I found that in textured and multi-layered ways I was retreating into the lore of the South."[30] Thus, Missus K. E. B. Walker serves as a type of magical amanuensis who can literally draw us into an image world in which both death and desire can be acknowledged. An image world in which sound becomes form.

The End of Uncle Tom and the Grand Allegorical Tableau of Eva in Heaven is an effort to "rememory" the visual stories out of the mediated testimonials of the traumatic events and lingering repercussions of slavery that Truth's slave narrative exemplifies. But Walker not only visualizes the sanctioned histories that can be culled from such a story; she critiques the "cleansing" of history that abolitionist rewriting performed: she attempts to rememory what is missing, to say what they could not. Her works are, as curator Thelma Golden has noted, "the slave narratives that were never written."[31] Through visual utterance she commands the return of the repressed, the seeing of the unspeakable. In this way, the implication of Isabella's sexual torture at the hands of her mistress correlates to the unspeakable actions of the children who both serve their axe-wielding mistress and await an opportunity to skewer her.

In an effort to be heard, in a desire to declare repressed feelings and experiences, the tambourine-playing slave child has mangled and corrupted the voice so that oral expression comes out as anal excrement. "Really it's about finding one's voice in the wrong end," explains Walker, "searching for one's voice and having it come out the wrong way."[32] But for something to come out the wrong way, something must first go in. In a related print by Walker, titled *Vanishing Act*, we see the consumption and internalization of whiteness within the black body (plate 6). On the proscenium are two figures in the magical process of becoming one.

The larger figure, a crouching black woman in a bell-skirted dress and beribboned bonnet, is busy swallowing whole a European American girl-child. Like Goya's Saturn devouring his children, her mouth opens wide as she engulfs the small body headfirst with the natural ability of a boa constrictor consuming a rat.

In *Vanishing Act* the black body consumes the white, taking all of the other into the self, absorbing its being, wholly and completely. Walker explains that the act of "cannibalism is wanting to have everything of the other person, body and soul. . . . There is a little bit of masochism, I think, involved . . . so much love and hate involved in eating something; to kill something and eat it. It's very sexual, very sensual."[33] The act of loving cannibalism that Walker describes here, and that is found in *Vanishing Act*, echoes the writings of Brazilian art theorist Oswaldo de Andrade, author of the 1928 dadaist "Anthropophagite Manifesto." In this rambling and nearly incoherent, yet fascinating and dynamic treatise, de Andrade exhorts the postcolonial subject to devour the former colonizer in order to transform him from "taboo into totem." "The lucta between what one would call the Uncreated and the Creature [is] illustrated by the permanent contradiction between man and his taboo," writes de Andrade, his words initiating a process in which the formerly colonized body absorbs the entirety of the colonizer, mind, body, and spirit, to reconstitute that being as a basis for a new social organization. "Anthropophagy. Absorption of the sacred enemy. In order to transform him into totem. The human adventure. The mundane finality. . . . What happens is not a sublimation of sexual instincts. It's the thermometric scale of the anthropophageous instinct."[34] With his words de Andrade proposes an artistically created reconciliation between the conflicted dyad of exploiter and exploited and a thermodynamic process in which matter is transformed.

Walker continues de Andrade's pan-American, postcolonial tradition in both *The End of Uncle Tom* and *Vanishing Act*, where cannibalism/anthropophagia acts as a mechanism of Freudian pregenital sexual organization. Each piece proposes an image world in which "sexual activity has not yet been separated from the ingestion of food; nor are opposite currents within the activity differentiated . . . sexual aim consists in the in-

corporation of the object — the prototype of a process which, in the form of identification, is later to play such an important psychological part."[35] In the case of Sojourner Truth's Isabella, the unspeakable physical and psychological abuses perpetrated by masters and mistresses instigated a Freudian torture of the ego by the superego within the psyche of the subjugated person, while at the same time they stirred a desire in her to reach a point of oneness with her oppressor. As a bonded individual, Isabella became complicit in her miserable situation and grew to accept it as the natural state of her lived reality. Her anxiety to please her torturer and oppressor, and to then in turn benefit from that pleasure, is echoed in *Vanishing Act*. This small print visualizes this need to understand and internalize the Hegelian master-slave dialectic.

However, it is the masochistic character of the young mistress with the inverted axe lifted above her head who reminds the viewer that the desire of the slave to reach a point of convergence with the master is really a mutual endeavor, one that references the American tradition of blackface minstrelsy. The act that Walker's characters perform in these two works rememories and signifies on the manner in which blackface's European American practitioners consumed and inhabited the black body as they reconstructed it along specific lines of difference.[36] Violence toward the other is really violence toward the self; this is why the axe is turned backward, for the other represents the externalization of the repulsive that is always within.

The scene that follows continues to explore these themes of sexual trauma, the subversive, and the anthropophagistic through its visualization of sadistic sexual activity, of sodomy, of murder and mutilation. It centers on the silhouette of an adolescent slave girl bending at the waist, raising her buttocks in the air, and grasping a corn stalk with both hands for support. Resting on her back is the enormous belly of a legless master character who stands with the aid of a wooden leg and a saber that is thrust into the body of a small child on the ground behind him. The two larger characters merge, as the slave girl's legs become a substitute for the man's missing limbs. They are further connected by his abdomen, which is physically and metaphorically supported by the labor of her

back. Echoing Truth's Isabella, she is complicit in the act of her domination; she is taking in the body of the oppressor; she is becoming one with him.

The master's prostheses may be read as phallic replacements for his symbolically castrated body. They are similar to ones found in an 1839 painting by John Quidor, *Antony Van Corlear Brought into the Presence of Peter Stuyvesant* (figure 10). Historian of American art and literature Bryan Jay Wolf has recognized that the sword, peg leg, walking stick, and pipe, all attached to Stuyvesant's body, are direct phallic replacements and images of his sexual potency that serve to underscore his visceral pleasure at hearing Van Corlear "blow his horn."[37] In addition to being visual analogues, Quidor's illustration of this farcical scene from Washington Irving's *Knickerbocker Tales* features the type of nasty wit that is found

FIGURE 10. John Quidor, *Antony Van Corlear Brought into the Presence of Peter Stuyvesant*, 1839. Oil on canvas, 27 3/8 × 34 1/16 in. Munson-Williams-Proctor Arts Institute, Utica, New York. 63.110.

throughout *The End of Uncle Tom.*[38] Both are grimly humorous in that they revolve around a play on words and rude phraseology that is unspeakable in polite society. The phallic cornstalk that the slave grasps for support is a joke about "corn-holing," vulgar slang for the anal penetration in which the master and the slave are engaged. Its nasty implications are further evoked by the implication that the slave master is corn-holing the girl with what might be called his "third leg," which in turn is common slang for penis, as well as an ironic reference to his missing leg and his victim's function as a surrogate limb supporting his bulk.

The word play of corn-holing and the many phallic additions that extend from the master character are twisted yet witty references to a specific sexual practice. Further, the act of impaling the infant with the saber emphasizes the sadistic irony of the sex act in which the master and the slave are engaged. Anal sex, felatio (the most cannibalistic of sex acts), and other forms of sodomy are, of course, nonreproductive, even antireproductive. Despite being widely practiced by heterosexuals, homosexuals, and bisexuals, today consensual sodomy remains illegal in some parts of the United States. This is in part due to a general secular antihomosexual sentiment, but can also be linked to religious beliefs that all sexual contact should be for the purpose of procreation rather than mere sexual satisfaction. This explains why the rather vague designation of sodomy itself incorporates a variety of nonreproductive sexual acts, including anal and oral sex. And sodomy is, historically speaking, the most gothic and literally sadistic of sex acts; the Marquis de Sade (for whom sadism is named) had anal (rather than vaginal) sex with his partners for the specific reason that it was subversively antireproductive. Sodomy has most often been represented in American culture as something gothic and threatening; in *Beloved*, it is Sethe's companion, the ex-slave Paul D., who must rememory the hellish experience of repeated oral rape by Georgia prison camp guards. Significantly, when the book was made into a film in 1998, directed by Jonathan Demme and produced by Oprah Winfrey, this section of it was not dramatized.

The contemporary cultural conception of sodomy as a violent male homosexual activity is borne out in another recent American film, *Pulp*

Fiction, directed by Quentin Tarantino. Similar to *The End of Uncle Tom*, the film includes a wide array of gothic characters and themes in an attempt to shock the spectator into experiencing feelings of both terror and titillation. The theme of sodomy, and anal penetration in particular, is linked to sadomasochistic homosexual sex in a scene in which the characters of Butch and Marcellus are kidnapped and tortured by a group of fetishistic weapons enthusiasts. The setting for their ordeal is the subterranean, crypt-like basement of a gun shop. The potential for death and pain literally surround the two men as various knives and other phallic torture devices cover the walls. And yet, the most powerful element of terror produced by this scene is the threat of homosexual violation. From the southern accents of the captors to the subhuman character of the "gimp" that is kept in a trunk in the dungeon, the scene is a thinly veiled homage to the backwoods rape scene from John Boorman's 1972 gothic rafting drama *Deliverance*. This threat in *Pulp Fiction*, while visited upon both Butch and Marcellus, is only carried out on the African American character Marcellus. And the revenge that he later seeks on his violator is no less than death.

Sadistic sex, and the cultural links to torture and death that are associated with it, is also found in the silhouette of the baby that is impaled on the blade of the master's saber. This steely connection references the potential for violence in the relationships between European American slave masters and their "mulatto" children. Like the ancient Roman pater familias, the American slave master had legal and mortal control over the bodies of his slaves and their children, whether fathered by another slave or by himself. Frederick Douglass wrote in his narrative, "I know of such cases; and it is worthy of remark that [the enslaved children of such masters] invariably suffer greater hardships. And have more to contend with, than others. . . . [The master] must not only whip them himself, but must stand by and see one white son tie up his brother, of but few shades darker complexion than himself, and ply the gory lash to his naked back."[39] In a sense, the image of violent oppression that Douglass evokes for his readers is circumvented in this scene by Walker as the master is witnessed disposing of his own spurious issue by killing it. At the

same instant that he murders the child, his choice of antireproductive, sadistic sexual activity also eliminates the possibility of creating other children.

The numerous phallic references and the allusions to sodomy that are made in this scene moors *The End of Uncle Tom* in the realm of gothic sexuality under the system of slavery, in which permission is not granted and submission is legally required. In Walker's shadow world, the master can sodomize his physical and racial subordinate, but only with her presence beneath him supporting his unseemly girth. The slave, in turn, must hang on to the cornstalk for support and wait until the act is finished, resigned to the futility of a potential struggle with such a crushing load. Like Sade's heroine Justine, she is submissive in the face of her domination; she takes in the body of her oppressor; she becomes one with him.[40]

The disremembered legacy of the sexual sadism borne under slavery that is evoked by the image of the prosthetically re-membered master sodomizing his slave is continued in the next scene from *The End of Uncle Tom*, in which the silhouette of a mature male slave crouches, bent at the waist and knees, with his hands raised toward heaven. He bends in prayer as his head tilts back and his grossly exaggerated lips, echoed by a wreath of curly hair, are pursed in an expression of supplication. Like Delia's bodice, his trousers have been pushed down and his feet are bare. A cord trails from his anus to the belly of an infant that lies beneath him on the ground. The cord appears to pierce his body and emerge from the gap between his pants, becoming a diminutive substitution for his penis. These last two scenes mirror each other in the uncanny way that the slave prays to heaven opposite the master who preys upon his terrestrial victim.

The character of the praying man in this scene is a direct descendant of the kneeling slaves prevalent in antebellum abolitionist visual culture. His bent stature echoes not only the fetal position of the child beneath him, but also that of the kneeling slave in Josiah Wedgwood's brooch, *Am I Not a Man and a Brother* (figure 11). Art historian Kirk Savage has recognized that the Wedgwood pendant marked a decided change

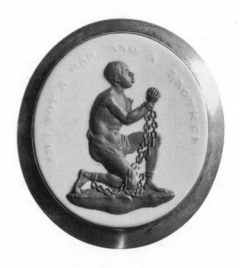

in the imagery of slavery when it first appeared in the late eighteenth century. It "changed the focus from submission to supplication," states Savage. "Neither crushed by the weight of oppression, nor driven by it to defiance, the Wedgwood figure was calculated to inspire benevolent sympathy."[41] In intention, the praying character is directly linked to Stowe's Uncle Tom character, who would rather appeal to God for his release from the system that oppresses him than take matters into his own hands. However, Walker has altered Wedgwood's initial design in a number of ways to transform a benevolent figure into a scatological one. First, she raises the character up off his knees and into a crouching position. This new position implies a state of incomplete evolution, much like that found in charts depicting the ascent of man. He exists somewhere between animal and human, not quite able to stand upright on his own. Second, she transforms the chains that bind the Wedgwood figure's wrists and ankles into the umbilical cord that hangs from the shadow character's anus. And yet, despite having transformed the bondsman's chain into an umbilical cord, the idea of shackling that is present in the

FIGURE 11. Josiah Wedgwood, *Am I Not a Man and a Brother*, ca. 1787. Wedgwood brooch, jasperware set in silver. Mint Museum of Art, Charlotte, North Carolina. Delhom Collection. 1965.48.85.

Wedgwood medallion remains palpable in Walker's image. This is per-haps because under slavery, birth was the beginning of a life of unend-ing misery and oppression for its victims. Because the children of female slaves belonged to the slave owner rather than to the parent, servitude was perpetual for the slave's blood lineage. "The whisper that my mas-ter was my father, may or may not be true," Douglass wrote of his own parentage. "The fact remains in all glaring odiousness, that slaveholders have ordained, and by law established, that the children of slave women shall in all cases follow the condition of their mothers; and this is done too obviously to administer to their own lusts, and make a gratification of their wicked desires profitable as well as pleasurable; for by this cunning arrangement, the slaveholder, in cases not a few, sustains to his slaves the double relation of master and father."[42]

Birth into slavery, as the child of two slaves or of a slave and a master, was the beginning of an existence that was at all times plagued by mortal terror. It is rememoried in Morrison's *Beloved* when Sethe finds it mor-tally abhorrent to imagine that her children would inherit only pain and suffering if they were returned to slavery. Knowing that her prayers to save them have not been enough, she takes matters into her own hands, trying to spare them hell on earth by dispatching them to heaven above. It is this vain hope for a release from the horror of the corporeal that is visualized in the action of Walker's male slave as he prays for deliverance for and from his own child.

However, this last scene in *The End of Uncle Tom* presents the viewer with an image of a male slave birthing a child. As such, it also references the fate of children born from unions between free European Ameri-can women and enslaved black men as well as those born to two black parents. Often, these infants suffered horribly despite the freedom that was supposed to follow their being born to free mothers. The escaped slave Harriet Jacobs wrote in her narrative, *Incidents in the Life of a Slave Girl: Written by Herself*, that "in such cases the infant is smothered, or sent where it is never seen by any who know its history."[43] In Walker's tableau, it is the father, feminized by the act of giving birth, who defecates his child. In raising his hands to heaven he seeks release from this parasitic

product of his intestines, as though it were a tumor grown from anti-reproductive sodomy gone awry. The defecated child becomes the ultimate unformed gothic creature in the process of fantastic transformation from a state of humanity to one of human waste. Visually it rhymes with the other child on the ground just to the left, who has been skewered with a saber by the slave master, as the cord that rises from the defecated fetus's belly rhymes with the sword being driven down into the guts of its counterpart. Both babies are linked to men who could be their fathers, one by violence and the other by bloodline. In their helpless fetal positions the infants echo the piles of waste that trail from the anus of the child playing the tambourine. They are as refuse upon the ground, at the mercy of the feet that stomp above them.

The shadow characters in *The End of Uncle Tom* signal the return of the repressed, and in so doing they remind us of our own corporeality and mortality. Consonant with the ghost-child Beloved, they provoke dis-remembered racial and sexual trauma and/or guilty feelings of one's role in a continuous, omnipresent historical narrative. Regardless of whether these memories of trauma and feelings of guilt are lived or received, they remind us that as postmoderns living in an increasingly diverse image world, we are all haunted by slavery. We are at the mercy of our own punishing superegos as the repressed within each of us is encouraged to return.

Through its complicated distortions of cultural history *The End of Uncle Tom* resurrects and reenacts a phantasm of inherited guilt over slavery that many Americans have long tried to reconcile in a rush to declare a race-free society. Gaines M. Foster, a specialist in southern history, argues persuasively that many historians have claimed "white southerners felt guilty about slavery, that in their heart of hearts they found it impossible to reconcile their peculiar institution with their democratic sentiments and evangelical faith."[44] This assertion has been key in various attempts to rehumanize the Confederate slave owners: they may have done evil things, but they did feel really bad about it. The manner in which some European Americans deal with personal guilt and the legacy of slavery today is similar to this rehumanizing impetus of professional

historians. In contemporary European American culture, this type of genetic guilt is often ignored or denied. It is different from the stigma of being descended from slaves that is carried by African Americans. And it is born from the knowledge (or in some cases, only the vague suspicion) that one's ancestors participated in or benefited from slavery.[45]

For certain diehards, the Confederacy is still a state of mind, in which the war that was lost was a war that never really ended. In *Confederates in the Attic: Dispatches from the Unfinished Civil War,* journalist Tony Horwitz tells the stories of contemporary people who are actually still fighting the war via battlefield reenactment in the vain hope of an alternative outcome to the conflict. Through this type of rememory, Civil War history buffs engage their desire to conquer a traumatic past and to force a new vision of the future. Horwitz claims that for some European Americans, Civil War "reenacting [has] become the most popular vehicle of Civil War remembrance," with over forty thousand participants each year. "The freedom of slaves [does not] figure much in [reenacting]," he states. "Although *Glory* inspired several units modeled on the black regiment depicted in the film, the Wilderness reenactment and a half-dozen other battles I later attended were blindingly white affairs."[46] Similar Civil War pageants and battlefield reenactments are regularly held in Walker's childhood home of Stone Mountain, Georgia, in the park that features a large stone memorial to Confederate heroes Stonewall Jackson, Jefferson Davis, and Robert E. Lee.[47]

And yet, guilt over the inherited legacy of slavery is not something that European American viewers shoulder alone as they stand before Walker's tableau. In witnessing the complicity of the black characters— and we must read them as black on multiple levels, from the color of the silhouettes to the pervasive racist cultural association of blackness with evil and degradation—African American viewers are given the opportunity to confront the traumatic possibility that their ancestors may at times have been complicit in the violent culture that they were forced to live in. The nagging suspicion that all of us are not descended from resisters or runaways, that some of us actually have an "Uncle Tom" in our family tree, perhaps hanging next to a noosed runaway, has the power

to create in some African American viewers a revised relationship with the past.[48] This move toward self-examination stems from the artist's personal obsession with southern mythology and the romance of sub-jugation and sympathy that stems from American libertine and senti-mental literature. "I began reading these [romance] novels and got very interested in that way of couching inconsistent desires into one format," Walker stated in 2002. "It's about power, it's about submission, it's about glorified rape fantasies! There's always a heroine who's strong and wins in the end and gets what she wants, and all these background characters. It's a really intricate way of linking the reader with the heroine with the author. Everyone's involved with this titillation."[49]

The dramatic relationship to the past that is found in *The End of Uncle Tom and the Grand Allegorical Tableau of Eva in Heaven,* its way of reenacting and apocryphally creating shared histories, is also found in the surge of post-Negritude drama that has appeared in theaters in the past two de-cades. Beginning with George C. Wolfe's 1988 farce, *The Colored Museum,* these plays take the form of minstrelsy and "Tom shows" that subvert the themes of race, sex, and the legacy of slavery, both physical and men-tal, into a type of performance as public exorcism. Plays like Suzan Lori Parks's *In the Blood* (1999), Robert O'Hara's *Insurrection: Holding History* (1997), and Keli Garrett's *Uppa Creek: A Modern Anachronistic Parody in the Minstrel Tradition* (1998) all deal with these issues, using the kind of far-cical and ironic approach to racialized subject matter that Walker has taken in her own visual and textual work. Garrett's work lies closest to Walker's because it was in fact inspired by the artist's print suite *The Means to an End . . . A Shadow Drama in Five Acts* (1996; illustrated and discussed in chapter 3). The characters in the play were developed from the fig-ures in the prints and their performance adds Garrett's voice to the sce-nario that Walker had conceived. In *Uppa Creek* the characters exist in the "Friendly Confines" of "a southern plantation within the antebellum of our nightmares. . . . There is a creek by the plantation which divides the play's world from another, which is our present reality." In creating her own dialectical drama, Garrett both authenticates and participates in Walker's vision of an alter-world in which historically repressed doppel-

gängers run wild, giving voice to the discourse of the unspeakable and enacting Walker's scenarios of the unimaginable.

Art critic Dan Cameron argues that Walker's sprawling, slavery-themed silhouette installations like *The End of Uncle Tom* are a dark sort of equal opportunity battlefield reenactment in the way they rewrite an unknowable part of our shared history through life-size restaging.[50] In Walker's shadow installations, it is not the bodies of twentieth-century would-be confederates and unionists who squeeze into the costumes of their imagined forebears to battle it out on the ancient ground. Rather, it is a shadowy fantasy of Morrisonian rememories, spawned by the artist's experience growing up in Georgia surrounded by a dominant culture obsessed with a myth of the Old South, a Tara-mania of happy slaves and benevolent owners, who cavort across the gallery walls.

Thus, Kara Walker's life-size silhouette installation *The End of Uncle Tom and the Grand Allegorical Tableau of Eva in Heaven* signifies on the predictable myths of antebellum plantation life using a complex synthesis of racial imagery, nostalgic visual devices, and historical literature. Art critic Nico Isreal observed, "[Walker] records, in her distinctly incendiary way, the trauma attendant on 'surviving' the master-slave dialectic and the necessary failure to find a grammar or a voice — official, vernacular or intimate — adequate to that experience."[51] In the fantasy world that the artist has created, all characters, regardless of race or social position, are guilty of vile acts and intentions. Each viewer is prompted to face his or her own potentially traumatic relationship to history and acknowledge whatever repressed guilt and complicated feelings he or she might have about any personal relationship to slavery. Walker's gothic world reminds us "that fantasy, history and nostalgia, and the way they are worked on in the unconscious, have tangible, ongoing consequences."[52] As literature historian Mark Edmundson explains in *Nightmare on Main Street*, "Gothic is the art of haunting. Gothic shows time and again that life, even at its most ostensibly innocent, is possessed, that the present is in thrall to the past. All are guilty. All must, in time, pay up."[53]

Walker's tableau ensures that the act of viewing is the moment in which the viewer, regardless of racial self-identification, is allowed to

confront his or her guilt over the traumatic legacy, the disremembered and the unspeakable, the real and the imagined, of slavery. All who gaze on this signifying drama are implicated as active participants in an un-ending cyclorama, as they find separate yet shared histories of domination, suffering, and emancipation being turned upside down. The young mistress may wield an axe, but the slave child holds a spike. The master may rape his property, but his victim does not hang her head in shame; instead, she looks back over her shoulder to see if her attacker is pleased. In this bizarre and horrific tableau there are no innocent heroines, no loyal retainers, and no one escapes unpunished—not the black paper characters on the white walls, and certainly not the viewer. In *The End of Uncle Tom* the self and the other become one in a gothic rememory as the margins seek to consume the center.

THE LACTATION OF JOHN BROWN

I have asked to be spared having any mock, or hypocritical prayers made over me when I am publicly murdered; and that my only religious attendents [*sic*] be poor, little dirty, ragged, bareheaded and barefooted, Slave boys; and Girls, led by some old gray-headed slave mother.

—John Brown, letter to Mrs. George L. Stearns

In 1996 Kara Walker completed a large-scale gouache drawing of John Brown, the legendary leader of the 1859 raid at Harpers Ferry, Virginia (plate 7).[1] In the drawing, simply titled *John Brown,* three figures are engaged in a bizarre tryst, which can be quite challenging to read in reproduction. Awash in sepia paint, a slave child held in its mother's arms pulls viciously at Brown's nipple with its teeth, stretching it several inches. The bearded old man grimaces and turns his head away, yet does nothing further to resist the child's oral assault. Walker represents Brown in an "other" guise. By re-visioning a broad swath of imagery of Brown, by stripping him of the visual markers of his patriarchal power, the artist reveals the tensions "between white abolitionists and their relationships to black slaves," as well as the relationship of African Americans to their history.[2] *John Brown* eviscerates and re-

casts archetypal images of Brown as a soldier in the army of God descending the steps of the Charlestown, Virginia, jail destined for martyrdom. It subverts nineteenth- and twentieth-century visual constructions of the convicted and condemned Brown by recasting the virile, patriarchal white icon as an impotent, feminized figure. This transformation is accomplished through the emasculation of Brown's white male body, the liberation of his black female companion, and the forced osculation that is performed on him by the small child wedged between their two bodies.

This chapter seeks to explicate the complex manner in which Walker utilizes and transforms American racial iconography by subverting previous representations of Brown by nineteenth-century European American artists such as Louis Ransom, Thomas Satterwhite Noble, and Thomas Hovenden. It also examines Walker's critique of the myth of the heroic white savior/martyr that such images perpetuated and the subsequent African American dependence on that myth, as seen in the work of Jacob Lawrence, William H. Johnson, and other African American artists of the early twentieth century. In so doing she is engaging in a distinctly post-Negritude cultural practice which, as theorized by film historian Mark Reid, is characterized by its focused interpretation of the overlapping relationship of sexism, homophobia, classism, and ethnocentrism within the cultural world of African American conservatism, liberalism, and nationalism. "The 'postNegritude' project interprets essentialist and dualistic myths about whiteness and blackness, masculinity and femininity, heterosexuality and homosexuality, civilized and primitive as forms of a dying colonialism." Post-Negritude, states Reid, acts to subvert these elements through a womanist mode to affirm "that black cultural identity is constantly unfolding to reveal its relationship to secular humanity."[3] Through a Post-Negritude investigation of subject matter and artistic motivation, it will become clear that Walker's rather muddy gouache drawing of John Brown both resurrects and deconstructs a controversial figure who has always occupied a precarious position between the black and white worlds of American visual culture.

Walker's drawing deftly re-visions visual representations of John Brown that were created by European American artists in the years following his death, during the Civil War and Reconstruction periods. In the mid-nineteenth century the memory of John Brown occupied a unique position in the American mythos. During his lifetime his zealous and threatening actions in the name of abolition engendered hysteria and disbelief among many whites. He was known for his personal association with former slaves, having both helped them to escape and hosted them at his farm in North Elba, New York. In an 1871 issue of the *Atlantic Monthly* Brahmin author Richard Henry Dana wrote in amazement at having eaten dinner at Brown's table in the company of escaped slaves, whom Brown addressed as "Mr. and Mrs." After Brown's execution, seemingly benign representations of him placated concerns over the state of race relations in war-torn and Reconstruction America.

The time before John Brown's execution most often featured in these representations and the scene that Walker reenvisions in her drawing has its roots in both written and visual sources of that era. The originary textual source detailing Brown's demise is an account found in a report published in Horace Greeley's *New York Daily Tribune* three days after Brown's hanging for conspiring to incite insurrection and treason: "On leaving jail, John Brown had on his face an expression of calmness and serenity characteristic of the patriot who is about to die with a living consciousness that he is laying down his life for the good of his fellow creatures. . . . As he stepped out of the door a black woman, with her little child in her arms, stood near his way. The twain were of the despised race, for whose emancipation and elevation to the dignity of children of God, he was about to lay down his life. . . . He stopped for a moment in his course, stooped over, and with the tenderness of one whose love is as broad as the brotherhood of man, kissed [the child] affectionately."[4]

This image of Brown, bound and condemned to death, stopping and stooping to kiss a black baby, riveted pre–Civil War white abolitionists. It was repeated in numerous textual forms during the period. Just a few weeks after Brown's execution Quaker poet John Greenleaf Whittier

wrote a memorializing poem titled "Brown of Ossawatamie." An ardent abolitionist, Whittier sought to reconcile the man with the deed and used the newly created myth to aid his goals. The second verse reads:

> John Brown of Ossawatamie, they led him out to die;
> And lo! a poor slave-mother with her little child pressed nigh.
> Then the bold, blue eye grew tender, and the old harsh face grew mild
> As he stooped between the jeering ranks and kissed the negro's child![5]

The image of benevolent white paternalism toward (literally) child-like blacks that the *Tribune* account and the Whittier poem created held broad interest for an abolitionist European American culture that largely believed that African Americans were and should remain a socially subordinate people.

Poems and popular accounts of Brown's death, coupled with African American and European American abolitionist reactions, characterized by the praise of Frederick Douglass and the "Plea" of Henry David Thoreau catalyzed American interest in his sacrifice.[6] Thoreau, like Whittier, figured Brown as a patriotic Christian martyr, a dedicated and divinely inspired abolitionist who turned word into action, an example to all who would stand by indifferent to the plight of the enslaved Africans. Such words of religious and moral exaltation began the cultural construction of his martyrdom, of what cultural critic Van Wyck Brooks would have termed a "usable past."[7]

The beatification of Brown by blacks began on the actual day of his death, December 2, 1859, when many free African American and European American communities in the North celebrated "Martyr Day."[8] It continued in 1881, when Frederick Douglass helped to establish a John Brown professorship at the recently founded Storer College in Harpers Ferry.[9] Two years later, George Washington Williams, arguably the first major African American historian, devoted an entire chapter to Brown in his two-volume *History of the Negro Race in America from 1619 to 1880*.[10]

The exaltation of Brown by prominent African Americans in the public sphere continued into the twentieth century, when the October 1906 issue of *The Voice of the Negro* (Atlanta) published a speech given at the

John Brown Day observance at Harpers Ferry. According to historian Benjamin Quarles, this oration by Reverdy C. Ransom of the Charles Street African Methodist Episcopal Church in Boston was "the highlight of the second annual convention of the Niagara Movement, a black civil rights organization."[11] Three years later, in 1909, W. E. B. Du Bois, the sociologist and one of the founders of both the NAACP and the Niagara Movement, published a biography that delineated the abolitionist as an unequivocally heroic figure. In the introduction to the work, Du Bois declares his project to be "a record of and a tribute to the man who of all Americans has perhaps come nearest to touching the real souls of black folk."[12] On December 2 of that year, marking the fiftieth anniversary of Brown's death, African Americans in Boston held a "John Brown Jubilee" at Fanueil Hall for an overflow audience.[13] Between 1920 and 1950 several poems extolling Brown were printed in the African American popular press. These included Georgia Douglas Johnson's "To John Brown," published in the August 1922 issue of *The Crisis*, and Countee Cullen's "A Negro Mother's Lullaby," published in the January 1942 issue of *Opportunity*.[14]

As bright as Brown's star shone in the late nineteenth and early twentieth centuries, in recent years it has faded from the popular consciousness. Today, "the old man," as the historian Truman Nelson called him in his 1973 biography,[15] is no longer at the center of the African American collective mythos. This descent has largely occurred since the post-WWII civil rights movement found new, African American martyrs and saints in the fallen figures of Martin Luther King Jr., Malcolm X, and others. For Walker's generation, the latter-day saints of "Malcolm and Martin" have come to dominate among the contemporary icons of nationalist African American history.

Returning to Walker's drawing of John Brown, we see the visualization of this cultural amnesia. As though dismayed by the unforgiving march of history, the "old man" of the artist's imaginings stands with his arms behind his back, his left leg extended and his head turned away from the other two figures. His eyes are squeezed shut and his lips, framed within a bushy beard and mustache, are pursed tightly. He is naked from

the waist up, exposing his breasts, while his belly and legs are wrapped in a swath of fabric so tight that his sex is nearly revealed to the viewer. The woman opposite him holds the naked child in her arms with its body pressed tightly to her own bosom. She wears a wrap on her head and a long dress with a tight-fitting bodice tied by a sash at her waist. Both she and the child are shown in profile, with their heads turned toward Brown. She gazes with unseeing eyes down at the child, who has Brown's nipple clamped solidly between its large, pale lips.

Walker's gouache drawing is composed in a vertical, rectangular format. Its frenzied brushstrokes bear witness to the impassioned speed with which it was created. In contrast to her silhouettes, the gouache drawings that she produces are about working through ideas in a very fluid and timely manner. This practice began when the artist was in graduate school at the Rhode Island School of Design. "I started drawing as my main activity and stopped painting," explains Walker. "It simply took too much time and I had too much to learn."[16] With drawing, the ephemeral can be made instantly visual: the expressive lines and forms are made to appear instantly, without the inherent delay of the silhouette practice.

The figures in Walker's image are realized by loose strokes of brown gouache that at times are quite muddy and carelessly applied. They puddle and pool, a few drips run down the right side near Brown's arm, and in some spots, particularly around his shoulder, the child's head, and the woman's arm, the paint is overworked and hard to read. In other areas, such as Brown's forehead, his beard, and his sagging breasts, it is extremely thin, nearly absent. The limits of the woman's skirt begin to disappear into the atmosphere between the three figures, yet the thin line of paint along Brown's leg clearly separates the two from each other.

In Walker's image, Brown has become a hollow icon, empty of meaningful nourishment for the descendents of the black folk who have kept the memory of his martyrdom alive. It presents the viewer with an odd family comprising two parents with a demanding child jammed between them. The "great white father" is nursing the child as its dark-skinned mother casts a sightless gaze on their misery. Her subversion lies in the

child's attempt to draw sustenance not from its black mother, but instead from the power of martyred masculine whiteness that Brown's body represents in American visual culture. The tortured expression on Brown's face and the horribly stretched skin of his breast implies that the slave child is sucking at the teat of a white patriarchy that is painfully dry.

While also pointedly critiquing twentieth-century fantasies of John Brown, at its core Walker's drawing is a scathing critique of the visual representations of his last moments that were created by European American artists in the years immediately following his death. The drawing takes as its sources several images related to Brown, images that communicate within the larger visual rhetoric of slavery, emancipation, and the Civil War. The artist found much of this material in Harold Holzer and Mark Neely's 1993 book, *Mine Eyes Have Seen the Glory: The Civil War in Art.* The first of these images to visualize the popular accounts of Brown's trip to the scaffold, and to serve as a direct source for Walker's rendition, is Louis Ransom's 1860 painting *John Brown on His Way to Execution.* This composition by a relatively obscure white male American artist drew on the mythology of the event without actually showing the moment of interracial contact that made it so significant. Now lost, Ransom's original painting was popularized by lithographers Currier and Ives, who issued two print adaptations of it during the decade that followed its creation.[17] The first of these hand-colored lithographs was issued in 1863, in the middle of the Civil War (figure 12) and the second in 1870, in the middle of Reconstruction (figure 13).

The first print made after Ransom's painting in 1863 was inscribed "John Brown / Meeting the slave mother and her child on the steps of Charleston jail on his way to execution / Regarding them with a look of compassion Captain Brown stopped, stooped, and kissed the child." The verse drew directly on the *New York Daily Tribune*'s story of Brown's final moments, but it did not show the kiss itself. Rather, Brown is shown exiting the jailhouse and gazing down on the slave mother nursing her child at the bottom of the stairs.[18] The temporal location in this image, set at the moment just before the kiss is to occur, allows Brown to remain pure from the carnality of his earthly existence. Here, the publishing firm of

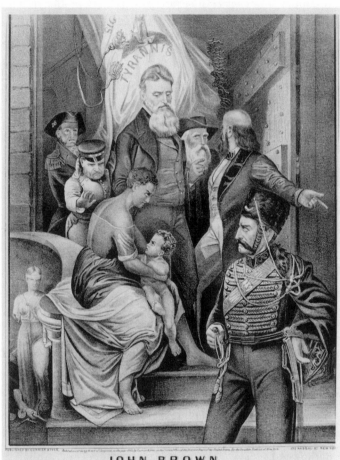

JOHN BROWN

Meeting the Slave mother and her Child on the steps of Charlestown jail on his way to execution.

The Artist has represented Cap! Brown regarding with a look of compassion, a Slave-mother and Child who obstructed the passage on his way to the Scaffold.... Cap! Brown stooped and kissed the Child.... then met his Fate.

FIGURE 12. After Louis Ransom, *John Brown / Meeting the slave mother and her child on the steps of Charleston jail on his way to execution / Regarding them with a look of compassion Captain Brown stopped, stooped, and kissed the child,* 1863. Lithograph. Currier and Ives.

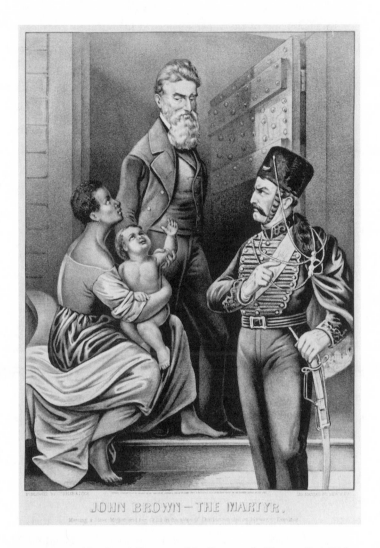

JOHN BROWN – THE MARTYR.

FIGURE 13. After Louis Ransom, *John Brown—the Martyr*, 1870. Lithograph. Currier and Ives.

Currier and Ives, one of the most successful lithography companies of the nineteenth century, demonstrates white America's reluctance to envision a moment that might imply interracial familial intimacy.

The second lithographic version of the Ransom painting, released in 1870, was titled *John Brown—the Martyr*. In this version we see a formal distillation of the myth of which Walker's work is a studied revision. A variation on the theme presented by the first image, it shows Brown standing alone, framed by the empty doorway of the jail and surveying the supplicants beneath him.[19] Like two pilgrims at his feet, the slave mother and child turn and lift their heads to meet his lingering look. Here the mother is raising the child's arm in an effort to touch Brown's passing body. In this pose the child may be read as a Doubting Thomas querying the validity of Christ's wounds, or as John the Baptist recognizing the savior, or even as Christ himself seated in the lap of the Virgin and offering a blessing to the martyr.

The second Ransom-based Currier and Ives image omitted the explanatory text of the first, as well as the majority of the allegorical characters. It did retain the figures of Brown, the slave mother and child, and a single soldier in the original setting of the jailhouse steps. These omissions were no doubt because the event had entered the popular consciousness to such an extent that it no longer needed such a complex and didactic explanation; Brown had taken his place as a martyr in the postbellum collective consciousness. But above all, the *retention* of the adoring African American figures in the second lithograph demonstrates the Reconstruction period's near deification of white antislavery advocates like the executed Brown and the assassinated President Abraham Lincoln. Over the intervening years Brown had become a soldier in the cause of emancipation and the reformative preservation of the Union, one who had fallen in the days preceding the great conflict. Like that given to Lincoln, the secular sainthood granted Brown was both to provide a paternalistic, white hero for a newly freed African American population and to validate the sacrifices made by a war-weary European American society.[20]

The slave mother's offering of her child's wrist in the 1870 Ransom

print may be linked to other interracial imagery of the period that the artist was probably not familiar with. Art historian Kirk Savage notes the significance of this gesture as found in an 1866 sculpture group by Randolph Rogers that features a similar action on the part of another white patriarch (figure 14). *Lincoln and the Emancipated Slave* presents the slain president "gazing down upon a crouching, semi-nude woman whom he is lifting by the wrist with his left hand. . . . The physical touch between the figures," explains Savage, "suits more the interaction of parent and child. Lincoln's clutch in effect replaces the manacle still visible on the woman's left wrist, the hold of the slave owner exchanged for the hold of the emancipator."[21] Savage also asserts that this gesture of grasping the wrist, rather than holding the hand, removes the possibility of sexual connotations that could be made from the physical contact between the dead president and an African American slave woman. In Walker's drawing, the grotesque solicitation found in this gesture has been overturned by the shift from Brown's clasping of the child's wrist to the child's ruminating on Brown's nipple. Just as Rogers's plaster imagining of Lincoln holds another slave woman's wrist tightly, as though to lift her up forcibly from slavery, Walker's frenzied gouache drawing of an impetuous child will not relinquish control over the old man's body.

Through its removal of the additional soldiers and onlookers of the 1870 lithograph, *John Brown—the Martyr* emphasizes the importance of the remaining characters by shifting the burden of meaning onto them alone, rather than distributing it through a complex of peripheral allegories. Walker's drawing furthers this process of distillation with the elimination of the soldier. It becomes significant, then, that in this print, as in the Walker drawing, the mother is *not* nursing her child. Rather than engage each other, the pair looks toward Brown. The significance of their gaze may be seen in a comparison with Thomas Ball's *Emancipation Group* (figure 15). Ball's monumental sculpture is a typical example of the effort to create public images that would maintain white superiority and the authority of the emancipatory act under the guise of Christian benevolence toward dispossessed blacks.[22] President Lincoln's downward gaze upon the crouching slave man at his feet is echoed in the pitched

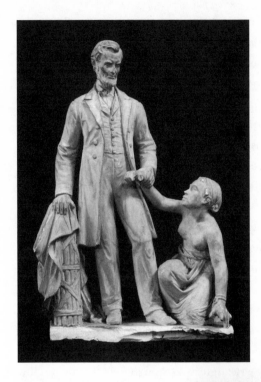

FIGURE 14. Randolph
Rogers, *Lincoln and the
Emancipated Slave*, ca. 1866.
Plaster, 54 × 38.1 × 21 cm.
University of Michigan Art
Museum.

FIGURE 15. Thomas Ball,
Emancipation Group, ca. 1874.
Maquette, no dimensions
given. Courtesy Library
of Congress.

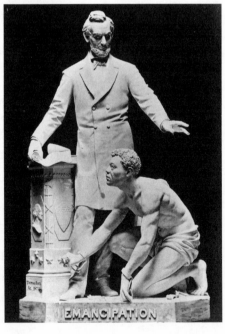

angle of Brown's head as he regards the slave woman and child on the jailhouse steps before him.

By favoring a direct rather than adoring gaze, Walker's drawing also rejects the crouching position of the slave woman in the Ransom images, and of the male slave of the *Emancipation Group*, in favor of a standing position. This compositional choice is related to the one found in Thomas Hovenden's 1884 painting *The Last Moments of John Brown* (figure 16). In the composition, Brown descends the jailhouse stairs with his arms bound at the elbow behind his back, yet with just enough slack to allow him to steady his body on the railing, where a slave woman is presenting him with a small child. Although the way before Brown is flanked with armed soldiers, almost unbelievably the enslaved pair has managed to push their way through and up against Brown's body so that he can kiss the child's forehead. While one soldier at the left of the composition is busy repelling onlookers, his peers are all enraptured by the scene of the patriarch's pale face pressing against the child's brown head. Held in its mother's arms at the bottom of the steps, the child strains to embrace Brown's neck as if saying a final goodbye to its father. It is notable that Hovenden's 1884 painting, unlike the 1863 and 1870 Ransom-based prints, actually depicts the child receiving the kiss popularized by the newspaper accounts of Brown's last moments.[23]

Walker's image alters the child's physical extension up the jailhouse steps toward Brown in Hovenden's painting by placing Brown, the mother, and the child on the same plane. Brown no longer stands above them, and the child no longer reaches out to him; instead, the now naked toddler is being pulled away from him. She also reverses the familiar intimacy and the symbolic paternalism of the blessing kiss that is bestowed by placing the child's hungry mouth on Brown's body. She further subverts the physical interaction between the three main characters by turning Brown's head away from the slave mother and child.

In addition to the Ransom and Hovenden compositions, another key painting in the nineteenth-century tradition that is being subverted by Walker's image is *John Brown's Blessing* (1867, New-York Historical Society) by Thomas Satterwhite Noble (figure 17). In Noble's image of

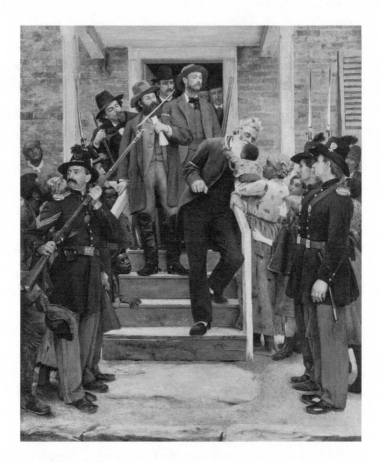

FIGURE 16. Thomas Hovenden, *The Last Moments of John Brown*, 1884. Oil on canvas, 46 1/8 × 38 3/8 in. Fine Arts Museums of San Francisco.

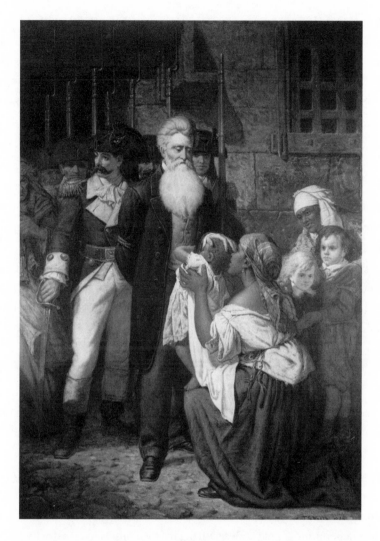

FIGURE 17. Thomas Satterwhite Noble, *John Brown's Blessing*, 1867. Oil on canvas, 84 1/4 × 60 3/8 in. Collection of The New-York Historical Society.

Brown's last moments, the slave mother's unusually fashionable blouse falls away from her rounded shoulder, sexualizing her submissive body as she kneels before the bearded old man. Her left hand presents her plump child to the patriarch, who in turn extends his own left hand in a sign of blessing. With this clasping of hands over the body of the child, who is dressed in a white christening gown and whose skin tone rests between that of the two adults, Brown may be symbolically read as the baby's father and the mother's lover. Thus, Noble's painting may be read as a trope of nineteenth-century sexual sublimation, in which Brown becomes a surrogate figure embodying the socially unacceptable lust that many nineteenth-century white males, artists and viewers alike, had actively to repress.

This image of Brown explicates the taboo of interracial sexuality; it shows his transgressive whiteness, his role as a "nigger lover" and a "race traitor," characterizations that made him one of the only nineteenth-century white men who could be envisioned in such an affectionate pose with a black female. Brown had a dubious closeness to the people that he would free. It is the visualization of this closeness that Walker achieves, the fleshing-out of this kinship, if you will, that helps us to understand better why white artists like Noble found the "blessing" to be both a difficult and a desirable moment to portray.

At first, it is mystifying why so many white male American artists like Ransom, Hovenden, and Noble, who was not only a Kentuckian from a slave-owning family but a man who served in the Confederate army, found the "blessing" to be a desirable vehicle through which to transgress hegemonic sexual codes. During his own time, Noble's work was explained as the response of a guilt-ridden southerner attempting to atone for his involvement in slavery and the Civil War. Scholars today often view this work as part of a larger discourse, a discourse that held Brown up as a hero who, much like the lesser-known slain white journalist Elijah Lovejoy, sacrificed his life to save the lives of blacks. In the art historian Albert Boime's 1990 book *The Art of Exclusion: Representing Blacks in the Nineteenth Century*, for example, the painting is discussed as part of a genre that visualized a republican and abolitionist rhetoric around

the martyred body of Brown.[24] Therefore, the blessing scene may have also been a visual opportunity for white males like Noble, Ransom, and Hovenden to reassure themselves that the racial hierarchies they had grown up with would endure. If the war forced the slave-owning Noble to lose his right to control black bodies sexually, to dominate black female bodies on his Kentucky plantation, then the scene of *John Brown's Blessing* allowed him to reinhabit this role on the canvas.

And yet, Walker does not allow this nineteenth-century act of reassuring artistic inhabitation to stand in the late twentieth century. Her drawing revokes the sexual power of the white male body by transforming significant paternalistic devices, including the benevolent gaze found in the 1863 Ransom lithograph and the blessing kiss of the 1884 Hovenden painting. One of the most important gestures that her image critiques is that of the child's arm, which is upraised by its mother's hand in an effort to touch Brown's passing body, found in the 1870 print version of the Ransom painting.

In its subversion of expectation, the forced suckling of Brown's breast by the slave child highlights the sexual connotations that could be made from the physical contact between powerful white men and an African American slave woman. In the Rogers sculpture of *Lincoln and the Slave* and the Noble painting of Brown, slave women kneel suggestively before their white saviors, demonstrating their physical submission to them. The disheveled state of their dress, the white blouse that opens suggestively at the neck of Noble's slave woman to reveal the smooth, dark skin of her shoulder, is only a few inches from the near nudity of the slave woman in the Rogers sculpture. In both images, Lincoln and Brown are figured as dignified, bearded patriarchs, who preserve their white male identity by maintaining control over black female sexuality, a kind of control that Walker's drawing eradicates.

Thus, we may read these images of Brown's last moments and Lincoln's benevolence in which black women kneel before white men as scenes about sexualized power relations, scenes that figure the dominant white male character as an Old Testament patriarch with the slave woman placed before him in pious prostration. Metonymically, we may

read her as Ruth to his Boaz, or even Hagar to his Abraham. The latter association is indeed tempting because some artists and writers during this period who were concerned with slavery found that the story of Hagar was an appealing way to allegorize the plight of the African American woman. Edmonia Lewis, the Native American and African American artist, for example, chose the subject of Hagar for an 1875 sculpture (figure 18). Hagar was the Egyptian slave of Sarah, who, because her mistress was barren, was made to lay with her master Abraham in order that he might have an heir.[25] Several years later, because of Sarah's jealousy, Abraham cast out Hagar and their child, Ishmael. The distraught Hagar wandered in the desert until an angel saved her by promising that Ishmael would be the father of a great race of people. In the images that Walker critiques, Brown can be read as the rejecting patriarch Abraham; he can also be seen in the role of the angel who assuages Hagar's fears over the probable death of her child in the desert.

In her attempts to re-vision mythic representations of John Brown, Walker consciously subverts the messianic patriarch by radically reducing the amount of clothing on his body to effect a significant gender transformation in which the white male martyr can be read as a masochistic black mammy. This change is effected by first replacing Brown's clothes with the swirling cloth drape that we see about the knees of the slave mother in the Ransom lithographs. Walker is able to effect a striking transformation by transferring the drape from the slave woman's body onto Brown, essentially freeing her from slavery while imprisoning him within his martyrdom. Rather than heroicizing the figure as a symbol of ancient wisdom and democratic ideals, as Jacques Louis David's use of a drape did for the figure of the condemned philosopher in *The Death of Socrates* (figure 19) or Peter Paul Rubens did in *The Death of Seneca* (1615, Museo del Prado, Madrid, Spain), Walker's usage reveals the flaccid, naked body of a vulnerable old man. Unlike David's Socrates, who, with his finger held high in the air, seeks to make one last point before he drinks his cup of death, Brown's body seems to sag beneath the weight of its heavy mantle. In her use of the drape, Walker exposes the façade of power that is so often invested in the fully clothed, white, male body.

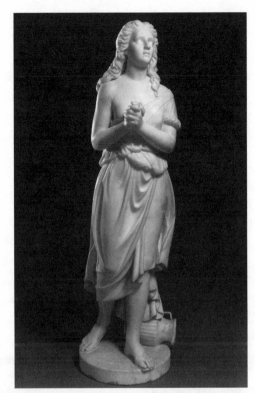

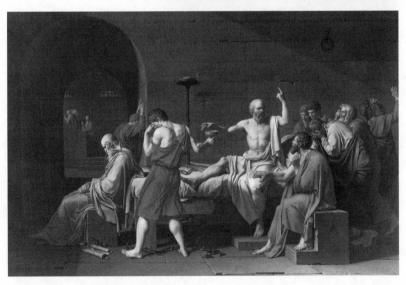

FIGURE 19. Jacques Louis David, *The Death of Socrates*, 1787. Oil on canvas, 51 ×
77 $^{1}/_{4}$ in. Metropolitan Museum of Art.

But beyond the anti–Greco-democratic allusions that the drape makes, Walker's use of it as a pictorial device questions the American tradition of canonizing Brown; it interrogates his cultural status as a secular martyr. We must not forget that during his last moments, Brown was not a free man: he was condemned to death, on his way to the gallows. Yet his bonds were consistently denied in popular imagery. Interestingly, neither of the Currier and Ives prints actually shows Brown's shackles; rather, they imply them through the placement of his arms behind his back, whereas the Hovenden painting locates the binding rope around his elbows so that his hands remain free to grasp the stair railing for balance as he kisses the child.

The transcendence of terrestrial shackles that Brown's loose and absent restraints represent in these nineteenth-century images corresponds to a traditional Christian martyrdom aesthetic. Walker echoes the use of drapery in Western art to both sexualize and signify the body of saints as they met their death by using the slave mother's cloak to similarly bind Brown's body. Sebastiano del Piombo's 1520 painting *Martyrdom of St. Agatha* pictures a youthful saint in a highly sensual yet resoundingly sadistic manner, with her arms tied behind her back and her sex covered by a nearly transparent loincloth (figure 20). Like the fabric that clings to Brown's naked body, St. Agatha's drape echoes what it would conceal. Here, the wearer's gender appears to be reversed, as the knot in St. Agatha's drape takes on a decidedly phallic form. Thus, Sebastiano's sexually ambiguous image offers us an antecedent for the presentation of scantily clad saints at their martyrdom that Walker's composition emulates.

Like Walker's drawing of Brown, Sebastiano's painting presents the main character in a pose of sexual masochism during the most miserable moments of her martyrdom. "Not only is the particular form of torture to which the saint is being subjected an overtly sexual one," notes Edward Lucie-Smith, "but she herself seems to welcome it with far from holy ecstasy."[26] A parallel may be drawn between the image of the Sicilian virgin being tortured by the pincers of her Roman persecutors and the slave child's own ravenous grip on Brown's nipple. In these scenes, the Roman

senator Quintanius, shown relaxing at the far left of the Sebastiano, and the blank-eyed slave woman of the Walker image, oblivious or indifferent to the pain that the child she holds is inflicting, both seem blind to the significance of their inaction. Walker's image emphasizes the masochism inherent in the traditional martyr image, and like her artistic predecessor Sebastiano, she too seems to side with the executioner. The patriarch is the helpless one, as his bound and tortured body is pulled in a direction that he cannot resist. The slave child's sadistic suckling at his naked breasts negates his masterful gaze and fully feminizes him by placing him in a new, submissive role.

The feminization of Brown's body is emphasized by the placement of the fabric drape that swirls about him, bisecting his groin and creating a vaginal space between his legs, similar to the one seen in Antonio Canova's 1812 sculpture *Venus Italica* (figure 21). His belly bulges beneath the folds of fabric in a round, impregnated swell. His is a body busy with both lactation and gestation. By revealing Brown as emasculated and sexually vulnerable, Walker denies him his masculine power: like Venus, he cannot face his attackers, but can only turn away and scowl.

If comparisons with the *Saint Agatha* and the *Venus Italica* reveal Walker's use of the drape to be sexualizing, canonizing, and feminizing, then the incongruous nature of Brown's lactation in Walker's drawing may be addressed when the image is compared to Rembrandt Peale's *Roman Daughter* (figure 22). Viewing this painting, we are reminded that it is not so much that images of mature men nursing are unfamiliar in art history; it is just that it is almost exclusively imaged in reverse. Peale's painting, like Matthäus Stromer's *Roman Charity* (Prado, Madrid, Spain) and Peter Paul Rubens's *Roman Charity* (1612, The Hermitage, St. Petersburg, Russia), depicts the story of the faithful daughter who saved her imprisoned father's life by feeding him her own breast milk. Stromer's painting is constructed as an encounter between daughter/mother and father/child. As the daughter strokes her father's balding pate and offers up her breast to his mouth, she exudes a sexualized yet maternal affect that is in conflict with what would seem to be the proper expression for this life-saving activity. This impropriety is emphasized by the

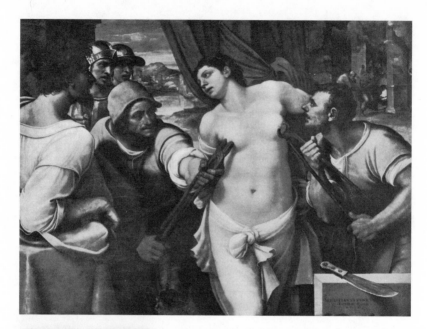

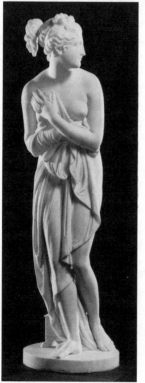

FIGURE 20. Sebastiano del Piombo, *Martyrdom of St. Agatha*, 1520. Oil on panel, 50 × 78¹⁄₈. Galleria Pitti, Florence, Italy. Su concessione del Ministero dei Beni e le Attività Culturali.

FIGURE 21. Workshop of Antonio Canova, *Venus Italica*, ca. 1815–22. Marble, h. 67³⁄₄ in. (172.1 cm.). North Carolina Museum of Art, Raleigh. Purchased with funds from the North Carolina Art Society (Robert F. Phifer Bequest). Su concessione del Ministero dei Beni e le Attività Culturali.

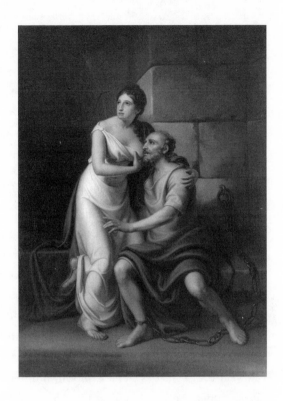

father's crouching position and near naked body, save for the drape that covers his groin; it is a position that figures him as both her undressed lover and a childlike creature, dependent on the giver of milk for his survival. The rope that binds his wrists highlights his vulnerability as well as hinting at the deviant sexuality implied by the tryst between father and daughter that is depicted. Walker's image counters the idea of the daughter/mother supplying the life-giving milk with the nursing function being transposed onto the father/child. In Walker's drawing we see a mature white male body, swaddled like a baby, being milked by a hungry black child, and in this case, it would seem that the fount of "Roman Charity" has run dry.

FIGURE 22. Rembrandt Peale, *The Roman Daughter*, 1811. Oil on canvas, 84 3/4 × 62 7/8 in. © Smithsonian American Art Museum, Washington, D.C./Art Resource, New York.

And yet, in Walker's drawing the specific placement of the fabric drape goes beyond the simple feminization of Brown's body: it transforms him into a slave woman. Walker effects this metamorphosis by making an important allusion to specific visual constructions of female African Americans in the nineteenth century as subhuman sexual commodities. Walker's image directly references J. T. Zealy's daguerreotype *Delia* (figure 9), discussed in detail in the previous chapter, in which the slave woman's breasts are visually exploited to signal her use value in the oppressive system that contained her. Delia's worth under slavery lies not only in her ability to work on the plantation of her owner, or in her potential to "breed" more slaves through her reproductive organs, but also—and most important for Walker—in her capacity to nurse the white babies of her enslavers. This same reproductive availability is alluded to in the Noble painting, where the black woman's blouse slips suggestively from her shoulders. Here, in contrast to the dehumanizing pose of Delia, the slave woman has been eroticized and orientalized. Her head wrap is less like the rags of slavery than like the exotic fabrics of North Africa or the Near East.[27] Just as Delia is shown with her dress pulled down from her shoulders and gathered at her waist, so, too, is Walker's figure of Brown partially (un)wrapped in the guise of the slave woman. The irony of Delia's nourishing her future oppressors on the fluids of her own body is shifted onto the body of Brown when his breasts are exposed in the same manner, and in so doing, he assumes her functional identity.

Not only does Walker refigure Brown as a black mammy, with his breasts exposed for the viewer, but she also recasts him as a slave mother who must endure separation from his child. Walker's repeated and increasingly complex use of the multiple tropes of the slave woman and child may be linked to her interest in its construction in Harriet Beecher Stowe's *Uncle Tom's Cabin*, discussed in chapter 1. Although it is no longer widely read, the novel was vastly popular at the time of Brown's execution, and it is one of the chief inspirations for Walker's work overall. "I was . . . trying to discover parts of me in texts like *Uncle Tom's Cabin* and *Gone With the Wind* and lesser romances," Walker recalls about her early forays into the area. "[I was] finding a kind of crude empathy with every

character."[28] By reconstructing Brown as the nursing slave mother faced with the potential loss of her child, Walker makes a direct allusion to one of the most celebrated characters of the novel: the quadroon slave girl Eliza. In the opening chapters of the book, Eliza learns that her son is to be sold away from her by their owner, along with Uncle Tom, to settle a debt. To retain her child, she makes a daring escape with him from the slave state of Kentucky across the thawing Ohio River to freedom. Throughout her journey she receives assistance from sympathetic white men who are consistently figured as her saviors.

Eliza's journey, and its linkages with Walker's recreation of Brown, may be seen in the cult of religious abolitionism that both Stowe's novel and Brown's legend inspired.[29] Stowe captivated the northern reading public with her marriage of sentimental literature and the pleading conventions of the abolitionist-sanctioned slave narrative. By strategically inserting direct addresses to her women readers at climactic points in the narrative, Stowe urged them to act as the moral conscience within their homes to sway their enfranchised husbands to the cause of abolition.[30] Stowe's writing style, as well as her choice of female victims and heroines in the novel, proved to be an effective strategy for the mobilization of antislavery sentiments in northern, middle-class, European American households. However, it also helped create the trope of the slave mother and child as divided from black patriarchy and hopeless without white help, the type of help that could be rendered only by a powerful white man like Brown.

At the core of Walker's painting is this gap between good intention and gross intervention that is found in the trope of African American helplessness exemplified by Stowe's slave mother Eliza. In an illustration by Hammat Billings from the original 1852 publication of *Uncle Tom's Cabin*, Eliza tells "Uncle Tom that he is sold and that she is running away to save her child" (figure 23). The image itself seems to obfuscate Stowe's physical description of her characters; in it, Eliza is pictured as much darker than the text describes her and her four-year-old son seems small enough to be a toddler. Regardless, the manner in which he clings to his mother presents a stark contrast to the distracted way that the slave

woman of Walker's image grasps the corpulent, suckling child in her arms.

Whereas Brown the mammy is tethered by the drape, the skirt of Walker's slave woman (like that of Eliza) bells out at the back, echoing the forward motion of the fabric that defines Brown's feminine, almost pregnant belly, and indicating her own potential mobility.[31] Liberated from the bottom of the steps, Walker's slave woman rises to Brown's full height so that she stands directly in front of him, in a location similar to the one found in the Hovenden painting. Her awkward handling of the child—it seems to be slipping from her hold as it turns back to chomp on Brown's nipple—raises the question of her maternal instinct. Compared to Eliza, who snuggles her precious bundle close to her breast, it is clear that the role of the slave mother has been thrust upon the figure of Brown, and it is he who now endures separation from his child. Thus, the ambivalence found in Brown's grimace may be read not only as the

FIGURE 23. Hammatt Billings, *Eliza comes to tell Uncle Tom that he is sold, and that she is running away to save her child*, 1852. Reproduced in Harriet Beecher Stowe, *Uncle Tom's Cabin* (New York: Norton, 1994).

pain of having his nipple stretched, but also the mortal terror of having his child wrested from his maternal bosom.

In the Ransom and Hovenden images, Brown's *impending* pain, his death on the gallows, is highlighted over the actual suffering of the slave woman and child, whereas in Walker's image, the slave woman's suffering, exemplified by Delia and Eliza, has been transferred onto the body of Brown. In both Currier and Ives lithographs the slave mother is shown as well-dressed and *free* to sit on the stairs that Brown must descend to go to his imminent death. In the first print she is shown nursing her child, and in the second print she freely relinquishes him into the hand of the would-be messiah. In the Hovenden painting Brown's arms are bound with rope while the slave mother is *free* to lift her child up to him to receive its blessing kiss. In Walker's image, the spectator has been made over into the spectacle, and the savior must now endure the potential separation from his progeny.

The trope of the African American slave woman and child at the mercy of white patriarchy, for which the biblical story of Hagar is an analogue, has been reversed. In Walker's image the pain of slavery, symbolized by the reality of Delia's exposed breasts and the fictive anxiety of Eliza's losing a child, has been grafted onto the body of the white martyr, effectively making the powerful white male Brown into a helpless black slave woman.

By connecting the child to the old man's flabby teat, Walker highlights the moral vacuity of Brown's status as a martyr for African American culture. In so doing she implies that, although black milk was once used to sustain untold numbers of white children, there is not enough white milk in Brown's martyred body to nourish a single black baby; his empty breasts come to signify a much broader vestigial status in American culture. Brown is revealed in Walker's work to be a faded icon, one that persists beneath decayed layers of allegory and myth.

In addition to critiquing the racialized martyrdom aesthetic developed in nineteenth-century images of John Brown's last moments, Walker's painting also interrogates the subsequent African American depen-

dence on that myth. Her image indicts the symbolic use of Brown as an Afro-Christian representation of a white savior for the black masses by early twentieth-century African American writers and artists. As with other antiquated symbols associated with popular perceptions of the African experience in the United States, the figure of John Brown fits well within Walker's broader artistic project. Like much of the nineteenth-century abolitionist history and culture that her work draws on, including once prominent literature like *Uncle Tom's Cabin*, the figure of Brown and his accompanying "legend" have fallen into relative obscurity, while still remaining familiar to audiences in the abstract. In the same way that other symbols of interracial strife in the United States have transcended their origins, Brown is now important for what remains of him in the popular imagination, rather than for what he once was in day-to-day reality.[32] By choosing Brown as her subject matter, and by questioning his relevance for contemporary African Americans, Walker continues to challenge and resist specific conceptions of what constitutes proper artistic production on the part of a young, black woman.

As noted, since the beginning of the Civil War, Brown was foremost among the European American patron saints of the Afro-Christian cult of salvation at the core of the African American cultural construct that Walker's artistic production takes as its focus.[33] In his discussion of Horace Pippin's paintings of John Brown, Richard J. Powell argues that anticipation of 1940 as the seventy-fifth anniversary of the Thirteenth Amendment to the Constitution, which abolished slavery in the United States, led to a general increase of interest in Brown's role in African American history and drew black artists to the subject.[34]

The African American painter Jacob Lawrence later recalled his introduction to Brown's role in black history as having been during his teenage years in a Negro History Club at the Harlem YMCA. It was there that he "first heard the stories of Frederick Douglass, Harriet Tubman, Toussaint L'Ouverture, Nat Turner, Denmark Vesey, and John Brown along with many others . . . and their stories were told in a very dramatic way."[35] Inspired by these animated presentations, Lawrence went on as an adult to create several multipanel series to illustrate these stories.

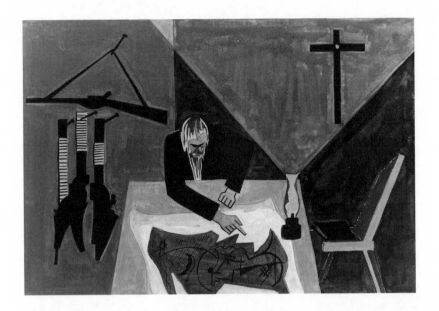

These broadly conceived works from the 1930s and 1940s were intended
to be didactic in nature, designed by Lawrence as teaching devices for
the communication of African American history as well as an expression
of his own artistic vision. In 1941 Lawrence completed the twenty-two-
panel series of the life of John Brown that constructs the abolitionist as
an Afro-Christian martyr on a holy crusade to abolish the mortal sin of
slavery and to free the African Americans in its grasp (figure 24).[36] Some
of the images are violent, depicting the massacre in Kansas that Brown
was rumored to have ordered and his final stand at Harpers Ferry. They
are also overtly religious.

Lawrence's series begins with an image of Christ on the cross and the
descriptive caption, "John Brown, a man who had a fanatical belief that

FIGURE 24: Jacob Lawrence, *The Life of John Brown, No. 13. John Brown after a long
meditation planned to fortify himself somewhere in the mountains of Virginia or Tennes-
see and there make raids on the surrounding plantations, freeing slaves*, 1941. Gouache
on paper, 13 5/8 × 19 7/8 in. The Detroit Institute of Arts, gift of Mr. and Mrs.
Milton Lowenthal. Artwork © 2003 Gwendolyn Knight Lawrence, courtesy of
the Jacob and Gwendolyn Lawrence Foundation.

he was chosen by God to overthrow black slavery in America."[37] A panel of Brown and his family surrounded by crosses and praying at the dinner table follows it. Three more of the panels include crosses in a prominent way, and still others integrate them into the image more covertly, for example, in the form of crossed tree branches. The repetition of the crucifixion theme in the series serves to highlight Brown's religious commitment, to shape him as a martyr for his cause, and to liken him to Christ himself. And yet, Lawrence conceived the entire twenty-two-piece cycle without including a single image of Brown's last moments on the jailhouse steps, an episode that not only depicts Brown's martyrdom, but has often been referred to as the "blessing" scene.

The series connected Brown to the dominant Afro-Christian society that was the audience for Lawrence's work in the 1930s and 1940s, long before he became celebrated in the mainstream art world as he is today.[38] Lawrence's pious construction of Brown's importance to African American visual culture is subsequently subverted in Walker's drawing, where Brown is shown grimacing from pain as the child sucks at his teat. Walker's Old Testament patriarch is empty of the nourishing dogma that his flock would require, a departure from the self-sacrificing Christian nature and moral symbolism that Lawrence sought to emphasize in his series.

The two artists' disparate paint-handling techniques also display their different conceptions of the importance of Brown as a historical figure. While both Walker and Lawrence use gouache watercolors in their work, they do so in very different ways. Lawrence paints with an opaque palette of bold colors. His paint texture is opaque and his lines are angular. Walker prefers an uneven wash of monochromatic brown to form her figures. They float on the surface of the paper, threatening to disappear before the viewer's eyes. While Lawrence paints to the edge of the composition board, Walker leaves the borders of her paper untouched, even allowing them to buckle from excess water. Lawrence's paint technique betrays his investment in the subject matter and his confidence in its lasting importance for his viewers, while Walker's handling of her materials implies that the myth of Brown is fading.

For African American artists like Lawrence who were working during this period, Brown was a vibrant and stirring image of passion in the cause of righteous social change, a white savior for the black masses.[39] That Brown was included in Lawrence's list of historically significant New World Africans warranting didactic cycles is extremely important because it demonstrates the way that Brown's cultural and social identity traversed the color line. In many ways, Brown was seen as an honorary black in the African American community. As W. E. B. Du Bois asserted, he alone came "nearest to touching the real souls of black folk."[40] Just as L'Ouverture and Turner had led bloody slave rebellions that risked their own safety, so too did Brown put his neck on the line for the lives of enslaved Africans in the New World, and this earned him the remarkable status of honorary black hero.

The African American painter William H. Johnson's *John Brown (or) On a John Brown Flight* (ca. 1940, Smithsonian American Art Museum) stresses this role as a heroic liberator of slaves, a role that Walker's image actively subverts.[41] In Johnson's image, which shows Brown, rifle in hand, leading a wagon train of blacks to freedom, he is a white savior for the black family that is crowded into the composition behind him.[42] Brown points the way to freedom and the Promised Land of Gilead with his left arm, while his right hand steadies the shotgun over his shoulder. Johnson depicts him at the center of the composition in hieratic scale, physically larger and therefore more important than the anonymous African Americans whom he leads.[43]

Johnson's image of Brown as a Moses-like figure presents a slightly different conception of his historic role from that of the Christ-like martyr seen in the Lawrence series, yet it is still a wholly religious one. Johnson emphasizes the importance of Brown's life, rather than his death, for the African Americans who huddle behind him in the covered wagon. This is in significant contrast to Walker's image, where Brown's arms are nearly absent, signaling that he has no hand in the destiny of the black woman and child who stand before him. Bound up in drapery, he is unable to lead them anywhere. As the woman pulls the child away from him, she indicates that she has no interest in remaining with him, let alone fol-

lowing him to the scaffold. In Walker's drawing, Brown is no longer the patriarch who would lead the slaves forward to Gilead; rather, he has become the relic who turns his head to the past.

Both Lawrence's and Johnson's constructions of Brown as a messianic white hero continued the tradition of representation begun seventy-five years before with the Ransom, Noble, and Hovenden images. And yet, these Afro-Christian images noticeably neglect the subject of Brown's last moments and the trope of the slave mother and child that they traditionally contained. Surely, this was not because they were unfamiliar with such images. The Currier and Ives prints had been widely distributed beginning in 1863, and the Hovenden painting was widely exhibited and reproduced beginning in the mid-1880s. Further, Powell notes that many of these popular prints had found their way into black households by 1940.[44] Noble's *John Brown's Blessing* was reproduced in the inaugural issue of the *Negro History Bulletin,* in October 1937.

And yet, despite the fact that these images were readily available to Lawrence and Johnson as source material, they chose to ignore the iconic scene of Brown's last moments. The phenomenon of avoiding the scene could either signal disinterest on the part of these black artists in emulating the demeaning imagery of their white predecessors, or their aversion to the interracial subject matter that such images presented. The former certainly seems a plausible reason, but the latter must also be taken seriously and examined in depth.

The interracial sexual subtext present in nineteenth-century images of Brown's last moments, and found most explicitly in the Noble painting, that Walker finds ripe for re-vision at the end of the twentieth century may have made some African Americans of an earlier generation and alternate sensibility uncomfortable. For black artists like Johnson and Lawrence, perpetuating an interracial image of African American female subservience and sexual availability like that shown in the Noble painting—even if the white man in question was the "nearly black" John Brown—was out of the question. For nineteenth-century readers/viewers familiar with Stowe's work, the use of this pairing in images of Brown's

last moments served to highlight everything that was noble and Christian in Brown's motivation to mount the raid on Harpers Ferry. For many twentieth-century African American readers/viewers, however, the image would remind them of the painful legacy of rape and exploitation that the racially mixed body connoted.

It is arguable that an aversion to the type of sexually loaded, interracial subject matter that is found in nineteenth-century scenes of John Brown's last moments lessened the likelihood that the visual trope would be perpetuated in early-twentieth-century African American art. Similarly, the rac(e)y content of the images increased the appeal of the work to an artist like Walker, whose practice depends on excavating, investigating, and exposing the underbelly of American visual culture. This project of resurrecting and reanimating the detritus of African American cultural history found in her revisionist drawing, *John Brown*, is central to her artistic practice. The sources for the image readily yield evidence of the sociosexual dysfunction of slavery-induced miscegenation that is subsumed within the scene through the disparate hues of the African American characters and their location in each image. In her artistic lexicon, the figures of the slave mother and child found in the Ransom, Noble, and Hovenden images are a recurring trope used to expose their subconscious impact on the psyches of twentieth-century viewers.

This explication of the interracial sexual subtext in Walker's source material demonstrates Brown's suspicious closeness to the people that he would free and helps to elucidate why both black and white artists found Brown's last moments a difficult and a desirable moment to portray. For example, in the first of the Ransom lithographs the slave mother's servile position on bended knee demonstrates her physical submission to Brown, and the comparatively lighter skin of her child, indicating a previous interracial relationship, signals the woman's past and potential sexual availability to Brown as a white male. This hint at the presence of white blood in the system of slavery is also seen in the Noble painting, where the children who stare out from the shadows at right are of varying skin tones, indicating their mixed heritage.[45] For nineteenth-century art-

ists, Brown was one of the only white men who could publicly be placed in close proximity to the African American sexuality that they and their fellow white male viewers may have desired and had to actively repress.

A dynamic critique of this phenomenon of subsumed interracial desire may be seen in Walker's recasting of Brown in the part of the slave mother. In many ways, this act of recasting Brown relates to the performative mode of blackface. In *Love and Theft: Blackface Minstrelsy and the American Working Class*, Eric Lott discusses the dual purpose of racial oppression and cultural adulation that the act of "blacking-up" had for European American performers and their white audiences in the nineteenth century. "The black mask offered a way to play with collective fears of a degraded and threatening—and male—Other while at the same time maintaining some symbolic control over them," states Lott. This "self-protective derision with respect to black people and their cultural practices," he argues, "made blackface minstrelsy less a sign of absolute white power and control than of panic, anxiety, terror, and pleasure."[46] In the reinhabitation of the body of Brown by white artists in the nineteenth century we have evidence of what might be termed "Browning-up." And in Walker's image we have a further reversal of this act, in which the substitute figure for male desire becomes a surrogate slave mother.

Through her drawing, Walker exposes the fear of social disempowerment that interracial relationships represented for nineteenth-century white artists by putting Brown into a type of ersatz blackface through role reversal. Additionally, this move exposes the related fear of exploitation that black artists may have seen in these same unions. It becomes clear that, in an effort to subsume the controversial nature of Brown's relationship to their culture, modernist African American male artists chose to write new narratives of his story, rather than to perpetuate the entrenched ones.

With the execution of *John Brown*, Walker has chosen to excavate certain symbols of our shared American past rather than continue to obscure them beneath further layers of mythos. Her interest in Brown as part of a "usable past" for the production of post-Negritude art pro-

vides an interesting contrast to the way her various male antecedents approached this visual legacy. This resurrection and subversion of the obscured corners of (African) American art and history are the cornerstone of her artistic production, and with *John Brown* she continues to reinforce the important elements of her seditious, post-Negritude vernacular. In Walker's vision, the allegory of Brown and the slave woman and child has become a ruin in which legacy and bodies are merged. They exist together as an unholy family, set within a nonspace that is completely divorced from architectural indicators and temporal locators, somewhere between the sentimental and the sacrilegious. According to Walter Benjamin, history, as witnessed in the emblem of the ruin, "does not assume the form of the process of eternal life so much as that of irresistible decay."[47] In Walker's painting, Brown's ruin of a body is rapidly degenerating: he has become an allegorical form representing and corrupting the different parts from which he originated; he is neither male nor female, neither black nor white. Rather, he is the product of a withered source — one that is flaccid and feminized, malleable and manipulated — from which a new whole has been reanimated. In Walker's critique of the pantheon of African American art and history, Brown has been exposed as a hollow icon, a failed patriarch, and an impotent mater familias.

CENSORSHIP AND RECEPTION

The whole gamut of images of black people, whether by black people or not, are free rein in my mind. Each of my pieces picks and chooses willy-nilly from images that are fairly benign to fairly charged. They're acting out whatever they're acting out in the same plane: everybody's reduced to the same thing. They would fail in all respects of appealing to a die-hard racist. The audience has to deal with their own prejudices or fear or desires when they look at these images. So if anything, my work attempts to take those "pickaninny" images and put them up there and eradicate them.

—Kara Walker, quoted in Hilarie Sheets, "Cut It Out!" *Artnews*, April 2002

In July 1999 the Detroit Institute of Arts (DIA) was preparing to open an exhibition titled "Where the Girls Are: Prints by Women from the DIA's Collection," when a decision was made to pull a work by Walker from display. The print *A Means to an End: A Shadow Drama in Five Acts* (1995; figure 25) was deemed too controversial by the administration of the museum and its advisory group, the Friends of African and African American Art. The work consists of five connecting scenes set in a linear, rectangular format. In the first section is a half-clothed woman with

a naked boy hanging from her breast, followed by the small figure of a young girl riding a fox backwards, then a woman leaping across what has been described as a river using partially submerged heads for stepping stones; next, a head and hand rise from the water, and last, a corpulent man strangles an emaciated young girl.

While the figures of *A Means to an End* may be read within an American historical context of racialized sexual depravity, a disturbing encounter of masters/mistresses and their helpful/helpless slaves, they also fit within a Western art historical tradition that goes back to the late gothic Netherlandish painting of Hieronymous Bosch. In his most famous work, *The Garden of Earthly Delights* (ca. 1500; plate 8), Bosch depicted a tumult of licentious behavior between white and black figures in a pastoral setting of sin and seduction. Details of black male figures swimming through water and mounting white women, people riding beasts and black women with fruit on their heads to symbolize their carnality, flowers sprouting from anuses, all echo in the scenes that make up Walker's suite of prints. Further, the *Garden*'s large scale (it is 2 meters high, roughly 7 feet) and its tumultuous composition of cavorting characters is very similar in impact to *The End of Uncle Tom* and other silhouette wall installations made by Walker in the mid-1990s.

The grotesque phantasmagoria found in *A Means to an End* continues to demonstrate Walker's interest in the carnivalesque. The figure of the girl astride the fox resurrects the stock character of the fool riding backwards on an ass. This comical pairing can be seen in carnival representations as early as *Balli di Sfessania* by the seventeenth-century French caricaturist Jacques Callot. It is also found in slightly altered form as late as Henri de Toulouse Lautrec's *Une Redoute a Moulin Rouge* from 1893, which pictures bare-breasted showgirls sitting atop donkeys and cattle and surrounded by clowns of various sorts.

"Just as carnival challenges the narrow authority of Lent, so carnivalesque imagery has acted as a corrective to each successive hegemony in the visual arts," notes curator Timothy Hyman in the exhibition catalogue *Carnivalesque*.[1] So it should not be surprising that the topsy-turvy nature of Walker's work, the abject effrontery of it, led to its eventual

censorship. The decision in Detroit to pull *A Means to an End* from "Where the Girls Are" was due to a long-standing conservatism in certain segments of the African American art world about the acceptability of controversial racial and sexual content. "The organization didn't feel that this was an appropriate time for the display of the work," said Samuel Thomas, chair of the Friends of African and African American Art. "It's primarily because it's controversial and there's no clear art-historical position with respect to [Walker's] work," he explained.[2]

Today, conservative African American fear of negative racial imagery is particularly strong. "We believe that it is our responsibility to present controversial art in a way that helps our visitors to understand the work and the artist's intent," said Maurice Parrish, the DIA's interim director. "In this instance, we determined that we could not present the work with the appropriate didactic material. Because we were concerned that we could not present it properly, we decided to exclude the piece from this particular exhibition."[3] This is in part because many African Americans are continuously aware of being judged in relation to preconceived racial prejudices, despite the gains of the civil rights movement.[4]

Cultural constructions of the African American imago as hypersexual, lazy, and brutal subhuman creatures still permeate racial discourse in the United States, and Kara Walker's representation in her work of these stereotypical signs of corrupt blackness coupled with images of perverted whiteness challenges the limits of what is tolerable to a community striving to overcome the impact of two centuries of negative imagery. Ironically, this overwhelming fear of sanctioning a potentially negative presentation of blackness on the part of the African American middle class has been a strong force fueling Walker's meteoric success. This antagonism has served to disconnect the artist from certain reactionary elements of the African American art community while ensconcing her within the mainstream art world.

To understand why *A Means to an End: A Shadow Drama in Five Acts* was censored at the DIA we must examine the constituencies concerned with Walker's work: the mainstream, white-dominated art world and the African American art community. By comparing the gendered reception of

FIGURE 25. Kara Walker, *A Means to an End . . . A Shadow Drama in Five Acts*, 1995. Hard ground etching and aquatint on Somerset Satin paper sheet: 27 × 19 in., five parts. Courtesy University of Michigan Museum of Art. Museum purchase made possible by the Jean Paul Slusser Memorial Fund 1996/2.4.1–5.

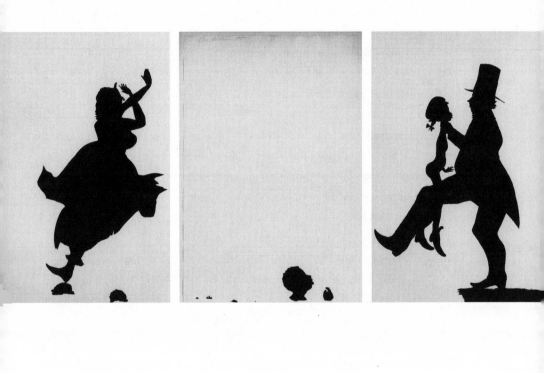

Walker's work with that of other controversial African American artists, I situate her artistic practice within these fundamentally different milieus of reception. By illuminating a limited number of key issues essential to the reactionary arguments against her work, I argue that confrontation with, rather than censorship of, the art's unspeakable content is a difficult choice that the American art world must soon find the courage to make.

In the spring of 1993 a controversy similar to the one in Detroit erupted at the University of Missouri, Saint Louis (UMSL) over the display of a painting by African American artist Robert Colescott (b. 1925) in a public space on the school's campus. The title of the work, *Natural Rhythm: Thank You Jan Van Eyck* (1976; figure 26), a reinterpretation of Jan Van Eyck's *The Wedding of Arnolfini* (1434; figure 27), referenced both an undependable type of birth control and a talent for musicality stereotypically held by African Americans. By employing his signature technique of loose and expressionistic brushwork, Colescott subverted the hard-edged clarity of form that made *The Wedding of Arnolfini* one of the most famous early oil paintings in Western art history. The palette of fluorescent pinks and greens further emphasized the act of reinterpretation. However, in *Natural Rhythm: Thank You Jan Van Eyck*, the chief shift in content made by Colescott came with the replacement of the figure of the Flemish bride with a black-skinned, pink-lipped caricature of a black woman.

Colescott chose the Van Eyck painting for reinterpretation during an artistic phase when he was reworking many of the classics of academic art history because of its status as one of the first European oil paintings.[5] It remains one of the germinal works of Western art history, a piece that most students of the discipline are taught to regard as key to the beginnings of modern artistic method and practice. Whole books, even careers have been devoted to the painting and its study.[6] Colescott's artistic method at one time consisted of inserting provocative racial and sexual imagery into iconic scenes. This was part of his investigation into, and the illumination of, the absence/presence of the African and African American subject/object in Western art history, and it was at the center

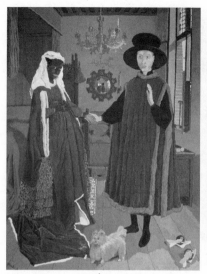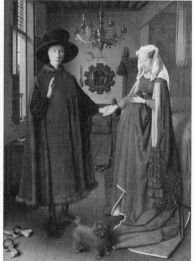

of his personal effort to maintain a certain racial tension in the 1970s
art world. The works he produced during this period are ironic and alle-
gorical, satirical and sociological. They include versions of Emmanuel
Leutze's *Washington Crossing the Delaware*, which became *George Washing-
ton Carver Crossing the Delaware: Page from an American History Textbook*,
and Vincent Van Gogh's *The Potato Eaters*, which became *Eat Dem Taters*.[7]
When made aware of the controversy surrounding *Natural Rhythm: Thank
You Jan Van Eyck* by a newspaper columnist, Colescott reacted wearily, "I
get this all the time . . . what happens is this: some African Americans see
my painting and get upset. Then the curators get nervous. We don't want
to upset black folks, because then we'd be racist, and we're not racist
even though we belong to a white club and live in a white neighborhood.
So if a black person complains, we must take it down because we are good
liberals. But it's still censorship."[8]

———

FIGURE 26. Robert Colescott, *Natural Rhythm: Thank You Jan Van Eyck*, 1976.
Collection of Robert H. Orchard, St. Louis, Missouri.
FIGURE 27. Jan Van Eyck, *The Wedding of Arnolfini*, 1434. Oil on oak panel, 82 ×
60 cm. National Gallery of London.

Over the six months following *Natural Rhythm: Thank You Jan Van Eyck*'s initial display in the lobby of Lucas Hall at UMSL, a battle took place between the school's administration and a small group of students, faculty, and staff who claimed to represent the university's African American community. The majority of the protestors who made their voices heard through demonstrations, panel discussions, and the press justified their opposition on moral grounds and issues of taste. Many had reached the conclusion that the artist's intervention into the content of the Van Eyck painting changed the story of the picture into a lewd and offensive parody. For some spectators, it was no longer a documentation of a wedding between social peers but instead depicted the interracial wedding of a white groom to a pregnant black bride. Others took a far dimmer view of it and saw it as the representation of a white slave master and his black mistress. "That painting lacked grace, poise, and dignity," claimed Norman Seay, the director of the university's Office for Equal Opportunity. "It reinforced for me the plantation ethic of the master in charge, violating the dignity of any female African-American he chose."[9] The image of miscegenation (a derogatory term generally defined as "the interbreeding of what are presumed to be distinct human races, especially marriage between white and nonwhite persons," a label of sexual and social transgression in American society that arose just before the Civil War) that the painting offered was one that could not be tolerated by the painting's opponents at UMSL.[10]

Some spectators found themselves confronted with their deepest fantasies, fears, and culturally constructed fictions. "My gut reaction [to the painting] was one of total outrage," said Karl Beeler, assistant to the vice chancellor of student affairs at UMSL. "I felt shame because you would think in this day of so-called enlightenment that people would realize that these kinds of images still have a stinging effect." But some African American community members at UMSL voiced complaints that were less focused on the actual painting at issue than on their feelings of disenfranchisement. They felt that they had enough negative images and realities confronting them when they were off campus. To these spectators it did not matter that the creator of the image was also African American;

what was important to them was that a derogatory visual image of a black woman was being displayed in their learning environment. "I personally take this position [against the display of the work]," explained Nicholas Wren, the president of the Associated Black Collegians of UMSL. "Because as an African student, I should not have to look at the degradation of African woman [*sic*] with the implication of them being portrayed as 'pregnant mammies.'"[11] Spectators like Wren believed that the university should provide a sanctuary for its members from the routine racism they encounter on a daily basis. Confronted with racially transgressive imagery in the university, these members of the African American community attempted to gain control over this particular representation of blackness. Norman Seay advocated replacing *Natural Rhythm* with decidedly middlebrow fare. He suggested that "other subjects by African-American artists" would be preferable to the one chosen by Colescott. "Maybe a still life or portraits of African-American women in history," he suggested. "We need pictures that are upbeat and positive."[12]

A few months after the painting was removed from Lucas Hall a decision was made to reinstall it on campus in the main reference room of the Thomas Jefferson Library.[13] *Natural Rhythm: Thank You Jan Van Eyck* was hung above a small conference table where a comment book and a binder full of newspaper clippings relating to the controversy were placed. Spectators were urged to express themselves on the pages of the comment book, which was filled in a few days.

In a situation similar to the censoring of *A Means to an End: A Shadow Drama in Five Acts*, the events in St. Louis surrounding the display of *Natural Rhythm: Thank You Jan Van Eyck* demonstrate the limits of what constitutes acceptable free speech in segments of the middle-class African American community. When a comparable community in Detroit, the DIA's Friends of African and African American Art, was confronted with a far more graphically vivid image of sexualized bodies in a racialized context, they reacted in a parallel manner.

In the censoring of *A Means to an End* the DIA adopted a type of hands-off curatorial method often used in the display of Walker's work. However, here this laissez faire attitude was taken to a new extreme in which

the safety of omission was deemed preferable to the challenge of explanation. This bypassed the precedent set by Gary Garrels, former chief curator and curator of painting and sculpture at the San Francisco Museum of Modern Art, who organized Walker's "An Outline: Upon My Many Masters" exhibition. Garrels, who was by that time already a veteran of several contemporary art museums and who is presently a curator at the Museum of Modern Art in New York, chose to fashion an exhibition brochure for this show out of a previously published interview with the artist that he then prefaced with a short introduction.[14] When confronted with the challenging task of didactic explanation of particular pieces, he opted to let the artist and the art speak for themselves. The museum did, however, post a sign at the entrance of the gallery, warning parents and other visitors to beware of the violent and sexual nature of what they were about to encounter.

In Detroit this same type of removed attitude about the art landed the curatorial staff in a bind. "I don't think the volatility of the piece was anticipated in preparation for the exhibition," explained DIA curator Nancy Sojka. "There was concern expressed about showing it and it sort of mounted. We didn't anticipate it would be so painfully felt."[15] In her interpretation of the situation, Sojka revealed the underlying problem as that of a museum that was out of touch and unprepared to address important concerns of a specific segment of its audience. All this implies that, while the "painful" nature of the work was one reason given not to display *A Means to an End*, the absence of a historian of contemporary art comfortable discussing issues of race and representation on the DIA staff was probably closer to the real reason the museum decided to pull the piece from view. Had there been someone who could authoritatively explain and defend the work's presence to the Friends of African and African American Art, they may have been less threatened by the confrontational nature of the work.[16] And though the acting director of the DIA at the time, Maurice Parrish, was African American, there was no culturally and critically sensitive curator on staff prepared to assume the task at hand.

It is important to note that the museum has since hired a curator to

cover this important area. In autumn 2001 Valerie Mercer, formerly of the Studio Museum in Harlem, was appointed the curator for the General Motors Center for African American Art at the DIA. "The development of the General Motors Center for African American Art is a natural extension of the DIA's commitment to African American art, and will provide a stimulating new dimension to our collections," said Graham W. J. Beal, the new director of the DIA. "We intend to create a center of excellence in this area, which will prove to be an invaluable resource for scholars and collectors, as it will house a specialized library related to works by African American artists."[17]

Because there are so few informed curators available to bring a racially sensitive perspective to exhibition content and didactic text, many mainstream institutions have often turned to citizens groups to aid them in better serving the black community. These groups and committees are generally made up of trustees, local collectors, and academics from the surrounding area, on the whole a conservative pool to draw from. They are asked to offer their opinions on and support for the African American–related exhibitions and programming at the institution, but they are not staff members and therefore cannot affect planning and execution in the same way. In some instances, in the case of the Africana Arts Committee at the Saint Louis Art Museum, for example, one of the committee's chief objectives is to increase the number of works by African and African American artists in the collection. This work is in line with the aims of both Du Bois and Locke, who eagerly sought opportunities for the display of African American art in a public context.

Once works by African American artists are accessioned into a museum's collection it becomes the responsibility of the institution's staff to place them on public view and to display them "properly." It is a task that cannot be accomplished if the museum lacks qualified staff to do so and, as seen in the case of *A Means to an End,* one that is sometimes at odds with the middle-class sensibilities of committee members. Although the work was originally acquired by the DIA in 1996, it remains to be seen when and how it will be displayed, if ever. In a similar situation, shortly after the *Natural Rhythm* debate, the Saint Louis Art Museum acquired

a different painting by Colescott, titled *Christina's Day Off.* The painting was placed in storage for several months until the curatorial staff felt that a satisfactory didactic panel, which had been vetted by the Africana Arts Committee and approved by the museum's director, had been written to accompany the painting on display.[18]

In the case of *Christina's Day Off,* didactics made the difference, yet explanatory texts are often not a part of current curatorial practice. Many curators who deal with contemporary artists do not feel that an interpretive stance is appropriate. This attitude is indicative of a liberal, avant garde art world that does not deign to assess work with content- or aesthetics-driven commentary. Unfortunately, it is a position that is at odds with the middle-class art-viewing public, whose expectations of what constitutes a satisfactory cultural experience are decidedly different. This situation will remain, due to the gulf between these significantly disparate museum audiences, represented by auxiliaries like the DIA's Friends of African and African American Art, who have censured Walker's work, and the SFMOMA's Society for the Encouragement of Contemporary Art, who have supported it.

In addition to facing censorious attacks, Walker has had to endure the wrath of those critical of her success. In 1997, when she received the MacArthur Foundation's "genius" grant, many senior African American artists were outraged that such a young woman (Walker was in fact the youngest artist ever to receive the award) should have been lauded with such a high honor. They felt that she had not paid her dues and that she did not realize the full impact of her work.[19] That same year, Kerry James Marshall (b. 1955), an African American artist of a slightly older generation who examines the world of post–civil rights African America through the lens of commemoration and kitsch and the false promises of bourgeois society, also won a MacArthur award. And yet, perhaps due to his age or gender, or the fact that his work does not contain overtly sexual or violent content, the lauding of Marshall went virtually unchallenged compared to the reception that the younger artist's work has met.

One person who does not see the postmodern irony of Walker's work is the septuagenarian assemblage artist Betye Saar. Saar has been among

the most vocal critics from the African American artistic community of Walker's work and her success in the mainstream art world. In the summer of 1997, following Walker's being awarded the MacArthur, Saar launched an extensive letter writing campaign to protest the collection and display of Walker's work. Her entreaty began, "I am writing you, seeking your help to spread awareness about the negative images produced by the young African American artist, Kara Walker." Further into the letter she questioned the "validity of a black person's attempt to reclaim and reverse racist imagery through irony," and warned the reader that "these images may be in your city next." In an interview published the following year, Saar questioned the process by which Walker had achieved so much attention so fast: "How do young persons just a few years out of school get a show at a major museum? The whole arts establishment picked their work up and put it at the head of the class. This is the danger, not the artists themselves. This is like closet racism. It relieves them of the responsibility to show other artists. Here we are at the end of the millennium seeing work that is derogatory and racist." And while Saar claimed, "I have nothing against Kara except that I think she is young and foolish," she nonetheless compared Walker's purveying of her images to a predominantly white art world with the activities of some Africans during the slave trade, saying, "Kara is selling us down the river."[20] Not surprisingly, Saar's criticism of Walker's work has been supported by other artists, including Thom Shaw, who commented that Walker's "works are obviously targeted at whites. It's ironic that they buy it. I do have a problem with some of the curators. One can make a substantial argument that they're only showing the stereotypes. We're still looked at as Sambos. So when you see them, bigger than life, frozen in time, it does, hurt."[21]

In many ways, both Shaw's and Saar's peer-directed criticism falls within the critical tradition against which Langston Hughes and Zora Neale Hurston first bristled during the Harlem Renaissance. Such an adversarial position echoes in Richard Wright's 1937 review of Zora Neale Hurston's novel *Their Eyes Were Watching God*: "Miss Hurston voluntarily continues in her novel the tradition which was forced upon the Negro in

the theatre, that is, the minstrel technique that makes the 'white folks' laugh. Her characters eat and laugh and cry and work and kill; they swing like a pendulum eternally in that safe and narrow orbit in which America likes to see the Negro live: between laughter and tears."[22]

Ironically, many of the elder critics, like Saar, who have been cautious about the nature of Walker's success were once the avant garde provocateurs of their own generation. Saar is best known for her own work in the area of stereotype repurposing. This area of her work with negative racial imagery is exemplified by the piece *The Liberation of Aunt Jemima* (1972, Berkeley Art Museum), in which a surrealist box frames a porcelain figurine of the rotund kitchen mammy reconceived as a revolutionary through the artist's addition of a clenched fist, the black power symbol, a shotgun, and a side arm. Saar's denunciation of Walker's work seemed to many an odd move on the part of an artist whose own production was, at least superficially if not philosophically, so closely related to what she was condemning. It is important to note that both Walker's and Saar's work is in fact part of a larger trend in late-twentieth-century art toward the figurative challenge of modes of cultural representation propelled by the work of nonblack artists such as Barbara Krueger and Jeff Koons, as well as by African Americans, including David Hammons, Carrie Mae Weems, and Glenn Ligon.

Saar's outrage, and that of like-minded art watchers, was soon given a forum by the symposium that was organized in February 1998 by the Harvard University Art Museums, the Carpenter Center for the Visual Arts, and the W. E. B. Du Bois Institute for Afro-American Research, "Change the Joke and Slip the Yoke."[23] The organizers brought together a wide range of academics, artists, dealers, and collectors to "address the current debate on the recycling of racist imagery, collecting and exhibiting black memorabilia, the use of black stereotypes in the work of contemporary American artists and representations of blackness in film and theater."[24] The conference, while aiming to address a larger trend in visual culture, focused on Walker's work and was accompanied by an exhibition of her silhouettes titled *Presenting Negro Scenes Drawn Upon My Passage through the South and Reconfigured for the Benefit of Enlightened Audi-*

ences Wherever Such May be Found By Myself, Missus K. E. B. Walker, Colored (1997).

Saar's objections to Walker's work continued into late 1999, when she contacted the Armand Hammer Museum as they were preparing to display Walker's exhibition "No mere words can Adequately reflect the Remorse this Negress feels at having been Cast into such a lowly state by her former Masters and so it is with a Humble heart that she brings about their physical Ruin and earthly Demise." Unlike the DIA, the staff of the Armand Hammer, led by director Ann Philbin, embraced the controversy and worked hard to anticipate any questions from visitors or objections that might arise by composing extensive wall text. "If there is, in fact, a controversy," said Philbin, "I welcome the opportunity, as a curator at an academic museum, to make a full dialogue around this very important issue. Certainly the last thing we would do is remove the work and back down."[25]

In response to Saar's objections, Walker said later, "I think I had naively assumed that the work I was doing would raise a lot of questions, and that, within the black community in particular, it would foster a dialogue more than a diatribe. But I think the question of whether or not this work should be seen, which was raised in Betye Saar's letter was absurd. You look or you don't look. But I'll make it as long as I have to. The whole gamut of black people, whether by black people or not, are free rein in my mind."[26]

In a comparable situation that same year, Colescott came under fire for having been chosen to represent the United States at the Venice Biennale. As the first African American to be given this honor, his selection was criticized by some conservative critics because of the provocative content of his work. As a result, the general opinion of the critics was that if a black artist was to be chosen, it should be one who represented African American artistic production in a more positive light.

Like Colescott, Walker has been condemned by her fellow African Americans of feeding the appetite that white American art consumers have for black flesh. At the same time, she has received praise from those whose appetites are satisfied by the visual feast of grotesques that she

purveys. Because black bodies have so often been seen only in the terms of parody, it is difficult for many African Americans to believe that derisive images can be repurposed in a beneficially subversive manner by artists. "I don't understand these things," Colescott admitted when asked about the negative reception of Walker's work. "Kara's work is, in a way, so conservative. You've really got to hunt for the little penises or whatever."[27]

Because of her success, Walker has become a contested presence in many segments of the art-viewing African American community, while her image as a postmodern African American artist, as a rebel and a provocateur, holds a certain appeal for the European American art world because of its origins at their own cultural margins. "History is carried like a pathology, a cyclical melodrama immersed in artifice and unable to function without it," explained Walker in the catalogue that accompanied her 1995 exhibition at Bard College. "The historical romance creates a will for abusive submission, exacerbated by contemporary ideologies that revere victimhood. Everyone wants to play the nigger now. There is more power in the role of the underdog, pop culture tells us. Be scary and disenfranchised, and you'll make great art."[28] In the role of the disenfranchised "other," Walker has been allowed to critique the dominant culture virtually unfettered by its proponents, in part because she does not spare her own community in the exercise. In this position as a provocative and shameless "other," she has been allowed into the center. For critics like Saar, Walker inhabits a role comparable to that of early -twentieth-century African American vaudevillians who performed in blackface for both white and black audiences. Whether or not she is complicit in selling out her race for fame and success, or if it is white art consumers who are being duped out of their money, remain points of contention. However, from her insider position Walker is allowed to say not only what those in the center cannot say, but also what those who remain at the margins have repressed.

In a special edition of the *International Review of African American Art*, editor Juliet Bowles brought together several articles about controversial African American art under the title "Stereotypes Subverted? Or For

Sale?" The *IRAAA* is one of the few periodicals solely devoted to critiquing this area of American art. A nonjuried publication, it has often produced theme issues containing a wide range of writing by both academics and professionals from the African American art world. The lead article in the "Stereotypes" issue is by Bowles herself and is titled "Extreme Times Call for Extreme Heroes." It is a freewheeling, provocative, and broad discussion of the controversy surrounding recent work by African American artists that use negative stereotypes of blacks; however, it soon degenerates into a subtly veiled attack on Walker alone. Rather than discussing the content of Walker's art, which was described in a cursory manner, Bowles compared the artist's professional persona and personal life with that of the painter Michael Ray Charles. Charles, whose "neo-coon" art was briefly mentioned as a similar artistic practice, was described as a student of stereotype history with an interest in exploring negative imagery rather than exploiting it. "Leading an upstanding life as a professor of art at the University of Texas, Austin, Michael Ray Charles only attracts criticism for his work and his defense of it," wrote Bowles, whereas "the controversial Kara Walker phenomenon . . . extends from her art to her entire persona." The depth of Walker's own interest in the visual history of images of blacks was completely ignored. Bowles chose instead to concentrate on comments that Walker had made in the mainstream art press about her personal experiences with interracial sexual relationships. These included a statement written by the artist in an exhibition brochure in the guise of a separate persona. Ignoring Walker's own acknowledgment of her interest in the power of artistic personae, Bowles quoted it in such a way as to imply that it was Walker discussing her own ambition: "She had always yearned to create a new identity for herself as the wife of a white man."[29] This was then emphasized by the immediate mention of the artist's having a white German-born husband. The section was concluded with the comment, "Underneath all of the sassy impudence, behind the occasional brilliant flash of insight, and within the worldly woman, there is a dejected girl." Bowles felt, however, that Walker's future artistic production might somehow be salvaged by the subsequent birth of the then-pregnant artist's child,

because, as she put it, "pregnancy, childbirth and mothering are totally transforming experiences."[30]

This hope—that mother nature and father time might put Kara Walker back in her place and possibly recreate her as an "upstanding" member of the community—reflects a gender-specific view of what is and what isn't appropriate behavior for a female African American artist. While not shying away from the debate over provocative work like Walker's, Bowles deflated her critical potential by resorting to conventional gendered narratives about the personal life of the artist. The problem of visuality in African American art, as Michele Wallace has termed it, lies at the root of the gendered and wholly disparate treatment that Bowles gave to Walker and to Charles in her piece. Wallace proposes that "vision, visuality, and visibility are part of a problematic in African-American discourse, and that problematic has much to do with related issues of gender, sexuality, postmodernism, and popular culture."[31]

In her historical treatise on African American women and feminism, *Ain't I a Woman*, bell hooks explains how the active sanctioning of the gendered subjugation of black women under the power of their male counterparts has been ingrained in African American culture over the past three hundred years.[32] The unequal relationship between African American men and women arose in part because the ability to preserve traditional forms of African family life under slavery was systematically undermined by the slave holding system. What arose out of this situation was a state in which the female slave was subjugated under two masters: her white owner and her black husband. Many African Americans who sought assimilation into American culture during Reconstruction continued to maintain the hegemonic attitude that a male-dominated nuclear family model was the most desirable one. This model, supported into the twentieth century by African American publications like *The Crisis*, was chosen in part to counteract the derisive myths of African American sexuality that had been perpetuated in popular culture for generations. "Americans are obsessed with sex and fearful of black sexuality," states Cornel West. "The obsession has to do with a search for stimulation and meaning in a fast-paced, market driven culture; the fear

is rooted in visceral feelings about black bodies and fueled by sexual myths of black women and men." An upstanding black family, in which the man is the head of the household and his wife the obedient subordinate, was a way to counteract "the dominant myths [that] draw black women and men either as threatening creatures who have sexual power over whites, or as harmless, desexed underlings of a white culture."[33] Further, West asserts that black and white Americans are unable to talk about race without talking about sex.

Michele Wallace reveals the impact that these myths have had on the black bourgeoisie with her analysis of the crisis that was presented by the television image of Anita Hill publicly challenging the appointment of Clarence Thomas to the Supreme Court in 1991.[34] She uses this example to highlight the fear in the African American middle class of the challenges presented by black feminism to traditional black male authority. Wallace identifies the threat that Hill presented to the black bourgeoisie as "a woman who had broken the unwritten law of gender." As a transgressive woman within the African American community, Hill found that her chief supporters came not from among her "sisters," but from the mainstream feminist community. Toni Morrison has observed that to many African American viewers, "as a black woman, [Hill] was contradiction itself, she was irrationality in the flesh . . . a black *lady* repeating *dirty words*."[35] In the beginning of the 1990s Hill found herself, as Walker would at the end of the decade, disowned by some members of her race because she spoke the unspeakable.

By both inhabiting and purveying an interracial, post-Negritude encounter for her spectator, Walker is the "bad girl" who rejects the role that her community would have her assume. Her lack of solidarity with the aims of a specific segment of the African American middle class makes her a traitor to their cause of assimilationist integration. As James Hannaham has noted, she has become like *das schrechlich Mädchen*, the nasty girl, betraying the secrets of her people to the world.[36] "After a long history of self-degradation, humility and humiliation (a subject of further research in future texts) I have reached a splitting point, a break with my past . . . with my past twenty-three years of do-gooder subjec-

tivity, comfort and the Afro-suburban experience," writes an anxious
Walker of her middle-class origins. "It's not good to break things, one
of the commands . . . the unspoken ones of the middleclass African-
American . . . akin to cosby's [*sic*] show . . . Humble yourself and be
strong . . . and you (my children) will never have to face the same fear
your fore(fathers) braved. . . . You never suspected fear would raise itself
beyond pain, beyond physical, social and political spheres and infiltrate
the collective unconscious of your laborious fruit(s)."[37] This transgres-
sion of "place" that Walker's work and life enact is profoundly disturbing
for cultural conservatives. Her carnivalesque vision of an abject world
consumed by violence and perverse sexuality flies in the face of the self-
repressed artistic culture of the black bourgeoisie represented by the
Friends of African and African American Art in Detroit. At the same
time, this eagerness to *épater le bourgeoisie* has made her a darling of the
avant garde–obsessed mainstream art world and a slippery subject for
some members of the African American art press to tackle.

The political impact of *A Means to an End*, as evidenced by its cen-
sorship, brings to mind the work of nineteenth-century French lithogra-
pher Honoré Daumier, whose popular lithographs skewered the social
dysfunction of Louis-Phillipe's post-Napoleonic Paris and eventually led
to his imprisonment on the grounds that he was "rousing hatred and
contempt for the King's government." Just as Daumier was able to turn
the figure of Louis-Phillipe into Gargantua gorging himself on the scraps
forced from his ragged proletariat, so too did Walker transform the ele-
gant silhouettes of southern aristocracy into monstrous spectres destroy-
ing their culture in cycles of sadistic anarchy. In laying bare the historical
myths of American culture, she has caught the attention of critics and of
the cultural guardians. "It seems important to recall that Bakhtin's vision
[in *Rabelais and His World*] was of a victory of laughter over fear," writes
Hyman about the postmodern, carnivalesque disposition for transgres-
sion and the abject. "The nexus of imagery . . . upside-down, mask, gro-
tesque—remains a perennial resource for artists of all media, by which
the freedom of foolishness can be reasserted for a new millennium."[38]

This is the position in which we find the reception of Walker and

her art today. Because of her ability to speak the unspeakable, her work has been the subject of debate nearly everywhere it has been shown. Although she continues to find widespread international acceptance and accolades from the mainstream art world, it was not until her 2004 exhibition at the Studio Museum in Harlem that she was invited to show at a museum of African American art or history. Walker remains a woman at the fringes, one who must find her own community. Like Langston Hughes, she will have to make her own way to the top of the mountain.

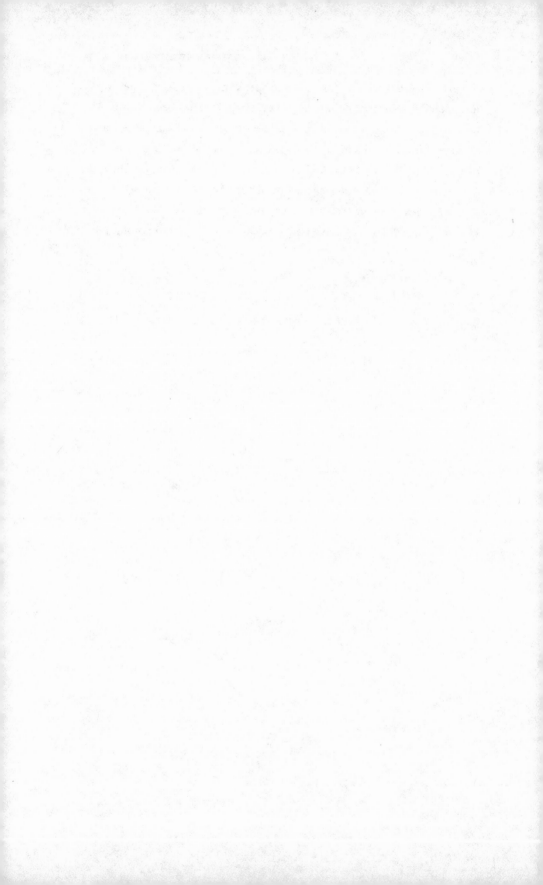

FINAL CUT

How do I (or do I) manipulate them . . . manipulate the viewer into an in-
sanity of swirling . . . excuse me . . . a vortex of representations . . . like some
post-Baudrillardian black woman . . . or do I?

—Kara Walker, *Kara Walker*, exhibition catalogue, 1997

Cut, Kara Walker's 1998 self-portrait, examines her role as an African
American woman artist in the public sphere (figure 28). It is a life-size
silhouette, cut from black paper and glued to the gallery wall, showing
a young woman sailing through space, her arms thrown back over her
head. Her breasts jut forward as her back arches, her skirt billows up,
and her heels click together. Her hair is plaited in two thin braids, each
about four inches long, like those of a little girl. They dance lightly be-
hind her back, caught up in the displaced air. However, all is not well
in this image of airborne ecstasy, for both of her wrists have been cut,
nearly severed at the joint by the straight razor that she holds in her left
hand. Four sprays of blood erupt from the wounds and gather in two
thickened puddles beneath her.

This image of grotesque self-mutilation and ambiguous ecstasy speaks
of the self-creation of Walker's artistic persona and her attempts to con-

FIGURE 28. Kara Walker, *Cut*, 1998. Cut paper and adhesive on wall, 88 × 54 in. Courtesy of Brent Sikkema Gallery, New York City.

trol the discourse around her work and to transcend her life as what Michele Wallace has termed the "'other' of the 'other.'" It examines a little of the pleasure and far more of the pain of performing such a gendered artistic otherness, the difficulty of achieving and retaining an authentic voice, and questions the promotion of that identity by an impresario. Through an in-depth analysis of *Cut*, this chapter investigates Walker's intellectual and physical existence as a black female artist who relives the past in order to confront it in the present.

The silhouette *Cut* is based on a Noe DeWitt photograph of Walker that accompanied a 1998 interview conducted by James Hannaham and published in *Interview* magazine (figure 29). Maintaining a jovial and familiar tone in the article, Hannaham, the artist's cousin as well as a featured cultural critic for the *Village Voice*, queries Walker about her artistic influences, her use of silhouettes, her youth in Georgia, the negative critical response to her work, and her interest in irony. Walker's portrait, in which she is shown leaping up into the air, illustrates the article along with a number of her recent silhouettes, including *World's Exposition* (1997), *Camptown Ladies* (1998), and *A Work on Progress* (1998). The photograph frames her body against the sky and the common of a park near her house in Providence, Rhode Island. As the sky blue, sunshine yellow, and grass green of the background blend together, Walker's own body, clad in dark gray with a square white apron in the middle, becomes silhouetted against the muted tones of the suburban landscape. On viewing the spread after its publication, the artist became interested in her own image and the way that it evidenced an intersection between photography, agency, and race at the turn of the century and constructed her as carefree and fashionably irreverent.[1] Evidently, she was struck by the way it masked the difficulties of her situation as an African American woman artist, the way it conveyed much of the pleasure and little of the pain of her professional life as it presented her for the viewer/reader as the "art world's New Negro."[2]

Shortly after the magazine's appearance on newsstands in mid-October 1998, Walker began to compose *Cut* for inclusion in her upcoming exhibition at Wooster Gardens Gallery in New York City. Unlike other

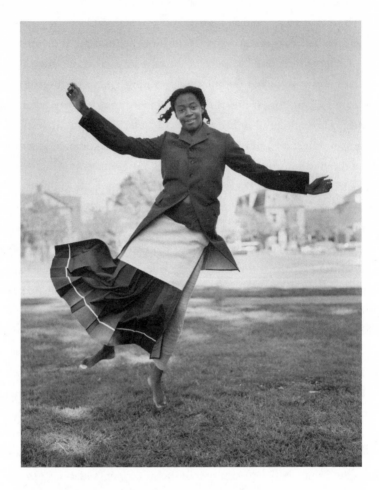

FIGURE 29. Noe DeWitt, *Kara Walker*. Reproduced in *Interview* (November 1998): 115.

projects that she worked on for weeks or months ahead of time, *Cut* was conceived and produced in the blink of an eye and installed in the first room of the gallery in time for the October 22 opening. The show was titled in a distinctly nineteenth-century mode: "*Missus K. Walker* returns her thanks to the Ladies and Gentlemen of New York for the great *Encouragement* she has received from them, in the *profesßion* in which she has practiced in New England." It was Walker's first Manhattan appearance after being awarded a MacArthur "genius" grant in 1997. As viewers entered the gallery they were confronted first by ironic takes on 1970s African American popular culture, including mirrors with commercially applied Afro-kitsch decorations of dancing women over which Walker had painted her own textual commentary. Art critic Nancy Princenthal wrote that although "it's hard, on several levels for anyone to see themselves in this work . . . self-reflection is, of course, literally unavoidable."[3] These pieces were followed by drawings made from coffee and gouache that took on the imagery of the civil rights movement. The use of coffee in the drawings singled the artist's concern with the broader implications of color and form in her work. In addition to being brown, a color that she has often favored in gouache, coffee also has the added aura of being a commodity. But it is not a simple commodity; it is tied up in legacies of imperialism, slavery, and continued Third World exploitation, as well as being a common descriptive of black skin color. It is one of the many "flavorful" analogies that have been used to describe the many shades of people of African descent: if you are not really "black," then maybe you are coffee-colored, or caramel, chocolate, and so on.

Keeping *Cut* company in the main gallery were silhouettes inspired by Josephine Baker (the single vignette *Consume* and the large wall installation *Danse de la Nubienne Nouveaux*, 120 × 240 inches overall) that examined aspects of African American female performativity and consumptive value.

Although Walker's vision of a thematically cohesive show seemed to elude some viewers, what was clear was the scathing self-analysis created in the inaugural image of *Cut*.[4] In this remarkable work, Walker dem-

onstrates what Michele Wallace has identified as the African American woman artist's "capacity for rendering the negative substantial and dialectical." Wallace sees "the very process of radical negation, or doubling and tripling the difference, [as providing] a way to reformulate the problem of black female subjectivity and black female participation in culture." In her theory of the "'other' of the 'other,'" black female creativity in American culture is analyzed as "incommensurable" and its products as "variations on negation." The reality of the metalanguage of race over the multiple categories of otherness embodied by the African American woman artist, including sexuality, gender, and class, brings to the fore her inherent incompatibility with any universal or dualistic understanding of the world.[5] In support of her theory, Wallace turned to the literary critic Barbara Johnson, who makes the point that "polar or binary oppositions are crucial to the logic of our culture's rhetoric about race and sex" and that when these binaries/polarities are disrupted, an ultimate otherness results. For Wallace, this ultimate other is the black woman, and it is her creative production, whether it be textual, visual, or critical, that is incommensurable when compared to the production of the dominant white male, whose work is seen as universal; the white female, who produces a complement to that universal vision; and the black male, who illuminates a state of otherness in relation to the first two.[6] In Wallace's estimation, then, the creative production of the black female is excluded from consideration through the tyranny of the binary system that cannot claim her as being anything but the other of the other. Walker herself has written, "Inequality is not just a dualistic construct. . . . It is not just a matter of Black and white, rich and poor, male and female."[7]

As an incommensurable artist, Walker has created in *Cut* a self-portrait that is essentially the sum of its parts. I argue that this self-portrait is a reaction to this state of ultimate otherness that the African American woman artist occupies by virtue of her race, gender, and social relationships with those members of the art world who would seek to guide, critique, and support her career.

The pain of constantly performing an authentic artistic otherness may be read in the fetishization of the female African American body found

in *Cut*. This fetishization begins at the site of Walker's hair, which was woven into four short braids for the *Interview* photograph. In *Cut*, the quartet of unraveling tresses is re-formed into two tightly bound plaits. In their affinity with the playful twists and braids that are worked on the heads of good little black girls who sit quietly between their mother's knees on the living room floor, they are symbolic of the middle-class assimilationist role that Walker has forsaken. And yet, they also recall the braids of the stereotypical pickaninnies that she is so often accused of exalting in her work, like the Little Rascals' Farina, who wore his pigtails tied at the ends with soft white rags. But for Walker, the braids are significant of something more than the coiffure of a good little black girl or the derisive image of a pickaninny; they symbolize her own fetishization within the discourse of both the white and the black art press.

In an article for the *New York Times Magazine*, critic Julia Szabo begins the fetishization of Walker's hair in her first sentences. "In a dimly lighted, subterranean gallery at the Institute of Contemporary Art (ICA) in Boston, a tall young woman stands near a staircase, contemplating a nine-foot-square sheet of black paper tacked to the wall," Szabo writes. "Hundreds of long, skinny braids quiver down to her waist, fraying at the tips in Botticelli-brown waves."[8] The description accompanies the photograph from the facing page, which shows Walker at work on the 1996 installation *New Histories*. She becomes a dark Venus rising from the underwater world of the ICA's basement gallery complex—a sexualized creative force working her magic on an ocean of black paper.

This fascination with the black female body at work, the notation of hairstyle, stature, and attention to craft, has its roots in general descriptions of artistic practice, and yet at the same time it moves into the realm of a racialized gendering of the subject within a darkened world of mysterious, natal energy. In an uncanny manner, this late-twentieth-century description of Walker echoes Henry T. Tuckerman's late-nineteenth-century description of the African American and Native American expatriate sculptor Mary Edmonia Lewis, whom he characterized as working in "coarse but appropriate attire, with her black hair loose, and grasping in her tiny hand the chisel with which she does not disdain—

perhaps with which she is obliged—to work, and with her large, black, sympathetic eyes brimful of simple unaffected enthusiasm."[9]

This fascination with the physicality of the African American woman artist by those who would review her work is also found in the writing of African American cultural critics and art historians. In a profile on Walker written for the *San Francisco Examiner*, Venise Wagner, too, thought Walker's braids and height were the significant descriptors of her identity. "Her shoulder-length cascade of braids accentuates the elegance of her tall, slim frame," wrote Wagner.[10] Her hairstyle of "waist length, auburn braid extensions" also fascinated *International Review of African American Art* editor Juliette Bowles, who felt they were significant enough to mention in her own critique of Walker's work and artistic persona. Bowles claimed that these artificial additions to Walker's hair were a part of the artist's desire to fetishize her own body for the gaze of the white male viewer.[11] Bowles would later explain her comments in direct address to Walker as "a way of raising the question of whether you wore the reddish, straight, almost waist-length, braid extensions because you were adopting part of the costume of your alter egos, 'Missus K. E. B. Walker, Colored' and the 'nigger wench.' Since they wish to be the white slave master's wife, do they also wish to have the white slave mistress's hair?" she queried, conflating the artist with the artistic persona. Bowles then interjected what she termed "a big sister . . . hair call" by critiquing Walker's braided hairstyle as "tired" and then praising her current "animated" hairdo as more becoming.[12] In so doing Bowles entered the realm of contemporary hair politics, in which no black woman can assert coiffure authority without creating a destructive binary relationship in which "good" and "bad" hair are set at odds with one another. In her pioneering article on the subject, "Beauty Rites: Towards an Anatomy of Culture in African American Women's Art," Judith Wilson seeks to chart the development of techniques of cultivating African American women's hair as a practice that cannot be contained within such a reductive binary. She sees African American women's hairstyling techniques as a "*convergence* of African and European needs, implements and beauty ideals."[13]

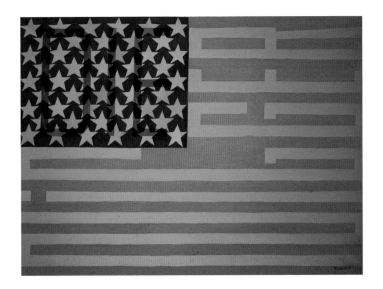

PLATE 1. Faith Ringgold, *The Black Light Series: Flag for the Moon: Die Nigger*, 1969. Oil on canvas, 36 × 50 in. Collection of the Artist.

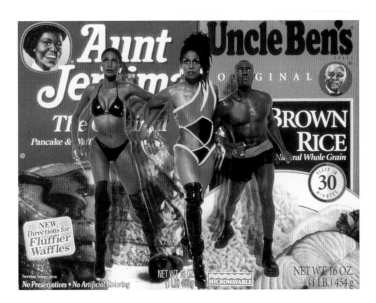

PLATE 2. Renée Cox, *The Liberation of Lady J and U.B.*, 1998. Ciba-chrome, 48 × 60 in. © Renée Cox. Courtesy Robert Miller Gallery, New York.

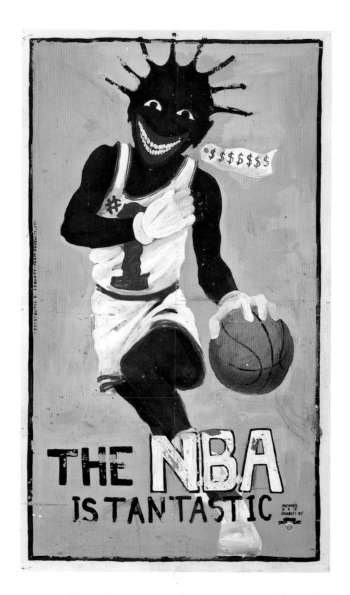

PLATE 3. Michael Ray Charles, *The NBA is Tantastic* (*Forever Free series*), 1995. Acrylic latex, stain and copper penny on paper, 60.5 × 36 in. Courtesy of Tony Shafrazi Gallery, New York.

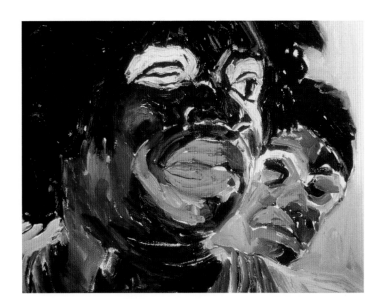

PLATE 4. Beverly McIver, *Me and Renee*, 1997. 16 × 20 in. Courtesy of the artist.

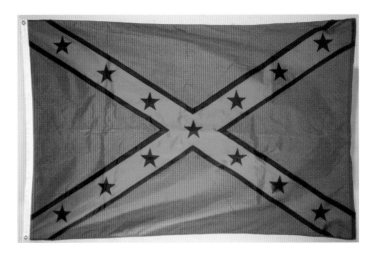

PLATE 5. John Sims, *Afro-Confederate Battle Flag*, 2000. 48 × 72 in. Courtesy of the artist.

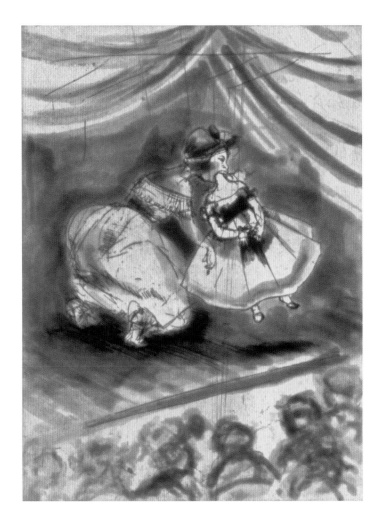

PLATE 6. Kara Walker, *Vanishing Act*, 1997. Etching aquatint; plate, 12 × 9 in.; sheet, 18 × 15 in. Photo courtesy of Brent Sikkema Gallery, New York City.

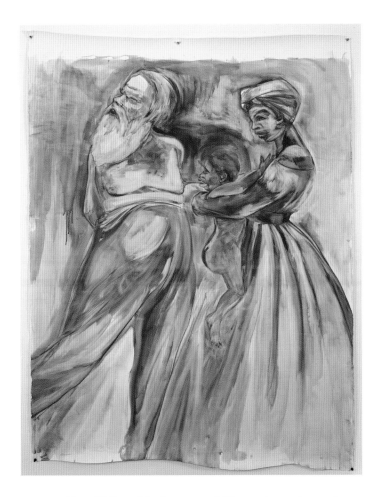

PLATE 7. Kara Walker, *John Brown*, 1996. Watercolor and gouache on paper, 65 × 51 in. Courtesy of Brent Sikkema Gallery, New York City.

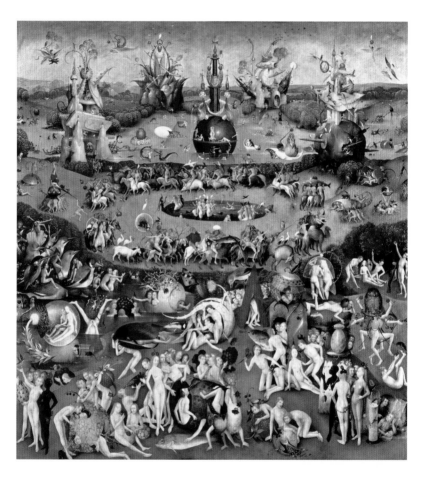

PLATE 8. Hieronymous Bosch, *The Garden of Earthly Delights*, ca. 1500. Oil on panel, central panel 220 × 195 cm. Prado, Madrid.

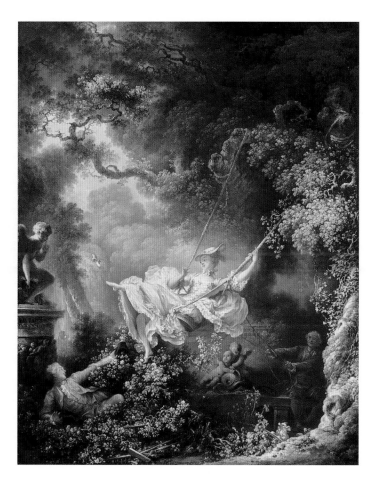

PLATE 9. Jean-Honoré Fragonard, *The Swing*, 1767. Oil on canvas, 81
× 64.2 cm. Wallace Collection, London.

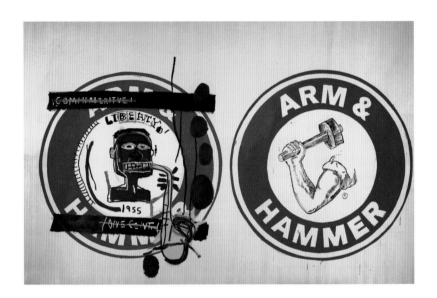

PLATE 10. Jean-Michel Basquiat, *Untitled*, 1984 (collaboration with Andy Warhol). Acrylic on canvas, 193 × 285 cm. Collection of Bruno Bischofberger. © 2003 Artists Rights Society (ARS), New York / ADAGP, Paris. © 2003 Andy Warhol Foundation for the Visual Arts / ARS, New York.

This convergence of needs may be seen in Walker's figuring of her own braids in *Cut* as a product of both white stereotypes and black aesthetics. However, their reduction in number from four to two and their delicately tapering ends indicates the impact of the hair pressure that Walker received during the two years preceding the creation of *Cut*. Her long, braided hair extensions had made her into a sexual exotic, a "Botticelli-brown" beauty in the eyes of Julia Szabo, and a self-loathing, deluded, slave wench in the eyes of Juliette Bowles. Removing the false braids and then refiguring her own hair into the child-like, regressive style found in *Cut* may be seen as a reaction to the pressures of her critical public on her own self-conception and physical presentation.

In addition to the deconstruction of the fetishization of her hair, *Cut* re-forms the clothing that Walker wears. In the *Interview* photograph she is dressed in a couture ensemble by Commes des Garçon comprised of a long skirt, apron, and button-front jacket. Though no doubt very modish and contemporary, the skirt and jacket also reference nineteenth-century fashion. They are particularly reminiscent of slave clothes in their make-do arrangement, much like hand-me-downs, but not quite the absurd costume of minstrelsy. This racialized context is furthered by the swath of white fabric set across Walker's waist that is suggestive of an apron. As she kicks up her heels while dressed as a high-style servant, she becomes a latter-day Mary Poppins, part artist/magician and part nanny/mammy. In her translation of the costume in *Cut* the skirt has been made much fuller, like an antebellum hoop skirt. The edge of the apron swings up and, in concert with the edge of the skirt, creates the illusion of a figure trapped beneath the fabric. The profile of a man with his hand raised can just be made out along the upper line of the silhouette.

The man's location under her skirt implies that not only is he servicing her in a sexual manner, but he is also controlling her movement. This may be drawn out through a comparison to Jean-Honoré Fragonard's painting *The Swing* (ca. 1766), which pictures an erotic ménage à trois in an eighteenth-century garden (plate 9). At the center of the composition is a young woman seated on a swing that is being pushed from behind by

one young man while another reclines on the grass beneath her. As she swings forward, playfully kicking her legs, the second man is afforded a view of the treasures hidden within her petticoats. His left arm gestures up toward her, directing the viewer's gaze to follow his own. In *Cut*, the angle of the figure's body and her billowing skirt as she glides across the gallery wall echo that of the young woman in *The Swing*, but rather than the male voyeur being seated on the ground, it is as though he has been swallowed up by the woman's clothes. He is found now in the profile of a face and hand that press up against the fabric, like a fish caught in a net. However, the face and hand that strain against the figure's skirts, defined by the apron's swoosh and the distended flip of the lower hemline, do not seem to be forcibly restrained. There is no sign of struggle; rather, in the way the hand wields what appears to be a conductor's baton, the man seems to direct the movement of the figure from behind the curtain of skirts and, by extrapolation, to control the freedom of the artist herself.

The trope of the mysterious figure behind the curtains, or in this case, beneath the skirts, acting to control an artist has its roots in the nineteenth century. One of the most memorable fictional accounts of such a relationship is the story of the tone-deaf singer Trilby, who was hypnotically controlled until her death by the evil Jewish magician Svengali. In George Du Maurier's 1894 novel *Trilby*, "With one wave of his hand over her—with one—look of his eye—with a word—Svengali could turn her into the other Trilby, his Trilby—and make her do whatever he liked . . . you might have run a red hot needle through her and she would not have felt it."[14] In an uncanny way, the image of Svengali, from an illustration in which he holds his baton as if it were a giant needle ready to be run through the entranced Trilby standing before him, is echoed in the profile found in the skirts of *Cut* (figure 30). And much like Trilby, whose body is controlled by Svengali, the same kind of hypnotic power over the female artist may be seen in *Cut*. Here, Walker's image of her own body is one that is out of her own control; she has sliced open her wrists and seems to care little for the damage she has inflicted or its potentially deadly consequences. Like the visual conflation of the baton with

which Svengali conducts Trilby's actions and the red-hot needle that he might use to torture her, the razor that the figure holds in *Cut* alludes to both the blade with which she practices her craft and the classic tool of suicide.

In *Cut*, then, Walker's figure may be read as under the control of a magic impresario who conducts and compels her forward from beneath her skirts, so that despite having nearly sliced off her own hands, she glides through the air in a carefree, almost ecstatic manner, feeling no pain. This action ironically suggests that her work is the cause of her own death, just as it was for Trilby. She seems to trade the pain of self-mutilation for the pleasure of self-realization: she sacrifices her body for her professional success. "This is the easy way out—my fantasy—in the future I will have a catharsis and go mad . . . the cause?" wrote Walker in 1997. "No doubt death in the family, death of my career, it never occurs

FIGURE 30. George Du Maurier, *Au Claire de la Lune*. Engraving, 11 × 7 cm. Reproduced in Du Maurier, *Trilby* (New York: Harper and Brothers, 1894), 319.

to my fantasy-me that I always maintain a straight face no matter how bad the circumstances . . . or how good."[15]

This idea of a Svengali figure acting behind the scenes to control and guide the career of a young artist, a "fantasy-me," who is on a headlong collision with death brings to mind the relationship of the male African American artist Jean Michel Basquiat and his mentor, Andy Warhol, as it was perceived by the white art world. In an ironic way, the portrait of Walker for *Interview* magazine that inspired *Cut* constructs the artist as the ghostly inheritor of the Basquiat legacy. Not only do Walker's un-kempt braids evoke the clusters of dreads worn by Basquiat, but her cos-tume references Basquiat's own turn as a celebrity model for the same fashion house's winter collection in 1985. Given this odd connection and the context of Warhol's magazine *Interview*, Walker's modeling of Commes des Garçon represents her as closer to one of Tama Janowitz's *Slaves of New York* than the temporal escapee from the antebellum South that the style of the clothes would imply.[16]

Like the Svengali figure beneath the skirts of the figure in *Cut*, Warhol was behind Basquiat, both within the artistic world and through their collaborations in the mid-1980s, when the two artists worked together on a series of sixteen paintings. In one of these works, *Untitled* (1984), Warhol stenciled two Arm and Hammer logos side by side on a large rectangular canvas (plate 10). Basquiat then painted over the logo on the left with the bust of a brown-skinned man with a saxophone clenched be-tween his teeth, making up the face of a "commemeritive one cent." The skeletal features of Basquiat's man juxtaposed with the bulging muscle of Warhol's Arm and Hammer logo evoke connotations of racial op-pression and brutality. The collaborative show received highly critical reviews that revealed a great deal of animosity toward the promotional relationship between Warhol and Basquiat, who was seen as the older man's protégé and pawn. "Once again Warhol reveals his version of the Midas touch, whereby everything he handles is infused with banality," wrote Eleanor Heartney in *Flash Art* after describing Basquiat as the "wild child" of the contemporary art scene. "Basquiat's 'authentic' images— those gritty figures and that hastily scrawled lettering—as well as the Big

Issues of life, death, greed, and lust that the show purportedly tackles, are all revealed to be as canned as Warhol's celebrated soup. . . . This collaboration brings together two masters of the carefully constructed persona. The real question is, who is using whom here?"[17]

Basquiat's contribution to *Untitled* resonates with *Cut* in its construction of the creative black figure as incapable of controlling the mode of his or her own artistic production and interpretation, and may in fact offer an answer to Heartney's question about usage. On the left side of the composition, Basquiat's black musician with the saxophone, a stereotype of African American musical virtuosity, is figured without hands with which to manipulate the tool of his own creativity. Like the figure in *Cut* who has nearly severed her own hands, the part of the body (after the head) that is traditionally symbolic of an artist's creativity, Basquiat's musician is powerless over the mode of his own expression.

In highlighting the alleged power of whiteness, and by asserting a sort of black creative impotence in the face of that power, Basquiat seems to acknowledge that his was an uneven relationship with Warhol, one that was based on competition. "Recognizing art-world fame to be a male game, one that he could play, working the stereotypical darkey image, playing the trickster, Basquiat understood that he was risking his life— that his journey was all about sacrifice," writes bell hooks. "What must be sacrificed in relation to oneself is that which has no place in whiteness. To be seen by the white art world, to be known, Basquiat had to remake himself, to create from the perspective of the white imagination. He had to become both native and nonnative at the same time—to assume the blackness defined by the white imagination and the blackness that is not unlike whiteness."[18] Warhol was the established celebrity and Basquiat was the "wild child." In the work that the two artists produced together, Warhol's stenciled icons created the base on which Basquiat's expressive content was superimposed. Just as Svengali prepared Trilby for her performances through hypnotic suggestion, Warhol set the figurative stage in their collaborations by priming the canvases on which Basquiat performed his work.

By leaving half of the canvas unaltered, allowing one of Warhol's Arm

and Hammer logos to remain pristine, Basquiat highlights the logo's purity as a symbol of white power. We are reminded that the arm that wields the hammer is white, just as the magical powder contained in the boxes that bear its emblem is also white.

The action of the well-muscled, yet disembodied Arm and Hammer also rhymes with the pose held by Svengali in the Du Maurier illustration and with the mysterious figure beneath the skirts of *Cut.* The menacing power of the activated and upraised arm, whether it wields a baton, a red-hot needle, or a hammer, lies in the foreknowledge that it will always come down on the body of its victim, a fact that is no more apparent than in the invitation to the exhibition in which *Cut* appeared (figure 31). The composition that advertises the show is not only a found image from the *Illustrations of the American Anti-Slavery Almanac for 1840*; it originally appeared as the illustration on page 115 of *The Narrative of the Life and Adven-*

FIGURE 31. Invitation to Kara Walker's October 22–November 28, 1998 exhibition at Wooster Gardens. *Mothers with young Children at work in the field,* detail. Woodcut, in *Illustrations of the American Anti-Slavery Almanac for 1840* (New York, 1839). Rare Book and Special Collections Division, Library of Congress.

tures of Henry Bibb, an American Slave, Written by Himself (New York, 1850). It depicts two slave women working in a field under the command of an overseer with a raised whip. His gesture, like those of the Svengali illustration and Warhol's Arm and Hammer, serves to control the figure of the slave woman he is threatening. His raised whip commands her obedience and submission. He stands between her and her unattended child at the right of the composition.[19] He literally blocks her from tending to her physical creation. She may not be his protégée, but he is definitely her master.

Oddly, the question of who is behind Walker's real-life career remains obscure. There is no single figure who might play the Svengali character, no one person preying on her sexual vulnerability and controlling her next direction. Neither is there a famous artist shepherding her way through the New York gallery scene, as Warhol did for Basquiat. Nor has her dealer, Brent Sikkema, while having no doubt gained through their association, acted as an intervening creative force in her production. And her husband, Klaus Bürgel, a well-established metalsmith and jewelry designer, is more concerned with maintaining a peak level for his own artistic production than trying to shape hers. Yet, in the catalogue from her 1997 exhibition at the Renaissance Society, Walker writes of the alienation of being an African American artist in the white art world, the feeling of always being under someone else's control: "How do I know that you are motivated and aroused by my presence in your sphere . . . a spectacle in the round . . . a blot on your landscape, an embellishment to your high society, a strange new face in a one horse town, a desirable outsider, a delicious new confection . . . brought to your kingdom by the conquistadors of consciousness . . . to be molded and sculpted, cultivated and cuisined, consumed and defecated and consumed again."[20] Here the pain of self-performance and of artistic commodification may be read in the description of an artistic body that is feted and then fed upon. Walker recognizes her status as a consumable item. Like Basquiat before her, she is the "flavor of the month," a product presented to a hungry white art audience waiting to see how good she tastes.

In this way, we can see that the popular and the art press alike display

Walker for their consideration in a decidedly Svengalian way. The mere act of being presented in *Interview* magazine for example, the Q&A process, creates her as an object that is available on demand. To return to the DeWitt photograph (figure 29), we see the artist following the commands of the mainstream press as she leaps into the air. One can almost hear the command "Jump when I say 'Jump!'" She responds willingly, with an eager-to-please grin on her face. And then later, regretting the capitulation to those who would fetishize and control her body, she recasts it in the figure of *Cut*, under her own control and yet still out of control. For Walker there may be no single figure that constitutes a Svengalian influence in her career, but rather the entire milieu of the mainstream art world. "I guess it's a little bit daunting. One or two pieces was funny enough, but after a while I feel a bit like . . . Stepin Fetchit," Walker explains. "To achieve success as an African American, one must spill out one's guts constantly—like the old sharecropper in [Ralph] Ellison's *Invisible Man*, who raped his daughter and kept telling his horrible story over and over, and the white people in town gave him things. He's an embarrassment to the educated blacks and a fascination to the whites."[21]

In this performance as the black darling of the white art world, Walker occupies a specific role, a role that she asserts has not changed significantly during the past 150 years, one that must therefore be performed in the guise of a separate persona. The title from the gallery exhibition in which *Cut* appeared, "*Missus K. Walker* returns her thanks to the Ladies and Gentlemen of New York for the great *Encouragement* she has received from them, in the *profeſßion* in which she has practiced in New England," sets the stage for this performance by invoking the language used to frame African American creativity and textual identity during the nineteenth century. In this way, Walker raises the issue of her own artistic autonomy by referencing the experience of the nineteenth-century African American woman artist as one of having to express constant gratitude toward her white supporters. It is likely that the phrasing was inspired by an advertisement placed in the October 11, 1802, edition of the *Baltimore Telegraphe* by the artist Joshua Johnson. This advertisement, which is reproduced and discussed in Romare Bearden and Harry Hen-

derson's *A History of African-American Art and Artists*, would have been familiar to Walker through her extensive research of African American art history. The advertisement reads, "Joshua Johnson, No. 52 Gay Street, returns his thanks to his friends and the public in general for the encouragement they have been pleased to afford him, towards establishing him in the line of PORTRAIT PAINTING; he, therefore, flaters [*sic*] himself, from an unremitting attention to give general satisfaction to the ladies and gentlemen of Baltimore, to merit a continuance of their favors, as he is determined to reduce his prices agreeable to the times, and use every effort to please them."[22] Walker's title hints at the indebtedness that African American artists have historically been made to feel as they pursued careers under the control of their supposed social betters. While no doubt having made significant inroads into mainstream museums and collections, black artists arguably remain the same objects of curiosity and condescension that they were during the nineteenth century.

Similarly, Walker's 1998 exhibition at Harvard University's Carpenter Center was titled "Presenting Negro Scenes Drawn Upon My Passage Through the South and Reconfigured for the Benefit of Enlightened Audiences Wherever Such May be Found. By Myself, Missus K. E. B. Walker, Colored," signifyin(g) on authenticity and identity as formed by nineteenth-century African American literary conventions. Here the title works in a way very similar to that of the nineteenth-century slave narrative. This is particularly apparent when the pseudonym and title are compared to that of an actual 1853 publication, *A Narrative of the Life and Travels of Mrs. Nancy Prince: Written by Herself*.[23]

Missus K. E. B. Walker is Kara Walker's superego persona, who, like the pseudonymic Linda Brent that gave voice to Harriet Jacobs's story of sexual exploitation under slavery that is recorded in *Incidents in the Life of a Slave Girl: Written by Herself* (Boston, 1861), articulates the experience of otherness on behalf of the witness. The role of authenticity and pseudonymic identity in the genre of the slave narrative is highlighted by the validating role that editors and amanuenses played in the creation and promotion of nineteenth-century slave narratives. The editor of Jacobs's

Incidents in the Life of a Slave Girl was the abolitionist feminist Lydia Maria Child.[24] To shield the escaped slave's identity, Child, in her role as editor, necessarily assumed an inordinate amount of control over Jacobs's work, subsequently creating controversy about the work's actual authorship. From the opening sentences of her introduction Child asserts her role in authenticating Jacobs's words and life experience. "The author of the following autobiography is personally known to me," wrote Child, "and her conversation and manners inspire me with confidence," thus effectively validating the contents of the volume through the authority of her own whiteness.[25] For many years, dissenters believed that it was Child who wrote the narrative rather than Jacobs, and it was not until the late twentieth century that literary historian Jean Fagan Yellin proved beyond a doubt that Jacobs had in fact written her own story.[26]

When Walker enacts a pseudonymic, nineteenth-century identity she is bringing to the fore the subordinate role that such relationships with liberal whites have always imposed on the production of their black protégés, thus highlighting the tradition of the white assessor authenticating the black creative product. Basquiat, too, was distressed by the racialized role of an authentic other that he was forced to play in his dealings with the white art world. "Even though socially Basquiat did not 'diss' those white folks who could not move beyond surface appearances (stereotypes of entertaining darkies, pet Negroes, and the like), in his work he serves notice on that liberal white public," writes hooks, citing the 1982 painting *Obnoxious Liberals* as evidence.[27]

However similar her own experience to Basquiat's, the arcane language that shapes Walker's performances and names the performer evokes the experiences of African Americans in the *nineteenth*-century American art world. Walker has said that when she finds herself under attack, "I make these little imaginary connections between my situation now and that of other creative black folk" in order to ease the anxiety of being the marginalized artist visualizing her own pseudo-experiences for the benefit of a watching audience of insiders.[28] In *Cut* Walker re-enacts a role at the end of the twentieth century that really hasn't changed much since the middle of the nineteenth century, when Ed-

monia Lewis became the first African American and Native American woman sculptor to be celebrated by European and American society.

Lewis was guided throughout the early years of her career by Lydia Maria Child, the same figure behind Jacobs's narrative.[29] And like Jacobs before her, with the abolitionist Child as her Svengalian impresario, Lewis had to struggle to maintain her own authenticity. As a woman artist of color she had no other choice than to carve her pieces directly. If she modeled the work in clay first and then had workmen complete the physically strenuous task of transferring the work to stone, as did many of her contemporaries, both male and female, she would have been accused of not having made the work herself. This criticism of artistic authenticity, of being unable to handle the tools of one's craft, is seen in *Cut*, where the razor that Walker uses to define her images has been turned on her own body to divide her flesh. And, like the mysterious figure pushing against the skirts of the figure in *Cut*, so too did the shadow of Child's contribution to Lewis's public career continue to impact the way her work was critiqued for years after their respective deaths at the turn of the century. Unlike Walker's extensive use of the interview format, such as the one found alongside the portrait that inspired *Cut*, which has begun to create a detailed if somewhat dubious narrative of her life, there is little first-person documentary evidence of Lewis's experience as a black woman artist. The researcher must therefore rely on Child's writings to provide insight into Lewis's life. In this way, Child continues from the grave to control the discourse around the life and artistic production of her protégée.

In a series of carte-de-visites from the early 1870s, Lewis defined her own physicality in the public eye, and the image that most often represents her in the absence of her body offers a marked contrast to the DeWitt photograph of Walker that served as the inspiration for *Cut* (figure 32). Unlike the airborne Walker, Lewis is posed quite formally, standing with one arm resting on a table covered by a cloth with a Greek key border. The backs of her smooth hands peek out of the cuffs, the palms hidden within slightly curled fists, barely hinting at the creative power they command. Turning back into themselves, they resist the exposure

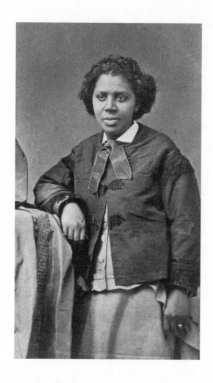

of the moment. Her clothes present her as a worldly woman, indepen-
dent and liberated, artistic and original. Her cropped hair, far from the
stereotypical tresses of an Indian princess or the tight kinks of the nigger
wench, the exquisitely trimmed bohemian jacket, and the loose cut of
her clothes identify her as an artiste. However, despite her efforts at self-
construction, she was always in danger of being viewed according to race-
related preconceptions held by her critics and viewers.[30] The carte seems
to show us everything about Lewis except the pain of her performance.

In *Cut* Walker examines the physical and emotional pain of achiev-
ing and retaining an authentic voice as an African American woman art-
ist by entering into the realm of artistic self-representation in American
culture. Her bleeding wrists, slashed by the tool of her trade, comment
on the public perception of her youthful ignorance and lack of control

FIGURE 32. Henry Rocher, *Edmonia Lewis*, ca. 1870. Albumen print, 9.2 cm ×
5.2 cm. Courtesy of Harvard College Library.

over the forces with which she would create.[31] But we are wrong if we believe that we are seeing a victim in this image, or that the work operates within an assumption of black women's art as being solely about victimization and exploitation. Rather, Walker is attacking the historic perception of the African American woman artist who, without the guidance of the figure beneath their skirts (figured here as the composite impresario character of Svengali, Warhol, and Child) to direct her flight, would not land on her feet.

Another artist who has articulated the predicament of the African American artist at the turn of this century as being little changed from the turn of the previous century is Glenn Ligon, whose *Narratives* series (1993) highlights the white impresario's role in promoting and presenting the production of the black artist. The set of nine etchings, which includes *Black Rage*, figures the artist as a former slave presenting the story of his life for a white viewer/reader (figure 33). "By routing slave narratives into a series of late-twentieth-century portraits, Ligon complicates the status of those narratives as documents of authentic black experience," argues art historian Richard Meyer of the piece, which features a long paragraph signed by an anonymous "white person" that validates the content that will supposedly follow. "*Narratives* draws out the tension between the first-person voice of the slave and the white reader for, and by whom, that voice was recorded."[32] In this way, Ligon's *Narratives*, and the vision of the male African American artist as escaped property that it creates, is comparable to the struggle for autonomy and authenticity as a female African American artist that Walker presents in *Cut*. As in Ligon's work, the combination of text and image in Walker's artistic practice plays "provocatively with autobiographical and fictionalized characters, physical appearance and anonymity, testimony and authority," asserts curator and art critic Eungie Joo. "This type of invocation of slavery in the context of late 20th century race relations generally, and art world politics specifically, suggests criticality towards one's benefactors and oneself that at once authenticates the work and undermines strivings for the authentic or authoritative black voice."[33]

Despite Walker's mainstream institutional success (the incident at DIA

BLACK RAGE;
or,
HOW I GOT OVER;
or,
Sketches
of the
Life and Labors
of

GLENN LIGON

CONTAINING A FULL AND FAITHFUL ACCOUNT OF
HIS COMMODIFICATION OF THE HORRORS OF BLACK LIFE
INTO ART OBJECTS FOR THE PUBLIC'S ENJOYMENT

WITH A PORTRAIT

"When we talk about the commodification of blackness, we aren't just talking about
how white people consume these images, but how black people and other people of
color consume them, and how these become ways of knowing ourselves."
—bell hooks

NEW YORK:
PRINTED FOR THE AUTHOR AND MAX PROTETCH GALLERY
BY BURNET EDITIONS

1993

FIGURE 33. Glenn Ligon, *Narratives* (Black Rage; How I Got Over . . .), 1993. 1 from a series of 9 etchings with chine collé, 28 × 21 in. Courtesy of the artist and D'Amelio Terras, New York.

notwithstanding), her own search for an accepting arts community has been difficult. Because her work has been castigated and critically misrepresented by many African American audiences, she has had to create her own support system. In the spring of 1999, while serving as artist-in-residence at the California College of Arts and Crafts in Oakland, Walker convened the first meeting of her self-styled Negro Emancipation Association (NEA). Composed of a loosely knit group of fine artists, designers, and academics, the association's inaugural reception was attended primarily by African Americans, although a number of other persons of color as well as European Americans were present. Many of the members were, like Walker, in interracial relationships or were themselves racially mixed. All of the attendees shared two things in common: their interest in and political support of Walker's artistic vision and a desire to provoke cultural discourse through their own work. By the second meeting a motto had been coined: "Not one stereotype, but many."

In a similar situation, Ligon has also sought support from an alternative arts community. Over the past decade and a half, Ligon's work has dealt primarily with issues of homosexuality and race. Not surprisingly, it has been embraced and celebrated most actively by the homosexual subsection of the art world, rather than the African American art community, which remains homophobic. In much of his work, images of male homosexual desire that crosses racial and temporal divides are featured. In 1996 he was given a solo show at SFMOMA which featured his series of large silkscreen self-portraits of the front, back, and side of his head, works that actively reinterpret Warhol's *Most Wanted Men* series from the New York State Pavilion at the 1964 World's Fair. In these images, Ligon figured his body as both the object of surveillance by other men and the subject representing his own desire.[34] At the artist's request, half the contents of the SFMOMA show were displayed off-site at the San Francisco Gay and Lesbian Historical Society, indicating Ligon's membership in, and support of, an alternative artistic community.

It is notable that Walker shares Warhol, the ultimate fabricator of self-styled community in the form of the Factory, with Ligon and Basquiat as a primary influence on her artistic development. She has been

quoted as admiring "his strategy for taking the most obvious things in the culture and blowing them up and placing them in a gallery," an act that she has refigured in her silhouette wall installations. Like Ligon's silkscreen panels of racialized homosexual longing and Basquiat's paintings of racist jargon, Walker's shadow dramas offer the American viewer/ reader a Warholian history of shared pain and desire. "In fact," said Walker, "my identification with Warhol was so strong at one point that when he died, people sent me condolence cards."[35]

With the inception of the NEA Walker ensured that, like Ligon, she would have an alternative community behind her in spite of the rejection of her originary one. Just as Basquiat found a home in Warhol's circle and Ligon has staked a claim in the queer art community, Walker's alternative arts community has become what *Village Voice* cultural critic James Hannaham terms the "New New Negro" group of artists. Whether members of the NEA or unaffiliated loners, this loose-knit cadre of theory-savvy, postmodern African American and multiracial intellectuals, that includes visual artists Laylah Ali and Steve Jones as well as playwrights Suzan-Lori Parks, Robert O'Hara, and Keli Garrett, takes no prisoners.[36] These New New Negroes represent the fruit of the previous century's long struggle for civil and social equality, as well as for artistic recognition, that African Americans and other racial, cultural, and sexual minorities have participated in. These are the artists who found themselves integrating their art school classrooms in the 1980s and 1990s, not as the first blacks in the school, as their parents' generation may have been, but as "the only one there at the moment."

Walker's self-fashioning in the self-portrait silhouette *Cut*, in the use of personae, and in retro-literary titling for her exhibitions may also be read as methods of coming to terms with the past by restaging it in the present. Called *Vergangenheitsbewältigung* in German, it is a strategy best witnessed in the early work of the contemporary artist Anselm Kiefer, who sought to examine certain taboos of his own culture's past through representation. In his *Occupations* series from the late 1960s, Kiefer photographed himself reenacting the *Sieg Heil* gesture of the Third Reich in various locations throughout Europe and in the privacy of his own

studio (figure 34). As odd ghosts of a past that would just as soon be
forgotten by its inheritors, Kiefer's figures have the peculiar status of
existing in two worlds, that of the phantasm of the past and in a night-
marish vision of the present. According to Andreas Huyssen, the images
are not entirely negative, but instead are full of irony: the small figure is
dwarfed by his surroundings and the jubilant masses of the Nazi period
are missing. And yet, "Are irony and satire really the appropriate mode
for dealing with fascist terror?" asks Huyssens in the role of the Devil's
advocate. "Doesn't this series of photographs belittle the very real ter-
ror which the Sieg Heil gesture conjures up for a historically informed
memory?"[37] Huyssen argues, and here I agree with him, that the act of
reenactment is important in itself. The role of the artist as provocateur
is not to be undervalued no matter how taboo or painful may be the ma-
terials he or she presents. For it is in their pain as artists, as workers in the
field of vision, that they must deal with such a legacy of tainted imagery

FIGURE 34. Anselm Kiefer, page from *Occupations*, 1969, in *Interfunkionen*, no.
12, 1975. Offset photo lithograph in softbound journal, 29.2 × 21 cm. Harvard
University Art Museums.

that the nonvisual world chooses to ignore, subsume, or reject. "It's as though the life of a living breathing moment were best suited to articulation via historical romances," Walker writes, "beginning with slave narratives and abolitionist testimonies which established the cast of characters, and subsequently reduced all truths to a language best suited to the readers."[38] In that Walker's revivification of antebellum imagery has also met with questions of its appropriateness, it must be seen as operating within the same theater of contestation as Kiefer's work. However, the two artists are by no means on equal footing. Kiefer, a German artist dealing with Nazi imagery, stands at the center of the photograph from the *Occupations* series and he also speaks from the center as a male artist working within his own dominant culture. Walker, however, is a black woman artist dealing with an art world and an art history that is largely white and male-dominated, one that has always attempted to judge and construct female blackness for itself. Walker's oppositional status as an artistic "'other' of the 'other'" dealing with the weighty subjects of historical domination and exploitation is in stark contrast to Kiefer's status as an ethnic German man dealing with Nazi iconography. She is not allowed the same sort of authority over such negative images; instead, she must negotiate with the dominant culture for that ownership. Is this attempt to obtain ownership of the visual culture that would seek to represent her like the antebellum slaves' search for freedom from slavery by attempting to purchase themselves, literally buying into a system that devalued their humanity in order to be free of it? Or is the artist merely an opportunistic individualist, trying to assert her own agency through the control of a system that is designed to withhold that same agency from her peers?

In *Cut*, Walker attempts to own her fetishized and contested body as it sails across the gallery wall, a mythical blip on the radar screen of the mainstream art world. The artist's wrists are slashed so that the blood spurts out in arcing plumes, becoming feathers with pointed tips at their roots, tips that in turn seem to pierce the flesh from which they grow. As the figure sails through the air she comes to resemble a fallen angel, whose wings have been clipped, sending her plunging toward the earth.

She is also like the hubris-stained Icarus, except that the flight of her artistic soul has been interrupted as the heat of the spotlight into which she has risen melts her homemade wings. The figure that presses against her skirts, pushing her forward through the air as if against her will, is the ultimate arbiter of her destiny. It would seem that there is no possibility of transcendence through visuality, that the pain of intervention will all too soon outweigh the pleasure of self-expression. The legacy of the past, guided by the example of Kiefer yet haunted by the ghosts of Basquiat and Lewis, is too much for the artist of the present to overcome. Ultimately, there is no alternative but to let the blood pool up in sticky puddles as the body flies, out of control and fixed in place, toward the gallery floor.

Conclusion

I perceived a negro, suspended in the cage, and left there to expire! I shudder when I recollect that the birds had already picked out his eyes; his cheek bones were bare; his arms had been attacked in several places, and his body seemed covered with a multitude of wounds. From the edges of the hollow sockets, and from the lacerations with which he was disfigured, the blood slowly dropped, and tinged the ground beneath. . . . The living spectre, though deprived of his eyes could still distinctly hear, and, in his uncouth dialect, begged me to give him some water to allay his thirst.

—J. Hector St. John de Crevecoeur, *Letters from an American Farmer,* 1782

When the eighteenth-century writer J. Hector St. John de Crevecoeur related his encounter with the "living spectre" in the woods of South Carolina, he raised the question of what it meant for a nation's collective identity that certain Americans embraced slavery's culture of torture and death. In "Letter IX: Description of Charles-town; Thoughts on Slavery; On Physical Evil; A Melancholy Scene," he crafted a textual image of a European American slave-holding society that was morally corrupt and hopelessly despotic. He lamented the state of a youthful,

self-styled southern gentry that was already decayed from its core, as gangrenous and putrescent as the bodies of the African slaves that it tortured to maintain its own dominance. Crevecoeur's question of what such malfeasance meant for a collective American consciousness was first levied in the eighteenth century, and we can still see it lying unanswered in the beginning of the twenty-first, as we come to the end of this investigation into Kara Walker's artistic practice.

In this study, Walker's paper silhouettes, prints, and drawings have shown themselves to be the shadows of similar sightless "spectres," monstrous ghosts haunting the American imago. Her images present themselves to the contemporary spectator as challenges to the politeness of middle-class and liberal society. The abject state of the work cannot be dismissed as merely the product of their creator's self-loathing, social contempt, and subversive vision; rather, it is linked to a pervasive culture of subsumed abjection, a culture in which pornography is consumed secretly via the Internet, high school students attempt to launch Caucasian clubs, and broad-nosed African Americans get plastic surgery to advance their careers. Their power lies in the way they make people feel uncomfortable by visualizing their sublimated fears and desires. It could be argued that the images Walker creates are apt to stimulate the repressed feelings within each spectator, so that whatever type of shame is contained by the psyche, whatever trifle of guilty feeling has been subsumed within the mind is let loose to rise to the surface. Regardless of whether it is the guilt of having benefited from racism or of having been a victim of it, or of having harbored interracial, homosexual, bestial, sadomasochistic, or pederastic sexual desire, it is the guilt of never having owned up to any of it that will bother spectators as they experience Walker's work. "It is not what you've done to me that menaces you," declared James Baldwin during a taped discussion with writer Frank Shatz about slavery and abolitionists. "It's what you've done to you that menaces you."[1] And it is a sort of stifled, self-righteous anger that plagues a typical American spectator who, steeped in a doctrine of freedom of speech and artistic license, cannot reconcile his or her desire for such images with his or her inability to punish such transgressive visions. All of this squelched

anxiety and negativity becomes embedded within the black paper characters, the brown gouache brush strokes, and the inky smears of aquatint from which Walker's work is formed.

It is "not whether to forget or remember," asserts art historian Andreas Huyssen in regard to the German artist Anselm Kiefer's work with the iconography of Nazism in the early 1970s, "but rather how to remember and how to handle representations of the remembered past at a time when most of us, over forty years after the war, only know that past through images, films, photographs, representations." Like the German visual imagery that was "perverted, abused and sucked up" by fascism, rendering it inaccessible to later generations of artists, much of the visual world that Walker's work deals with has been labeled a cultural taboo by those who seek to rehabilitate and protect contemporary African and European American imagoes from the taint of their own perverted origins.[2] However, in the contemporary political climate, where controversial racial icons continuously raise a legitimate outcry, her attempts to deal with some of the major visual tropes of Western cultural ideology in a violently satirical and often graphically sexual manner have generated great distress in certain quarters. Despite the animosity that has been directed at Walker for her usage of such symbols, she has continued to excavate and corrupt these painful images, gaining a wider and more mixed audience with every exhibition.

I have endeavored to discuss the way that Walker uses nineteenth- and twentieth-century source material to visualize unspeakable experiences and to produce psychologically disruptive, gothic silhouette "pageants." This has meant telling the story of the censorship and reception of her work, and the way that it illustrates the continuing conflict between the liberal white arts establishment and its middle-class African American constituency. In so doing I have found that, regrettably, the situation for today's black artists, though different from that of their predecessors, is still rife with pain. But despite the breadth with which I have attempted to address her artistic production, future directions for research still remain.

Where Walker's work might go now, and whether or not she has ex-

hausted the silhouette form, is probably the first thing that one might ask next. She has already begun to depart from the use of black paper alone. In the exhibition that she created for the Capp Street Project at the California College of Arts and Crafts in 1999, "No mere words can Adequately reflect the Remorse that this Negress feels at having been Cast into such a lowly state by her former Masters and so it is with Humble heart that she brings about their physical Ruin and Earthly demise," she used white, black, and gray paper as she reworked the Greek myth of Leda and the Swan across a curving gallery wall. The subject matter of this exhibition raised the question of whether she has tired of the antebellum themes that have become standards in her repertoire. At her 1998 Wooster Gardens show, pieces were inspired by a variety of twentieth-century sources, from the civil rights movement to the expatriate African American performer Josephine Baker. It remains to be seen if these new topics will resonate with spectators with the same force that previous Civil War–era themes have had.

Regardless of her ability to hold the fascination of the art-going public, Walker's work will no doubt continue to raise important implications for African American visual culture studies as it moves into an era of self-critique with a broader, more inclusive, and increasingly womanist mandate. Likewise, her work will remain a challenge to the once narrow field of American art history as a new generation of scholars struggles to incorporate increasingly complicated issues in the areas of race, gender, sexuality, and class.

Many postmodernists will find her work provocative as they move beyond what Gilles Deleuze once identified as "the indignity of speaking for others," and into a new millennium in which we are all de-centered subjects.[3] When we become fully conscious of our own individually racinated, classed, sexualized, and gendered states as being equally complex, the right to interpretation will no longer be a privileged tool of representation. Finally, all interested parties might concern themselves with a further explication of the discourse of the unspeakable in Walker's work, for it will continue to be a fertile area of research as long as there is so much that remains seen, yet unspoken.

Introduction

1 Harriet Beecher Stowe, *Uncle Tom's Cabin* (New York: Norton, 1994; originally published Boston: John P. Jewett and Company, 1852).

2 By using the term "signifying" I mean to link Walker's work to the creative tradition of revision that Henry Louis Gates Jr. has identified as unique in African American literary culture. See Henry Louis Gates Jr., *The Signifying Monkey: A Theory of Afro-American Literary Criticism* (London: Oxford University Press, 1988).

3 Ibid., 131.

4 This is a general artistic strategy, sometimes referred to as parody, that was recently the subject of public debate in a controversy engendered by the lawsuits made to halt the publication of Alice Randall's book *The Wind Done Gone* (Boston: Houghton Mifflin, 2001). The Mitchell estate sued the book's publishers under intellectual property rights which, they argued, protect the estate's control of sequels. In a move that is similar to what we see Walker doing in her racially charged silhouettes, Randall's book offers the reader a retelling of Mitchell's *Gone With the Wind* from the perspective of Scarlet O'Hara's mulatto half-sister.

5 For a discussion of this sort of triple consciousness, see Adrian Piper's essay "The Triple Negation of Colored Women Artists," in *Out of Order, Out of Sight, Volume II: Selected Writings in Art Criticism, 1967–1992* (Cambridge, Mass.: MIT Press, 1996), 161–173. Piper argues that "the ideology of postmodernism functions to repress and exclude CWAs [colored women artists] from the art-historical canon of the Euroethnic mainstream. Correctly perceiving the artifacts produced by CWAs as competitors for truth and a

threat to the cultural homogeneity of the Euroethnic tradition, it denies those artifacts their rightful status as innovations relative to that tradition through ad hoc disclaimers of the validity of concepts such as 'truth' and 'innovation'" (161). This position of being a threatening and necessarily repressible body is one that is frequently visible/readable in Walker's work, and is discussed further in chapters 4 and 5.

6 Cathy Caruth, *Unclaimed Experience: Trauma, Narrative, and History* (Baltimore: Johns Hopkins University Press, 1996); W. J. T. Mitchell, "Narrative, Memory, and Slavery," in *Picture Theory: Essays on Verbal and Visual Representation* (Chicago: University of Chicago Press, 1994).

7 Here I refer to Benjamin's study of tragedy and human wretchedness in *The Origin of German Tragic Drama* (London: Verso, 1985; orginally published 1928).

8 A note on terms: I use the terms "African American" and "black" in a popular sense to refer to peoples of African descent living in the United States. "European American" and "white" are used in a similar spirit.

9 Postblack is a term that was first coined by the artist Glenn Ligon and recorded by the curator Thelma Golden in her introduction to the catalogue for the exhibition *Freestyle* (Studio Museum in Harlem, 2001, 14): "Postblack was a shorthand for post-black art, which was shorthand for a discourse that could fill volumes. For me to approach a conversation about 'black art' ultimately meant embracing and rejecting the notion of such a thing at the very same time. . . . It was a clarifying term that had ideological and chronological dimensions and repercussions. It was characterized by artists who were adamant about not being labeled as 'black' artists, though their work was steeped, in fact deeply interested, in redefining notions of blackness. In the beginning, there were only a few marked instances of such an outlook, but at the end of the 1990s, it seemed that post-black had fully entered into the art world's consciousness. Post-black was the new black." The term is rapidly gaining currency, propelled by ideas that the work of contemporary African American artists of "generations X and Y" have a vision that is unique from, and largely in opposition to, the one that came out of the Black Arts Movement of the 1960s and 1970s, the movement that shaped the artistic discourse of their parents' generation.

Chapter 1 Race and Representation

1 Kara Walker, "Fireside Chat," sponsored by the Society for the Encouragement of Contemporary Art, an auxiliary of the San Francisco Museum

of Modern Art, 25 April 1999. All biographical information used in this study proceeds from this discussion and from other previously published interviews.

2 A particular incident that Walker related during her "Fireside Chat" that had profoundly affected her production occurred in her attic studio at her parents' home in Atlanta. It happened during a date rape encounter with what she calls a "good for nothing, white man," and it stands out for her as a life-changing experience. She says that as she endured his advances, she couldn't help but think that this scene had happened somewhere in the past. She felt a direct, lived connection to history, as her experience seemed to parallel that of a nineteenth-century slave woman being raped by her owner. The fantasy slave woman of Walker's imagination, caught between consent and condition, may be read in the shadow characters that cavort so recklessly through Walker's silhouette installations.

3 "Fireside Chat."

4 E-mail interview conducted by the author with Kara Walker, 31 May 2000.

5 Quoted in Frances K. Barasch, "The Meaning of the Grotesque," in *A History of Caricature and Grotesque in Literature and Art*, ed. Thomas Wright (New York: Frederick Ungar, 1968), viii.

6 *Los Caprichos* (1796–98) was published on Ash Wednesday of 1799, the day after the last day of Carnival.

7 Mikhail Bakhtin, *Rabelais and His World* (Cambridge, Mass.: MIT Press, 1968), 218, quoted in Timothy Hyman, "A Carnival Sense of the World," *Carnivalesque*, catalogue, National Touring Exhibition, organized by the Hayward Gallery, London, for the Arts Council of England, in collaboration with Brighton Museum and Art Gallery, 2000, 14.

8 Here I am paraphrasing Hyman's discussion of the power of carnivalesque imagery: "Perhaps we can say that every truly carnivalesque art is fuelled by an absence and a need; and it may be precisely where laughter is most forbidden that the carnivalesque becomes most meaningful" (ibid., 15).

9 An interesting discussion of freedom and of the Nortons' collecting habits and Christmas gift tradition can be found in "Paper Trail," *On Paper* 2, no. 4 (March/April 1998): 8–11.

10 For a review of this show, please see Claire Daigle's discussion in *New Art Examiner* 25, no. 6 (March 1998): 55–56.

11 Rinder has since left for the Whitney Museum of American Art in New York, where he was responsible for curating the 2001 Biennial.

12 Her appearance in the Istanbul Biennial was reviewed by Darlene Kryza in *New Art Examiner* 27, no. 5 (February 2000): 40.

13 Kara Walker, quoted in *Capp Street Project: Kara Walker*, exhibition brochure, interview with the artist by Lawrence Rinder, 24 February 1999.

14 "Fireside Chat."

15 E-mail interview.

16 Charles Colbert, *A Measure of Perfection: Phrenology and the Fine Arts in America* (Chapel Hill: University of North Carolina Press, 1997), 2. During the nineteenth century, physiognomy developed into the popular psychological system of phrenology. This system became hugely popular in the United States after the 1834 publication of George Combes's *Elements of Phrenology*.

17 Johann Caspar Lavater, *Essays on Physiognomy*, translated by Thomas Holcroft, 4th ed. (London, ca. 1844), 187–188.

18 The following supportive information from these scientists is cited by Lavater in his 1844 edition (ibid., 339–359): "Buffon on Negroes: 'Those of Cape Verd have by no means so disagreeable a smell as the natives of Angola; their skin, also, is more smooth and black, their body better made, their features less hard, their tempers more mild, and their shape better. — The Negroes of Senegal are the best formed, and best receive instruction. — The Nagos are the most humane, the Mondongos the most cruel, the Mimes the most resolute, capricious, and subject to despair.' Kant on the development of the races: 'External things may well be the accidental, but not the primary causes of what is inherited or assimilated. As little as chance, or physico-mechanical causes can produce an organized body, as little can they add any thing to its power of propagation; that is to say, produce a thing which shall propagate itself by having a peculiar form, or proportion of parts.' And Winkelmann on art and form: 'The projecting mouths of the Negroes, which they have in common with their monkeys, is an excess of growth, a swelling, occasioned by the heat of the climate; like as our lips are swelled by heat or sharp saline moisture; and, also, in some men, by violent passion. The small eyes of the distant northern and eastern nations are in consequence of the imperfection of their growth. ... Nature forms with greater regularity the more she approaches her centre, and in more moderate climates. Hence our and the Grecian ideas of beauty, being derived from more perfect symmetry, must be more accurate than the ideas of those in whom, to use the expression of a modern poet, the image of the Creator is half defaced.'"

19 Didactic label that accompanies an object in the catalogue of the 1990 exhibition by Janet Levine in Guy C. McElroy et al., *Facing History: The Black Image in American Art 1710–1940* (Washington, D.C.: Corcoran Gallery of Art, 1990), 10.

20 This image was made sometime before this sale, and we can see her new last name has been appended on the lower right in a different hand.

21 Kara Walker, quoted in Hilarie M. Sheets, "Cut It Out!" *ArtNews* 101, no. 4 (April 2002): 128.

22 As a mechanically mediated visual presentation, the portrait profiles made by this device promised their consumer a certain indexical primacy that other forms of image making could not. Like the photographic media that would eventually eclipse it, the Physiognotrace device produced what was viewed by many to be a pure act of mechanical mimesis, an image practically unaltered by human hands. But because the human intervention of hand cutting was a necessary part of their creation, Physiognotraced profiles also retained what Walter Benjamin would term an almost contradictory aura of originality. This shift from an individual image to an infinitely reproducible generalization raises many issues about the silhouette's nature as sign. See Walter Benjamin, "The Work of Art in the Age of Mechanical Reproduction," in *Illuminations* (New York: Schocken Books, 1985).

23 Henry Louis Gates Jr. discusses this type of anxiety and confusion in his introduction to *The Slave's Narrative* (Oxford: Oxford University Press, 1985), xxvi–xxxi.

24 Gates, *The Signifying Monkey*, xxiii.

25 That this act comes around 1802, at the beginning of his career, shows both his interest in fitting into the professional society of white Philadelphia and his ability to manipulate and defy its tenets. Williams's marriage to the Peale's white cook, Maria, further indicates this ability. And the fact that their daughter disappeared from history by changing her name and passing for white shows the legacy of the father's own search for identity within a racialized selfhood.

26 Kara Walker, quoted in Lynn Gumpert, "Kara Walker: Anything but Black and White," *ArtNews* 96, no. 1 (January 1997): 136.

27 Powell proposed an African American genealogy for Walker's work in his opening remarks at the panel "African American Imprint on American Arts and Letters" at the thirtieth anniversary celebration of the founding of the Department of Afro-American Studies at Harvard University, 8 April 2000.

28 Henry Louis Gates Jr., "The Face and Voice of Blackness," in *Facing History: The Black Image in American Art*, ed. Guy C. McElroy et al. (Washington, D.C.: Corcoran Gallery of Art, 1990), xxix.

29 Miles Unger, "Contested Histories," *Art New England* 19, no. 4 (June/July 1998): 29.

30 Alain Locke, ed., *The New Negro: Voices of the Harlem Renaissance* (New York: Albert and Charles Boni, 1925).

31 Langston Hughes, "The Negro Artist and the Racial Mountain," *The Nation* 122, no. 3181 (1926): 692–694.

32 Richard J. Powell discusses the myriad approaches to identity in African America during this period in "Black Is a Color," in *Black Art and Culture in the Twentieth Century* (London: Thames and Hudson, 1997), 121–159.

33 *Sweet Sweetback's Baadasssss Song* opens: "This film is dedicated to all the Brothers and Sisters who had enough of the Man."

34 The title played off the contemporaneous book *Die Nigger Die!* (New York: Dial Press, 1969) by Black Panther leader H. Rap Brown. For a discussion of *Flag for the Moon*, see Sharon F. Patton, *African-American Art* (New York: Oxford University Press, 1998), 197–199.

35 David Joselit, "Toward a Genealogy of Flatness," *Art History* 23, no. 1 (March 2000): 29.

36 When viewing the painting, one might think of figures like the Los Angeles Lakers' center Shaquille O'Neal, who starred in the 1996 movie *Kazaam* as a genie summoned from his home in a boom box by a lonely white boy. Acting as the child's magical (and enslaved) protector, the athlete assumes the stereotypical role of the loyal retainer who propels the white hero toward greatness and self-realization. Like Huck Finn's Jim, it is a familiar role in which many black male actors, from Stepin Fetchit in the 1920s and 1930s to Morgan Freeman in *Driving Miss Daisy* (1989), have been cast.

37 Lee is one of the largest collectors of Michael Ray Charles's artwork. Charles collaborated with Lee on certain aspects of the film's production and promotion, including contributing an essay on blackface to the film's Web site, http://www.bamboozledmovie.com/minstrelshow/index.html.

38 Quoted in Juliet Bowles, "Extreme Times Call for Extreme Heroes," *International Review of African American Art* 14, no. 3 (1997): 5.

39 For a discussion of these issues, see Catherine Lord et al., *Theater of Refusal: Black Art and Mainstream Criticism* (Irvine: Fine Arts Gallery, University of California, Irvine, 1993).

Chapter 2 The "Rememory" of Slavery

1 Alice Randall, *The Wind Done Gone* (Boston: Houghton Mifflin, 2001); Margaret Mitchell, *Gone With the Wind* (New York: Macmillan, 1936). Presaging Randall, who inserts a mixed-race protagonist into the mix of Tara, Walker

first dialogued with Mitchell's book (and the tendentious mythology of the Old South it has perpetuated) via her first major silhouette wall installation, *Gone: An Historical Romance of a Civil War as It Occurred Between the Dusky Thighs of One Young Negress and Her Heart*, shown at the Drawing Center in New York in 1994.

2 I have chosen the term character, rather than figure, because in psychoanalytic theory character is defined as a cluster of fixations, a definition that I think holds true for Walker's work. See Sigmund Freud's essay "Character and Anal Eroticism," in Peter Gay, *The Freud Reader* (New York: Norton, 1985), 293. When the work was first installed at the 1997 Whitney Museum of American Art Biennial exhibition, the "scenes" had a different order than the installation that I saw at the San Francisco Museum of Modern Art the following year. Because of this difference, and because it implies that the artist (who supervised both installations) is interested in exploring a multiplicity of meanings and possible narratives through the ordering of the various scenes, I do not attempt to construct a linear progression out of the scenes. Rather, I discuss each scene in relation to the others, as discrete episodes that produce a cumulative effect.

3 During Walker's 1997 exhibition at SFMOMA, I attended the opening and visited the galleries four times in the company of various groups of viewers. On three of these occasions I discussed the impact of the work with my companions, who included fellow employees of the museum, friends, and an organized group of female African American graduate students from Stanford University. Another time, I visited the show in the company of the artist and a group of viewers as part of a program, "Looking at Art with Artists," sponsored by the museum's education department.

4 Here I refer to social theorist Emil Durkheim's idea of collective consciousness, which holds the role of representation in social systems as pivotal to the cohesion of those communities. Durkheim saw "collective representations," idealizations and icons, models, and morals that define society and its members as common beliefs that people have about the world which allow them to associate with one another and act in expected ways. See Emile Durkheim, *The Elementary Forms of the Religious Life: A Study in Religious Sociology*, translated by Joseph Ward Swain (London: G. Allen and Unwin, 1915).

Even in the 1800s profile silhouettes were nostalgic due to their formal links to classical coinage. Today, thanks to the advent of photography and the subsequent boom in mechanical reproductive technology in image

making, silhouettes remain shadows of the originals that they were once believed to chronicle so precisely. They comment on and endlessly reference their own past history.

5 Kara Walker, quoted in Alexei Worth, "Black and White and Kara Walker," *Art New England* 17 (December 1995/January 1996): 27.

6 By taking *Uncle Tom's Cabin* for her textual flashpoint, Walker has tapped into the nineteenth-century manifestation of the dark world of the seduction narrative that began with *Clarissa*, a genre that literary historian Leonard Tennenhouse argues sought to explore relations between men through the exchange of women as property. Leonard Tennenhouse, "Libertine America," *Differences: A Journal of Feminist Cultural Studies* 11, no. 3 (1999/2000): 1–28.

7 Quoted in "Kara Walker," interview with Alexander Alberro, *Index* 1, no. 2 (1996): 26. The cyclorama to which Walker refers is *The Battle of Atlanta*, one of the few remaining cycloramas in existence in the United States. Containing nearly 20,000 feet of painted surface, it is located in Grant Park in Atlanta. The piece was commissioned in the late 1880s by General "Blackjack" Logan, a politician with vice presidential aspirations, and made in Milwaukee, Wisconsin, at William Wehler's American Panorama Company studio. Cycloramas, typically large-scale continuous paintings installed in a circular room, developed during the 1880s out of the slightly older genre of the panorama. American panoramas often depicted fantastic western landscapes like the Mississippi River, and were made by painting contiguous scenes on a large strip of canvas that was then put on rollers; these were cranked from right to left to give a seated audience the sense of moving through space. These two antique forms of "virtual reality" art/entertainment have evolved into the various emersion-style amusement park rides so popular today, such as Universal Studio's Back to the Future ride, which features an Imax screen and moving seats that literally put the spectator in the middle of the action.

8 In her 2001 exhibition at Brent Sikkema, Walker used black fabric to curtain off the space of the gallery in which she had installed similar projections. For a review of the show with a discussion of the projections, see Carol Schwazman, "New York," *Art Papers Magazine* 26, no. 1 (January/February 2002): 46.

9 Carl G. Jung, "Archetypes of the Collective Unconscious," in *Collected Works of C. G. Jung*, 2nd ed. (Princeton: Princeton University Press, 1968), vol. 9, part 1, pp. 3–41.

10 Freud, "Civilization and Its Discontents," in Gay, *The Freud Reader*, 722–771.

11 Freud, "The Ego and the Id. V: The Dependent Relationships of the Ego," in Gay, *The Freud Reader*, 654.

12 Freud, "The Ego and the Id. III: The Ego and the Super-Ego (Ego Ideal)," in Gay, *The Freud Reader*, 643.

13 Jung discusses the idea of the doppelgänger in relation to the fourth cycle of the hero myth that involves the twin children of the Sun, who have opposite personalities. Following their separation, they seek endlessly to be reunited. See Carl Jung, *Man and His Symbols* (New York: Dell, 1964), 103–106.

14 W. J. T. Mitchell, *Picture Theory: Essays on Verbal and Visual Representation* (Chicago: University of Chicago Press, 1995), 183–207. Mitchell provides a complex and deeply nuanced discussion of the genre of the slave narrative and the challenge of knowing that which can never be known about the experiences of people who were systematically denied voice and personhood.

15 Edgar Allan Poe, "Legeia," in *The Tell Tale Heart and Other Writings* (New York: Bantam, 1982), 64, 70.

16 Marilyn Yalom, *A History of the Breast* (New York: Knopf, 1997), 8. A discussion of American slavery and the breast is found on 123–125.

17 E. Hellerstein et al., eds., *Victorian Women: A Documentary Account of Women's Lives in Nineteenth-Century England, France, and the United States* (Stanford: Stanford University Press, 1981), 231–232, quoted in Yalom, *A History of the Breast*, 124.

18 Toni Morrison, *Beloved* (New York: Plume, 1988), 200.

19 It is important to note that in the "real-life" story of Margaret Garner, on which the fictional tale of *Beloved* is based, the child that Garner kills was probably fathered by her master, Archibald Gaines. The horror of this moment is intensified when Gaines discovers the body of his dead daughter and bursts into hysterics, thus emphasizing the complex nature of familial love and relationships under slavery. For more on Garner, see Steven Weisenburger, *Modern Medea* (New York: Hill and Wang, 1998).

20 "At a time at which the first beginnings of sexual satisfaction are still linked with the taking of nourishment, the sexual instinct has a sexual object outside the infant's own body in the shape of his mother's breast. . . . But even after sexual activity has become detached from the taking of nourishment, an important part of this first and most significant of all sexual relations is left over, which helps to prepare for the choice of an object and thus to restore the happiness that has been lost. All through the period of latency children learn to feel for other people who help them in their helplessness

and satisfy their needs a love which is on the model of, and a continuation of, their relation as sucklings to their nursing mother." Freud, "The Transformations of Puberty," in Gay, *The Freud Reader*, 288.

21 The taboos against lesbianism and child neglect that Walker flouts are similar to standard gothic tropes such as the dark secret of incest that lurks in the shadows in Edgar Allan Poe's "The Fall of the House of Usher," in *The Tell Tale Heart and Other Writings*, 25–43, or the spectacular picture of childhood abandonment that Shirley Jackson constructs in *The Haunting of Hill House* (New York: Viking, 1959).

22 Alice Walker, *The Color Purple* (New York: Pocket Books, 1985). See also Alice Walker, *The Same River Twice* (New York: Scribner, 1996) wherein she discusses the book and the process of making the movie.

23 Quoted in Jerry Saltz, "Kara Walker: Ill-Will and Desire," *Flash Art*, no. 191, international edition (November/December 1996): 84.

24 Frederick Douglass, *Narrative of the Life of Frederick Douglass, An American Slave, Written by Himself* (New York: Signet, 1968; originally published in 1854), 25.

25 Nell Irvin Painter, *Sojourner Truth: A Life, a Symbol* (New York: Norton, 1997).

26 Sojourner Truth, *Narrative of Sojourner Truth* (Chicago: Johnson, 1970; originally published in 1850, reprinted in 1875 with additional notes).

27 Painter, *Sojourner Truth*, 6, 15–16.

28 *Negress Notes* was displayed on the wall opposite *The End of Uncle Tom and the Grand Allegorical Tableau of Eva in Heaven* in the 1997 exhibition "Upon My Many Masters: An Outline" at SFMOMA.

29 Johnson was the author of *Clarence and Corinne; or, God's Way* (New York: Oxford University Press, 1988; originally published Philadelphia: American Baptist Publication Society, 1890). Mossell authored *The Work of the Afro-American Woman* (New York: Oxford University Press, 1988; originally published Philadelphia: G.S. Ferguson, 1894).

30 Rinder interview, *Capp Street Project*.

31 Quoted in Sheets, "Cut It Out!" 126.

32 Quoted in Saltz, "Kara Walker," 84.

33 Ibid.

34 Oswaldo de Andrade, *Revista de Anthropophagia* (São Paulo), no. 1 (May 1928); reprinted in Dawn Ades, *Art in Latin America: The Modern Era, 1820–1980* (New Haven: Yale University Press, 1989), 312–313.

35 Sigmund Freud, "The Phases of Development of the Sexual Organization,"

p. 273, from "Three Essays on the Theory of Sexuality," in Gay, *The Freud Reader*, 239–286.

36 For an in-depth discussion of minstrelsy, please see Eric Lott, *Love and Theft: Blackface, Minstrelsy and the American Working Class* (New York: Oxford University Press, 1993).

37 Bryan Jay Wolf, *Romantic Revision: Culture and Consciousness in Nineteenth-Century American Painting and Literature* (Chicago: University of Chicago Press, 1982), 132–133.

38 Washington Irving's humorous history of the Dutch regime in New York, *A History of New York*, was published in 1809 under the penname Dietrich Knickerbocker, an imaginary Dutch-American historian. See *A History of New York, from the beginning of the world to the end of the Dutch dynasty: Containing among many surprising and curious matters, the unutterable ponderings of Walter the Doubter, the disastrous projects of William the Testy, and the chivalric achievements of Peter the Headstrong, the three Dutch governors of New Amsterdam; being the only authentic history of the time that ever hath been, or ever will be published,* by Diedrich Knickerbocker (New York: Inskeep and Bradford, 1809).

39 Douglass, *Narrative*, 23.

40 In many ways, Walker's work reflects the influence of Sade's writings on libertine sexual freedom and pleasure and pain. See Marquis de Sade, *Justine or Good Conduct Well Chastised* (Paris: Olympia, 1959; originally published 1797).

41 Kirk Savage, *Standing Soldiers, Kneeling Slaves: Race, War, and Monument in Nineteenth-Century America* (Princeton: Princeton University Press, 1997), 21.

42 Douglass, *Narrative*, 23.

43 Linda Brent [Harriet Jacobs], *Incidents in the Life of a Slave Girl*, edited by Lydia Maria Child, introduction by Walter Teller (New York: Harcourt, Brace, Jovanovich, 1973; originally published Boston, 1861), 52.

44 Gaines M. Foster, "Guilt over Slavery: A Historiographical Analysis," *Journal of Southern History* 56, no. 4 (November 1990). I wish to thank the historian of American abolitionism Stephen Kantrowitz, my colleague at the Radcliffe Institute for Advanced Study in 2002–2003, for directing me to this valuable reference.

45 A quick Google search on the Internet for the key words "guilt" and "slavery" produces a bevy of articles from the current public discourse over reparations for slavery. These articles, largely authored by conservative

European American reactionaries who oppose monetary reparations of any sort to the descendants of slaves, routinely deny that any type of inherited guilt might be manifest in the reality of their own white privilege. These pundits also refuse the national, governmental culpability of the United States, or the responsibility of the still functioning companies that profited from slave labor during the nineteenth century. For a representative example of this mode of thought, see Robert W. Tracinski, "Apology for Slavery Will Perpetuate Racism," Ayn Rand Institute, 1998, http://multiculturalism.aynrand.org/apology.html.

46 Tony Horwitz, *Confederates in the Attic: Dispatches from the Unfinished Civil War* (New York: Vintage, 1998), 126, 136.

47 Art historian Robert Hobbs discusses the potential importance of the Confederate Memorial at Stone Mountain, Georgia, for the understanding of Walker's artistic development in his essay "Kara Walker: White Shadows in Black Face," in *Kara Walker* (Hannover, Germany: Kunstverein Hannover, 2002), 75–76.

48 The dyad of white and black viewers that I am presenting necessarily ignores the multiplicity of viewing self-identifications that are undoubtedly present among gallery goers at Walker's shows. Why not address other racial or ethnic identifications, sexual or gender differences among viewers, or question how other "others" approach and interface with the traumatic impact of African slavery in America? Unfortunately, complete investigations of these avenues of inquiry are beyond the scope of this book. But it is important to note that in discussions with viewers at several of Walker's exhibitions, including the one at which this work was shown, I have found that they frequently recognize personal affinities within and take offense at elements of these silhouettes along themes of universal human suffering. For example, Jewish viewers often discuss the Holocaust and the sense of guilt that survivors had. Interestingly, Walker's work has been best received abroad in German-speaking countries. Since the late 1990s she has had numerous exhibitions in Austria, Switzerland, and Germany. This response is perhaps due to the lingering nature of traumatic experiences like slavery and genocide and the guilt over nonresistance, lack of agency, or collaborationist complicity.

49 Quoted in Sheets, "Cut It Out!" 128.

50 Dan Cameron, "Kara Walker: Rubbing History the Wrong Way," *On Paper* 2, no. 1 (September/October 1997): 14.

51 Nico Isreal, "Kara Walker: Brent Sikkema," *ArtForum International* 40, no. 3 (November 2001): 145.

52 Simon Wallis, "London: Recent American Painting," *Burlington Magazine* 140, no. 1144 (July 1998): 496.

53 Mark Edmundson, *Nightmare on Main Street: Angels, Sadomasochism and the Culture of the Gothic* (Cambridge, Mass.: Harvard University Press, 1997), 5.

Chapter 3 The Lactation of John Brown

1 On October 16, 1859, Brown led a group of twenty-one men into what is now West Virginia to seize the Federal Armory in the town of Harpers Ferry and to incite a slave rebellion in the surrounding area. The plan was to strike the spark that would lead to an uprising of slaves in the surrounding area and throughout the South. Brown and his men managed to hold the town for twelve hours before they were defeated at a firehouse, to which they had retreated with eleven prisoners. Brown was wounded in the capture and jailed in Charlestown, Virginia. His trial began just ten days later, and by October 31 he had been convicted of treason and conspiracy to incite slave rebellion. He was sentenced to death on November 2 and hanged the following month. There is a large body of biographical work available on Brown; one of the most readable late-twentieth-century biographies is Stephen B. Oates, *Our Fiery Trial: Abraham Lincoln, John Brown, and the Civil War* (Amherst: University of Massachusetts Press, 1979).

2 Rinder interview, *Capp Street Project.*

3 Mark A. Reid, *PostNegritude Visual and Literary Culture* (Albany: State University of New York Press, 1997), 3.

4 *New York DailyTribune*, 5 December 1859 (dateline 3 December), p. 8.

5 John Greenleaf Whittier, *The Complete Poetical Works of John Greenleaf Whittier* (Boston: Houghton Mifflin, 1894), 106–107.

6 African American abolitionist and writer Frederick Douglass was an ardent supporter of Brown and spoke out publicly during his friend's ordeal. On receiving word of Brown's capture at Harpers Ferry, Douglass, acutely sensitive to the possibility of guilt by association, fled the country for Canada. On October 31, he wrote his hometown *Rochester Democrat* in an effort to prove his innocence: "I may be asked why I did not join John Brown— the noble old hero whose one right hand has shaken the foundation of the American Union, and whose ghost will haunt the bed-chambers of all the born and unborn slave holders of Virginia through all their generations, filling them with alarm and consternation!" Proclaimed Douglass, "My answer to this has already been given, at least impliedly given, 'The tools to those who can use them.' Let every man work for the abolition

of Slavery in his own way. I would help all and hinder none." Reprinted in Benjamin Quarles, *Blacks on John Brown* (Urbana: University of Illinois Press, 1972), 10.

Henry David Thoreau's "A Plea for Captain John Brown" was presented on October 18 in an effort to aid the prisoner and what remained of his family. It was first given as a lecture and later reprinted in a sympathetic, authorized biography of Brown by James Redpath. "I am told that his grandfather, John Brown, was an officer in the Revolution," began Thoreau. "He was by descent and birth a New England farmer, a man of great common sense, deliberate and practical as that class is, and tenfold more so." Thoreau then linked Brown to a familial tradition of dedication to liberty and to country: "He was like the best of those who stood at Concord Bridge once, Lexington Common, and on Bunker Hill, only he was firmer and higher principled than any that I have chanced to hear of as there." Reprinted in Richard Scheidenhelm, ed., *The Response to John Brown* (Belmont, Calif.: Wadsworth, 1972), 38–58. Here we see the desire to link the abolition of slavery to unfinished business of the Revolutionary War. Not only is Brown descended from an officer in said war, but he is in fact "higher principled" than the soldiers who actually fought it. Reaching back into history, searching for strands of idealism, purity of religious belief, and higher principles, Thoreau also linked Brown to Cromwell and the original Puritan colonists. Later, the essayist organized a memorial for Brown in Concord, Massachusetts, that was held on "Martyr Day," December 2, 1859, concurrent with the execution in Charlestown, at which both he and Ralph Waldo Emerson read eulogies.

7 Van Wyck Brooks, "On Creating a Usable Past," *The Dial*, 1 April 1918, 337–341.

8 Cities where such observations were held included Boston, New York, Philadelphia, Cleveland, and Detroit.

9 Quarles, *Blacks on John Brown*, 54.

10 George Washington Williams, *History of the Negro Race in America from 1619 to 1880* (New York: G.P. Putnam's Sons, 1883). The section "John Brown—Hero and Martyr" is generally laudatory and supportive. In addition to containing Williams's assessment of Brown's legacy, the chapter features a previously unpublished letter that Brown wrote to the wife of one of his supporters, Mrs. George L. Stearns. Given the apocryphal nature of the story of the kiss on the jailhouse stairs, and the fact that the letter remained unpublished until 1883, Brown's comments, quoted as an epigraph to this chapter, seem particularly prescient (volume 2, p. 227).

11 "The leonine soul of this old hero saint and martyr," began Ransom, who
would later rise to the office of bishop in the AME Church, "proves how im-
potent and defenseless are tyranny, injustice and wrong, even when upheld
by the sanction of law, supported by the power of money and defended by
the sword." *The Voice of the Negro* (Atlanta), October 1906, 412; reprinted in
Quarles, *Blacks on John Brown*, 79.

12 W. E. B. Du Bois, *John Brown* (Northbrook, Ill.: Metro Books, 1972), 8.

13 Quarles, *Blacks on John Brown*, 45.

14 Johnson's poem is in the form of an honorific song: "Hearken to the lay
chanted by dusky millions, soft and mellow-keyed, in minor measure, Mar-
tyr of the Freed, a song of memory across the day. / Truth cannot perish
though the earth erase the royal signals, leaving not a trace, and time still
burgeoneth the fertile seed, though he is crucified who wrought the deed."
The Crisis, August 1922, 89.

Cullen's "Lullaby" crowned Brown as an "Archangel" in heaven: "His
sons are high fellows; An Archangel is he; They doff their bright halos To
none but the Three." *Opportunity*, January 1942, 7.

15 Truman Nelson, *The Old Man: John Brown at Harper's Ferry* (New York: Holt,
1973).

16 E-mail interview.

17 Shortly after its creation in 1861, P. T. Barnum purchased the painting. The
flamboyant showman installed it in the motley collection of his American
Museum in New York City. Its presence there allowed the northern pub-
lic to judge for themselves whether the freedom of the enslaved African
American in the South was worth the physical sacrifices that abolitionists
insisted would have to occur. See Neil Harris, *Humbug: The Art of P. T. Bar-
num* (Boston: Little, Brown, 1973), 61–89.

18 Ransom's complexly allegorized scene of *John Brown on His Way to Execu-
tion* as adapted in the 1863 lithograph includes several other figures who
each carry the burden of allegorically representing a different aspect of the
martyrdom's narrative. Down to the left, beneath the stairs, is the crippled
figure of Justice, who, with a shifted blindfold, represents the miscarriage
of law achieved by Brown's execution. Standing above her is a male figure
dressed as a steamboat captain, representing the industrial and commer-
cial concerns of the northern states who profited from slavery's ability to
supply cheap raw materials for their factories and mills. Behind him stands
a male figure wearing antique dress and the evocative number 76 on his
hat, meant to be a veteran of the Revolutionary War. This figure embodies
the pre-Jacksonian patriotism and opposition to governmental tyranny

and the external subjugation of the individual praised by Thoreau. This antityrannical theme continues with the large flag of the old state of Virginia (where the raid on Harpers Ferry took place and where Brown was tried, convicted, and executed) unfurled to create a halo for the martyr's head. On its face are the symbolic figures of a woman with a sword and staff standing over the prone body of a man surrounded by the motto "Sic Semper Tyrannis," or "Thus ever to tyrants," a phrase that would have seemed ironic to abolitionists and free-staters at the time. Beneath the flag and to the right of Brown are three other figures representing forces at work in his martyrdom. First is a man with a long white beard and mustache wearing a wide-brimmed hat, representing the pro-slavery forces of the western territories. Next to him is the embodiment of the South in the figure of an elegantly dressed gentleman wearing a vested suit with velvet lapels and a silk necktie, finery that has been made upon the backs of slaves; although his distinguishing facial features are obscured, his prominently receding hairline indicates that his time is just about up. He too, like the frontiersman, directs Brown on his way out to the gallows in an effort to save his own way of life through the exemplary death of Brown. The final figure is a Hessian soldier of the Revolutionary War era, representing someone without patriotic loyalty, holding an unsheathed sword. Together, these allegorical characters represent the conspiratorial forces that sought to suppress the type of patriotic, Christian abolitionism that Brown personified.

The visualization of the desire to see Brown as a hero of the Revolution born too late may be witnessed in the personifications of political ideals of the founding fathers in the allegorical figures in the Currier and Ives print. We see the currency of Thoreau's argument (as stated previously) in the fact that they are presented as players in the contemporary discourse of the Civil War era. If we focus on the 76er in the composition, we can trace a diagonal line directly from him to the Hessian soldier. We can now see Brown standing in the line between patriotism and tyranny. He follows the path forged by the 76er and neglected by the other figures that surround him. He alone rises to meet the mercenary forces, represented by the soldier. In so doing, it is he alone who defends the enlightened and progressive ideals of the American Revolution.

19 Brown's general physical appearance in both of the Ransom compositions, and in the Walker as well, is adapted from an 1859 photograph. The abolitionist posed for J. W. Black that spring while visiting Boston on a trip to raise funds for the fateful attack on Harpers Ferry. It is reproduced on the frontispiece of *A John Brown Reader*, ed. Louis Ruchames (Lon-

don: Abelard-Schuman, 1959), with the caption "This copy made from a print for Thaddeus Hyatt, 1859, for sale to provide a fund for the relief of Brown's family." The image shows Brown holding his arms behind his back and staring out with a deeply penetrating gaze, producing an image of steadfast resolution. In the Ransom images, Brown is shown in this same pose; however, the arms that were once withdrawn willingly are now forcibly bound. His clothes are more smoothly tailored and his beard better groomed; his hair has been slightly parted and brushed neatly away from his face.

20 Other changes in the composition reflect the altered political milieu of the postbellum era. The soldier has absorbed all the significance of the other allegorical characters that have since vanished from the composition. He gestures toward the gallows with his right hand while his left rests on the hilt of his sheathed sword, a weapon that he held at the ready in the 1863 print. While retaining the stern look on his face, the change in the position of his weapon signals a postwar desire to figure the collective memory of the antebellum American military as that of a reluctant executioner.

21 Kirk Savage, *Standing Soldiers, Kneeling Slaves: Race, War, and Monument in Nineteenth Century America* (Princeton: Princeton University Press, 1997), 76–77.

22 In *Standing Soldiers, Kneeling Slaves,* Savage examines how the legacy of the Civil War and Emancipation was dealt with in monumental sculpture set in public spaces. Savage argues that images like the *Emancipation Group* perpetuated older ideas of slavery while attempting to create a nationalist image of a united country.

23 Unlike Ransom, Hovenden strove for historical accuracy rather than allegorical potential when it came to the costumes for his figures. Brown's clothes are threadbare, and he wears bedroom slippers on his way to the scaffold. However, the painter was not above employing additional visual devices to emphasize Brown's martyrdom: he created a crucifix behind Brown using the lines found in the rifle and belt of the jailer standing behind the condemned man and the bricks in the building. Brown's hair has taken on a bit of the ecstatic wildness of his zealotry, and his arms now strain at their bonds more forcefully.

24 Albert Boime, *The Art of Exclusion: Representing Blacks in the Nineteenth Century* (Washington, D.C.: Smithsonian Institution Press, 1990).

25 The story of Hagar is recounted in Genesis, chapters 16, 21, and 25.

26 Quoted in Edward Lucie Smith, *Sexuality in Western Art* (London: Thames and Hudson, 1991), 213.

27 This orientalizing impulse on the part of Noble may be linked to his studies in France during the late 1850s. For more on Noble, see James D. Birchfield et al., *Thomas Satterwhite Noble, 1835–1907* (Lexington: University of Kentucky Art Museum, 1988).

28 E-mail interview.

29 Ann Douglas argues that Stowe's method of sentimentalizing the plight of the enslaved blacks worked to incite and empower her largely white, Christian, female audience. See *The Feminization of American Culture* (New York: Noonday Press, 1977).

30 Jane P. Tompkins, "Sentimental Power: Uncle Tom's Cabin and the Politics of Literary History," in *Sensational Designs: The Cultural Work of American Fiction, 1790–1860* (New York: Oxford, 1985), 122–146.

31 The slave woman's dress, a long tight-fitting gown shown with the right sleeve rolled up above the elbow, is adapted from the Ransom lithograph and indicates her position as a woman of work, not leisure. The wrap that she wears about her head appears to be borrowed from the Hovenden, yet there is nothing servile about its placement on her newly defiant head.

32 The most recent fictional adaptation of Brown's life may be found in Russell Banks's novel *Cloudsplitter* (New York: Harper Collins, 1999). Banks is also the author of *Affliction* and *The Sweet Hereafter*, two critically acclaimed novels recently made into films, leading one to suspect that Brown's story may soon reenter public discourse in a cinematic format.

33 Quarles, *Blacks on John Brown* is an excellent resource for charting the development of this phenomenon within the rhetoric of the African American community itself. Quarles offers the reader original texts as well as analysis of their contents.

34 Powell cites three major exhibitions of "Negro" life that were held in the United States, at Dallas (1936), Baltimore (1939), and Chicago (1940), which featured exhibitions on the abolishment of slavery and information about Brown's importance to African Americans. He also stresses the importance that black organizations such as the Association for the Study of Negro Life and History had on the black community at large. Richard J. Powell, *Homecoming: The Art and Life of William H. Johnson* (New York: Norton, 1993), 71.

In 1942 Horace Pippin painted three images related to Brown: *John Brown Reading His Bible* (the Crispo Collection), *The Trial of John Brown* (the Fine Arts Museums of San Francisco), and *John Brown Going to His Hanging* (Pennsylvania Academy of Fine Arts). The final image shows Brown in the back of a wagon on his way to the gallows, rather than the familiar trip

down the jailhouse stairs. Powell suggests that a "possible consideration in looking at the . . . John Brown paintings was Pippin's desire—either conscious or otherwise—to create works that would indulge his overwhelmingly white, affluent, and racially tolerant clientele" (78). Pippin also created a number of works that display a decidedly leftist ideology, such as *Mr. Prejudice* (1943, Philadelphia Museum of Art). This desire to appease white patronage is an accusation that has been levied at Walker as well.

35 From an unpublished document held by the DIA, quoted in Ellen Sharp, "The Legend of John Brown and the Series by Jacob Lawrence," *Bulletin of the Detroit Institute of Arts* 67, no. 4 (1993): 21.

36 *The Legend of John Brown* (Detroit Institute of Arts, 1978). See Sharp, "The Legend of John Brown," for a brief analysis of the Lawrence series which follows an in-depth history of the Brown legend and imagery.

37 Ibid., 16.

38 It should be noted that beginning in 1941, when he secured representation from Edith Halpert's Downtown Art Gallery, Lawrence began to receive extensive critical attention from the mainstream art world. That same year his *Migration Series* was featured in *Fortune* magazine and was collected by Alfred H. Barr, curator at the Museum of Modern Art, and by Duncan Phillips.

39 The project for early-twentieth-century African American visual artists dovetailed with that of anticapitalist insurgents of the 1930s, who considered Brown a savior for the general proletariat, not just an icon for exploited and oppressed African Americans. For these activist-artists, the intent was to revise the visual record by emphasizing the heroic deeds of Brown's life, rather than to continue the sentimentalization of the fictional events directly preceding his death. Brown appealed to many politically radical artists because of what they believed to be his symbolic function as a "precursor of the modern Communist party and the Civil War, a forerunner of the coming proletarian revolution." M. Y. Himmelstein, *Drama Was a Weapon: The Left-wing Theatre in New York, 1929–1941*, quoted in M. Sue Kendall, *Rethinking Regionalism: John Steuart Curry and the Kansas Mural Controversy* (Washington, D.C.: Smithsonian Institution Press, 1986), 82. In a lost series of mural panels painted by the Mexican artist Diego Rivera for the New Workers School, the anti-Stalinist, Communist Party opposition, in 1933, Brown is shown no fewer than three times. In the cycle Rivera figures Brown, rather than Lincoln, as the hero of the Civil War. In 1937 Japanese American artist Eitaro Ishigaki chose to put Brown at the center of a mural that he was commissioned by the Federal Art Project of the Works

Progress Administration to create for the Harlem Courthouse in New York City featuring prominent figures from African American history.

The European American regionalist painter John Steuart Curry, also working under the auspices of the FAP/WPA, painted Brown at the center of his mural *The Tragic Prelude* at the Kansas State House in 1937–1942. At the center of the mural, Curry shows a wild-eyed and open-mouthed Brown with his arms outstretched, one dripping with blood and holding an open Bible, the other brandishing a shotgun. In her painting, Walker rejects the politically strident image of Brown as a communist crusader that the social liberals of the 1930s would have had him symbolize. Rather than the pro-letarian hero of the Rivera work or the truculent guerrilla of Curry's piece, she depicts Brown as deflated and empty of the fervor that inspired such agitated images. By contrast, her painting depicts Brown's arms as nearly amputated, his eyes squeezed shut, and his mouth unable to speak. The corpulent child who pulls hungrily at his breast has sucked out all of the fire and zeal that radiates from his body in these murals.

40 This ability to "touch the soul" was due in large part to Brown's funda-mental Christian belief that all of God's children were equal and that en-slavement was a mortal sin. Unlike Lincoln, who can be praised for his eventual emancipation of the slaves but was actually more motivated by capitalist concerns over the splitting up of the Union, with Brown's abo-litionism there was no ulterior incentive for economic or political gain. Brown risked his life, time after time, as though it were his own kin he was trying to liberate with his actions.

41 This painting is reproduced in Judith Stein et al., *I Tell My Heart: The Art of Horace Pippin* (Philadelphia: Pennsylvania Academy of the Fine Arts, 1994), 73.

42 In its purely "pioneering" subject matter, Johnson's composition is simi-lar in structure and content to George Caleb Bingham's 1851–52 painting *Daniel Boone Escorting Settlers through the Cumberland Gap* (Washington Uni-versity Gallery of Art), an image that shows the legendary frontiersman leading a group of white migrants through hostile and menacing territory.

43 It is important to note that Johnson was married to a Danish woman, the textile artist Holcha Krake.

44 Powell, *Homecoming*, 72.

45 Other works by Noble also share a racialized sexual subtext of persecuted slave women and powerful white men. In the 1865 painting *The Last Sale of Slaves in Saint Louis* (Missouri Historical Society), accessible today only in an 1870 replica, a group of slaves of varying hues have been gathered about

the bottom of a dais on which a human sale is taking place. The action focuses on the figure of a slave woman described by various reviewers of the time as an "octaroon" ("Home Art. 'Slave Sale, by Noble," *St. Louis Guardian,* 7 July 1866) and as "parti-colored" (cited in J. D. Birchfield, "Thomas Satterwhite Noble: 'Made for a Painter,'" *Kentucky Review* 6 [winter 1986]: 44), who is being auctioned off by a white man. As the right arm of the auctioneer rises up above his head, a diagonal line is created pointing to the seated figure of a light, yet not white, woman to the lower right.

The two mixed-race women at the center of *The Last Sale of Slaves at Saint Louis,* like the slave woman in *John Brown's Blessing,* are the product of miscegenation. All three women quite literally embody a legacy of interracial sexual encounters that offended and titillated these paintings' intended audience of white male viewers. The mixed-raced women who found themselves on the auction block had transgressive sexuality and potential availability inscribed on their very skin. Their lightness yet not whiteness made them the most expensive of slaves and arguably more often the object of their masters' sexual overtures and abuse. This is the story that we are told by Harriet Jacobs in her narrative *Incidents in the Life of a Slave Girl* (Boston, 1861). The Kentuckian Noble would have been familiar with stories of the sale of women who were nearly white yet legally black, as they were often used to dramatize arguments for abolition. We can now read the vulnerability of the sociosexual position of the slave woman in *John Brown's Blessing* as she kneels in pious prostration before Brown and presents him with her child. For she is much like the quadroon who stands on the block cradling her child in her arms, and she is related as well to the blonde-haired octoroon, whose downcast eyes and hands clasped primly in her lap simultaneously announce her virginity and protect it.

And yet there is another character in this drama, one that we should not forget: the figure of a bearded white man who sits just behind the lightest-skinned woman at the edge of the dais, in a position to control her fate. His head inclines toward the woman's back, his hands disappearing behind her chair, watching over her as she awaits her purchase. Because he ever so slightly resembles a balding version of Noble, and because he also resembles Noble's image of John Brown, we must read him as a mixture of the two, an incarnation of the dead man and a surrogate for the painter.

Another version of this figure may be found in the figure of the father in Noble's 1868 painting *The Price of Blood* (Morris Museum of Art). We see him in the plantation owner who sits to the right of a table before which a slave trader stands reading the terms of a sale agreement for the

exchange of the planter's mulatto son for several small stacks of gold coins. The planter is shown in a disheveled smoking jacket, open to the waist, indicating his debauched state, like his counterpart in *Last Sale*. But here the man's hand does not bless; instead, it commits a mortal sin as it signs away his own blood. The son, whose white features and brown skin mark him as the hybrid product of an interracial liaison, stands to the left of the table in a pose of sultry contrapposto modeled directly on Gainsborough's *Blue Boy*, exuding sexuality with his bare feet and close-fitting breeches. Like the figure of the slave women in *Last Sale* and *John Brown's Blessing*, the boy's blackness is cloaked and revealed simultaneously through his pose and clothing. He is an erotically charged figure who carries within his body the weight of his patrimony and the illicit union that it represents.

46 Lott, *Love and Theft*, 25, 6.

47 Benjamin, *The Origin of German Tragic Drama*, 178.

Chapter 4 Censorship and Reception

1 Hyman, "A Carnival Sense of the World," 72.

2 Quoted in Pamela Newkirk, "Controversial Silhouette," *Artnews* (September 1999): 45.

3 Ibid.

4 See Ellis Cose, *The Rage of a Privileged Class* (New York: Harper Collins, 1993). Cose, a journalist with *Newsweek* magazine, discusses the impact of racism today on the African American elite.

5 For a discussion of Colescott's work during the 1970s, please see Lowery Stokes Sims, *Robert Colescott, a Retrospective, 1975–1986* (San Jose, Calif.: San Jose Museum of Art, 1987). For information on his work from the 1990s, see *Robert Colescott: Recent Paintings*, organized by Miriam Roberts in association with SITE Santa Fe and the University of Arizona Museum of Art (Tucson: University of Arizona Museum of Art, 1997).

6 For more information on the history of and the discourse surrounding this image, see Linda Seidel, *Jan van Eyck's Arnolfini Portrait: Stories of an Icon* (Cambridge, England: Cambridge University Press, 1993).

7 Colescott's content-driven examination of Western art history during the 1970s and 1980s had a direct descendant in the work of the British artist Nelson Brown, whose 1991 series "All the Blacks of the National Gallery, London" explored the absence of black artists in this famous collection of European art. It was composed of small abstract compositions made from the cut-out black backgrounds of famous paintings taken from National

Gallery postcards. Each piece, a sort of reverse silhouette of its subject, was titled after the work from which it was cut. This project, which to my knowledge was not followed by additional work by the artist, seems an odd foreshadowing of Walker's silhouette practice. There is very little information available about Brown; however, one review of the show at A Space, in which "All the Blacks of the National Gallery, London" appeared, can be found in *Flash Art International*, no. 162 (January/February 1992): 135–136.

8 Quoted in Elaine Viets, "A Case of Black-on-Black Censorship of Art," *St. Louis Post Dispatch*, 21 September 1993, 3D.

9 Ibid.

10 Quoted in Clint Zweifel, "Colescott Painting Causes Controversy on Campus," *The Current*, 27 September 1993. The term miscegenation was coined in the 1850s, during the period directly preceding the Civil War. Its usage reflected a fear that if African slaves were set free, European American slave masters would continue as openly sanctioned alliances the transracial relationships that had been well-known secrets during the antebellum period. There was, however, an even greater fear that the reverse situation would occur, with black men gaining access to white women's bodies. As a result of these fears, African American sexuality soon took on mythic status. But just as whites have feared interracial liaisons, so too have African Americans. Often in the African American community, blacks who have maintained romantic or sexual relationships with whites have been viewed as rejecting their culture and people, as having made a choice against their blackness, thereby incurring the wrath of their own people.

11 Ibid.

12 Quoted in Viets, "A Case of Black-on-Black Censorship."

13 In an ironic twist, the site chosen was a building named in honor of the nineteenth-century U.S. president who, it has recently been scientifically proven, had several children by his slave mistress, Sally Hemings. At the time of the crisis, the DNA typing of the Hemings-Jefferson descendants had not yet begun and the scientific factuality of the relationship had not yet been proven.

14 "Kara Walker," interview with Alexander Alberro, *Index* 1, no. 2 (1996): 25–28.

15 Quoted in Newkirk, "Controversial Silhouette," 45.

16 Unfortunately, today the number of curators of African American art, a designation almost synonymous with African American curator, at top-tier museums in the United States is in the single digits. These numbers seem to be declining rather than increasing, despite the number of programs that

museums have put in place to attract more racial minorities to the field. Re-
cently, two of the most well-known African American curators on the New
York scene, Lowery Stokes Sims and Thelma Golden, have left their re-
spective positions at the Metropolitan Museum of Art and the Whitney Mu-
seum of American Art. In a dynamic and controversial move, the two have
joined the staff of the African Americanist Studio Museum of Harlem as
director and head curator. My initial interest in the Colescott crisis at UMSL
came out of my thirteen-month tenure at the Saint Louis Art Museum as
the Romare Bearden Graduate Fellow, a program that was designed to ad-
dress the dearth of qualified African American museum professionals. In
this capacity, while learning curatorial and educational practice in the in-
stitution, I was often called on to participate in community matters as one
of the few African American art historians in the region. With one excep-
tion, I was the sole African American in a non-support staff position in
the museum's offices at the time. This was also the case the following year,
when I completed a similar fellowship that was designed to create diver-
sity at the San Francisco Museum of Modern Art. At SFMOMA, however, I
was the only black. During the early 1990s, these types of programs flour-
ished, with the Metropolitan Museum of Art, the Chicago Art Institute,
and others offering six-month to two-year internship positions for minority
graduate students and recent grads. These programs began to wane as the
institutions lost interest in continuing them due to the logistical problems
involved with recruitment and retention. Many of the participants in these
programs felt that one of the most difficult hurdles in adjusting to museum
work was a lack of eager mentors among the overwhelmingly nonblack staff
of these institutions.

17 "The Detroit Institute of Arts to Establish the General Motors Center for
African American Art," press release, http://www.dia.org/information/gm
.htm.

18 It is interesting to note that in 1998, the Forum, the center for contempo-
rary art in Saint Louis, held an exhibition of Walker's work that featured
the large wall installation *Virginia's Lynch Mob*. Given the relatively minimal
press coverage of the exhibition—only one article about the exhibition ran
in the city's main newspaper, the *St. Louis Post Dispatch*—it would seem that,
not surprisingly, venue had much to do with the reception of controver-
sial, racially charged art in central Missouri. For coverage of the exhibition
at the Forum, see Jeff Daniel, "Black-and-Whites Are Tinted with Gray," *St.
Louis Post-Dispatch*, 26 April 1998, D3.

19 In October 1998 the American Studies Association sponsored a panel on Kara Walker at their annual meeting. Much of what was discussed by the roundtable participants and the audience members centered on the artist's age and the impact that it had made on older artists who remained embittered by their lack of mainstream recognition and success despite decades of dedication and production.

20 Quoted in Bowles, "Extreme Times," 4.

21 Ibid., 13.

22 Richard Wright, *New Masses*, 5 October 1937, 22–23. Alain Locke, writing in *Opportunity* (1 June 1938) had similar complaints: "[*Their Eyes Were Watching God*] is folklore fiction at its best, which we gratefully accept as an overdue replacement for so much faulty local color fiction about Negroes. But when will the Negro novelist of maturity, who knows how to tell a story convincingly, which is Miss Hurston's cradle gift, come to grips with motive fiction and social document fiction? Progressive southern fiction has already banished the legend of these entertaining pseudo-primitives whom the reading public still loves to laugh with, weep over and envy. Having gotten rid of condescension, let us now get over oversimplication!"

23 The title of the conference came from Ralph Ellison's essay on African American folklore, "Change the Joke and Slip the Yoke," included in *The Collected Essays of Ralph Ellison*, edited and with an introduction by John F. Callahan, preface by Saul Bellow (New York: Modern Library, 1995).

24 A copy of the press release for the conference can be found at http://www .artmuseums.harvard.edu/press/released1998/jokeyolk.html.

25 Quoted in "PaperTrail: News from around the World," *Art On Paper* 4, no. 2 (November/December 1999): 22.

26 Quoted in Sheets, "Cut It Out!" 126–127.

27 Quoted in "PaperTrail," 22.

28 Quoted in Sidney Jenkins, *Look Away! Look Away! Look Away!* (Annandale-on-Hudson, N.Y.: Center for Curatorial Studies, Bard College, 1995), 26.

29 Discussing the impact of Andy Warhol on her work, Walker has said, "But perhaps it was more Warhol's persona than his work that interested me early on. I mean, I was fascinated by the way he operated in the artworld, and by the fact that people for the longest time, perhaps to this day, couldn't figure out if he was a genius or an idiot savant, a Chauncey Gardner" (Alberro, interview, 28).

30 Bowles, "Extreme Times," 7, 8.

31 Michele Wallace, "Afterword: 'Why Are There No Great Black Artists?' The

Problem of Visuality in African American Culture," in *Black Popular Culture: A Project by Michele Wallace*, ed. Gina Dent (Seattle: Bay Press, 1992), 334.

32 For one perspective on the intraracial gender subjugation, see bell hooks, *Ain't I a Woman: Black Women and Feminism* (Boston: South End Press, 1981).

33 Cornel West, "Black Sexuality: The Taboo Subject," in *The Meaning of Difference: American Constructions of Race, Sex and Gender, Social Class, and Sexual Orientation*, ed. Karen Rosenblum et al. (New York: McGraw-Hill, 1996), 225.

34 Wallace, "Afterword," 335.

35 Toni Morrison, "Introduction: Friday on the Potomac," in *Racing Justice, Engendering Power* (New York: Pantheon Books, 1992), xvi.

36 James Hannaham, "Pea Ball Bounce." *Interview* (November 1998): 118. The 1989 German film, *Das Schrechlich Mädchen* (*The Nasty Girl*) by director Michael Verhoeven examines the implications of speaking the unspeakable in a roughly comparable context. Based on a true story, the film is about a young woman who uncovers the hidden Nazi past of the members of her small West German village while writing an essay for a national contest on the subject "My Hometown during the Third Reich." In the process of exposing the past transgressions of her neighbors, she becomes a pariah among her own people, thus leading to the nickname found in the title. It should be noted, however, that Walker occupies a different place in American power relations than does the German protagonist of Verhoeven's film, since she is fantasizing and thus revealing both black and white racial anxieties and perversities.

37 Walker, "How my work so . . . far is a miserable failure . . . How my work so far is a tremendous success . . .," in *Kara Walker* (Chicago: Renaissance Society at the University of Chicago, 1997), unpaginated.

38 Hyman, "A Carnival Sense of the World," 72.

Chapter 5 Final Cut

1 Conversation with Kara Walker, December 1998. As Roland Barthes asserts, the photograph fixes the subject in time so completely that mortality is undeniable. Once the picture has been taken, the subject is fixed, and there is no return to that moment in time. This unique relationship between mechanical reproduction and the temporal allows a photograph the rare ability to elucidate the construction of an individual's subjectivity within his or her own time. In this way, a photograph may be treated as a

constructed site wherein the subject's body functions as a visual sign for a larger, culturally derived signified. See Roland Barthes, *Camera Lucida: Reflections on Photography*, translated by Richard Howard (New York: Hill and Wang, 1981), 14–15.

2 Hannaham, "Pea, Ball, Bounce," 118.

3 Nancy Princenthal, "Kara Walker at Wooster Gardens," *Art in America* 87, no. 2 (February 1999): 106.

4 Art critic David Frankel wrote that "an installation using found ornamental mirrors [was] (the least rewarding here)." "Kara Walker: Wooster Gardens," *Art Forum International* 37, no. 8 (April 1999): 123.

5 Michele Wallace, "Variations on Negation and the Heresy of Black Feminist Creativity," *Heresies* 6, no. 2 (1989): 74.

6 Barbara Johnson, *A World of Difference* (Baltimore: Johns Hopkins University Press, 1987), 166–171, paraphrased in ibid., 72.

7 *Kara Walker*, catalogue, unpaginated.

8 Julia Szabo, "Kara Walker's Shock Art," *New York Times Magazine*, 23 March 1997, 49.

9 Henry T. Tuckerman, *Book of the Artists* (New York: G. P. Putnam, 1867), 603–604.

10 Venise Wagner, "For This Artist, the Joke's on All of Us," *San Francisco Examiner*, Arts and Ideas section, 16 February 1997, C17.

11 Bowles, "Extreme Times," 7.

12 Juliette Bowles, "Editor's Response," *International Review of African American Art* 15, no. 2 (1998): 50.

13 Judith Wilson, "Beauty Rites: Towards an Anatomy of Culture in African American Women's Art," *International Review of African American Art* 11, no. 3 (1994): 13.

14 George Du Maurier, *Trilby* (New York: Harper and Brothers, 1894), 457–458, quoted in Alexander Nemerov, *Frederic Remington and Turn-of-the-Century America* (New Haven: Yale University Press, 1995), 161.

15 *Kara Walker*, catalogue, unpaginated.

16 *Interview* magazine was founded by Warhol in 1969 as a film journal. It rapidly progressed to a general review of popular culture.

17 Eleanor Heartney, "Basquiat/Warhol: Tony Shafrazi," *Flash Art* (December 1985/January 1986): 43, quoted in Phoebe Hoban, *Basquiat: A Quick Killing in Art* (New York: Penguin, 1998), 265.

18 bell hooks, "Altars of Sacrifice: Re-Membering Basquiat," in *Art on My Mind: Visual Politics* (New York: New Press, 1995), 43.

19 On a speculative note, this image choice may have come about through

Walker's anxiety about having to attend to the preservation of her career through the constant increase of her oeuvre, rather than spend her days as a stay-at-home mom with her daughter, who was just over one year old at the time.

20 Kara Walker, "Motifs and Motivations: The Historical Romance and Me," in *Kara Walker*, catalogue, unpaginated.

21 Quoted in Szabo, "Kara Walker's Shock Art."

22 See Romare Bearden and Harry L. Henderson, *A History of African-American Artists: From 1792 to the Present* (New York: Pantheon Books, 1993), 8. Bearden and Henderson discuss the controversy over Johnson's mysterious origins: no one has definitively established his racial identity or ethnic background due to conflicting evidence; and the debate over whether his name was Johnson or Johnston is also addressed.

23 Mrs. Nancy Prince, *A Narrative of the Life and Travels of Mrs. Nancy Prince: Written by Herself*, 2nd ed. (Boston: Author, 1853), reprinted in Henry Louis Gates Jr., ed., *Collected Black Women's Narratives* (New York: Oxford University Press, 1988).

24 Child's writings included *The First Settlers of New England; or, conquest of the Pequods, Narragansets and Pokanokets* (Boston: Carter and Hendee, 1828) and *The Frugal Housewife* (Boston: March and Capin, 1829). In the 1830s she published a spate of books in the Ladies Family Library series, including *The History and Condition of Women in Various Ages and Nations*, 2 vols. (Boston: John Allen, 1835). By the 1860s most of her writing was devoted to antislavery causes. In 1860 she compiled *The Patriarchal Institution, as Described by Members of its Own Family* (New York: American Anti-Slavery Society, 1860).

25 Jean Fagan Yellin writes that without the support of Child, Jacobs could not have gotten her manuscript published. This is borne out by evidence that the former slave first approached Harriet Beecher Stowe, and then decided against such an alliance. She was subsequently unable to publish without a prominent endorsement until she was introduced to Child, who offered to serve as her editor. Jean Fagan Yellin, "Text and Contexts of Harriet Jacobs' Incidents in the Life of the Slave Girl: Written by Herself," in *The Slave's Narrative*, ed. Charles T. Davis and Henry Louis Gates Jr. (New York: Oxford University Press, 1985), 262–282.

26 Ibid.

27 hooks, "Altars of Sacrifice," in *Art on My Mind* (New York: New Press, 1995), 40.

28 As quoted in Jessica Kerwin, "Kara Walker," *W* (February 2000): 117. See

Gayatri Chakravorty Spivak, "Explanation and Culture: Marginalia," in *Out There: Marginalization and Contemporary Cultures*, ed. Russell Ferguson et al. (Cambridge, Mass.: MIT Press, 1990), 377–393. Spivak discusses the interaction between a marginalist feminism and a masculinist centralism as a narration of displacement, constantly shuttling between the outside and the inside of a discourse (381). This same kind of shuttling may be seen between the black subject/object and the white viewer/reader in the relationships between both Lewis and Walker and their respective intended audiences.

29 The two women were first introduced by the prominent abolitionist William Lloyd Garrison in 1863, when the aspiring young artist arrived in Boston from Oberlin, Ohio, where she had attended college for three years. Lewis began her professional career in earnest in 1865; using money from sculpture sales she moved to Rome, the center of sculptural study in the Western world. There she earned fame for her racially themed marble sculptures of idealized freed slaves, such as *Forever Free*, and of noble Indians, like *The Old Arrow Maker*. Lewis returned to the United States several times; in 1873 she exhibited in San Francisco with the Art Association, and in 1876 she exhibited a crowd-pleasing, life-size dying *Cleopatra* at the Centennial Exposition in Philadelphia. However, the neoclassical style in which she worked eventually fell out of favor, and her career went into an irreversible decline. Soon after 1900, Lewis vanished from the historical record. While the exact date of her death remains a mystery, what is believed to be the final record of her signature was recently found in a guest book from 1909 kept by the U.S. Embassy in Rome. See Charlotte Rubenstein, *American Women Sculptors* (Boston: G. K. Hall, 1990), 51–56. See also Deborah Pickman Clifford, *Crusader for Freedom: A Life of Lydia Maria Child* (Boston: Beacon Press, 1992), 265–266, for a brief analysis of the two women's relationship and for general information about Child.

30 In a strategy similar to that employed by Walker in the caustic self-critique of *Cut* to address her fetishization in the DeWitt photograph, Lewis responded to the identity politics of the nineteenth century by safeguarding her own carefully constructed physical identity. Art historian Kirstin Buick argues that Lewis achieved this control by consciously divorcing her persona from her work, a separation achieved by masking the facial features of her female characters with anglicized façades. In this way, she would not be identified with her works, and they could not be said to be autobiographical, because they looked nothing like her. An example of this strategy is the almost life-size sculptural group of *Forever Free* (1867). It depicts a woman

with predominantly European facial characteristics whose long hair flows down her back in rolling waves, kneeling beside a considerably larger male figure. Her companion, with round features and a head of curly hair, rests his left hand on her shoulder as he reaches with his right for the metaphor of freedom above him. Lewis was not herself a freed slave; her father had been a free black and her mother a Chippewa; neither did she have white features, as the portrait of her from the early 1870s attests. And yet, simply because of the racial subject matter and her own racial identification, as Buick states, she was destined to be compared to the female figure in the work. See Kirstin P. Buick, "The Ideal Works of Edmonia Lewis: Invoking and Inverting Autobiography," *American Art* 9, no. 2 (summer 1995): 5–20.

31 The issue of Walker's age has been raised in almost every publication that discusses her work. I address it in the previous chapter on the reception of her art.

32 Richard Meyer, "Borrowed Voices: Glenn Ligon and the Force of Language," in *Glenn Ligon: Un/Becoming*, ed. Judith Tannenbaum (Philadelphia: Institute of Contemporary Art, 1998), 15.

33 Eungie Joo, in *Kara Walker* (Hannover, Germany: Kunstverein Hannover, 2002), p. 32.

34 Richard Meyer, "Warhol's Clones," in *Negotiating Lesbian and Gay Subjects*, ed. Monica Dorenkamp and Richard Henke (New York: Routledge, 1995), 93–122.

35 Alberro interview, 28.

36 James Hannaham, "Funnyhouse of a Negro," *Village Voice*, 3 November 1999.

37 Andreas Huyssen, "Anselm Kiefer: The Terror of History, the Temptation of Myth," *October*, no. 48 (spring 1989): 30, 31.

38 Kara Walker, "The Big Black Mammy of the Antebellum South Is the Embodiment of History," in *Kara Walker*, catalogue, unpaginated.

Conclusion

1 James Baldwin, "John Brown's Body: James Baldwin and Frank Shatz in Conversation," *Transition*, no. 81/82 (2000): 261.

2 Huyssen, "Anselm Kiefer," 30.

3 Gilles Deleuze, in conversation with Michel Foucault, quoted in Craig Owens, "'The Indignity of Speaking for Others': An Imaginary Interview," in *Beyond Recognition: Representation, Power, and Culture* (Berkeley: University of California Press, 1992), 262.

Page numbers in italics refer to illustrations.

Gwendolyn DuBois Shaw is Assistant Professor of
History of Art and Architecture and of African and
African American Studies at Harvard University.

Library of Congress Cataloging-in-Publication Data
Shaw, Gwendolyn DuBois.
Seeing the unspeakable : the art of Kara Walker /
Gwendolyn DuBois Shaw.
p. cm.
Includes bibliographical references and index.
ISBN 0-8223-3361-9 (cloth : alk. paper)
ISBN 0-8223-3396-1 (pbk. : alk. paper)
1. Walker, Kara Elizabeth—Criticism and
interpretation. 2. African Americans in art.
3. Slavery in art. I. Title.
NC910.5.W35A4 2004
709.'2—dc22 2004009137